Nathan R. Jones
April 89

FAMOUS FOR

15 MINUTES

FAMOUS FOR 15 MINUTES

My Years with Andy Warhol

ULTRA VIOLET

HARCOURT BRACE JOVANOVICH, PUBLISHERS

San Diego New York London

Requests for permission to make copies of any part of the work
should be mailed to: Permissions, Harcourt Brace Jovanovich, Publishers,
Orlando, Florida 32887.

Lyrics from "White Light/White Heat" by Lou Reed © 1967 Oakfield Avenue Music
Ltd. All rights administered by Screen Gems—EMI Music Inc. Used by permission.
Excerpt on pages 178–79 from Peter Coutros's article © 1968 New York News, Inc.
Used by permission.

Library of Congress Cataloging-in-Publication Data
Ultra Violet.
Famous for 15 minutes: my years with Andy Warhol/Ultra Violet.
p. cm.
ISBN 0-15-130201-4
1. Warhol, Andy, 1928–1987. 2. Artists—United States—Biography. 3. Ultra Violet.
4. Actresses—United States—Biography. I. Title. II. Title: Famous for fifteen minutes.
N6537.W28U48 1988 700′.92′4—dc19 [B] 88-24328

Title display by George Corsillo Text design by G.B.D. Smith

Printed in the United States of America

First edition A B C D E

Disclaimer

Just as Impressionist painters used strokes of color rather than photographic techniques to portray objects, so I have taken artistic license in conveying both reality and essence in this book. I have relied on memory, diaries, tapes, recorded phone calls, press clippings, books, magazines, interviews, and conversations to document what I bear witness to. All conversations are reconstructed and are not intended, nor should they be construed, as verbatim quotes.

Contents

Contents

Dramatis Personae

Ultra Violet Andy Warhol

SUPPORTING CAST

John Chamberlain John Graham
Salvador Dali Edward Ruscha

Tom Baker Gerard Malanga
Brigid Berlin (Polk) Taylor Mead
Jackie Curtis Paul Morrissey
Joe Dallesandro Billy Name
Eric Emerson Nico
Andrea Wips Feldman Ondine
Pat Hackett Lou Reed
Baby Jane Holzer Edie Sedgwick
Fred Hughes Valerie Solanas
Ingrid Superstar Velvet Underground
International Velvet Viva
Jed Johnson Holly Woodlawn

Dramatis Personae

Cecil Beaton

Betsy Bloomingdale

Maria Callas

Truman Capote

Divine

Marcel Duchamp

Bob Dylan

Ahmet Ertegun

Mia Farrow

Jane Fonda

Miloš Forman

Princess Ira von Furstenberg

Greta Garbo

Judy Garland

Princess Grace

Jimmy Hendrix

Freddy Herko

Dustin Hoffman

Howard Hughes

George Jessel

Janice Joplin

Robert Kennedy

Timothy Leary

John Lennon

Liberace

Charles Ludlum

Norman Mailer

André Malraux

Max's Kansas City (Mickey Ruskin)

Jim Morrison

Tiger Morse

Si Newhouse

Barnett Newman

Richard Nixon

Rudolf Nureyev

Aristotle Onassis

Yoko Ono

Lester Persky

Pablo Picasso

John Richardson

Robert and Ethel Scull

Frank Sinatra

Sam Spiegel

Jon Voight

Duke and Duchess of Windsor

Andrew Wyeth

Acknowledgments

Many people helped me in the writing of this book, and they deserve credit for all its merits. Its flaws are my responsibility.

Before all, I thank Andy Warhol, for without him there would be no book.

I am grateful to Jean Libman Block for helping to tame my prose, which is as unfettered as my spirit. . . . A good agent makes a world of difference, and for that reason I am indebted to my lawyer-literary agent, Arthur Klebanoff. . . . At Harcourt Brace Jovanovich, my editor, Daphne Merkin, sustained me and this project with tireless encouragement and support, providing inspired editorial advice at every turn; Claire Reich Wachtel was of invaluable assistance in overseeing this manuscript and guiding it through production.

I am still puzzled about the white bird that landed on my terrace at the beginning of this book and remained with me, looking over my shoulder as I typed. I took its presence as an omen: to write freely without constraint or censorship.

FAMOUS FOR
15 MINUTES

MEMORIAL

April 1, 1987: I am apprehensive about attending the memorial service for Andy Warhol at St. Patrick's Cathedral. A month earlier, the *Star*, a gossip magazine, ran my photograph with the recklessly erroneous caption: "Valerie Solanas got her moment in the spotlight when she burst into Warhol's studio and shot him."

I never shot Andy. That was Valerie, a passionate revolutionary, who was sentenced to three years in prison for her crime. I am worried that today an Andy-worshiper may recognize me from that picture and take misguided revenge. Or the opposite may happen: A furious, still crazed Warhol acolyte, carelessly discarded when the master grabbed all the fame and money, may throw a bomb in the cathedral to commemorate a final happening on this April Fool's Day.

In death, as in life, Warhol deals in contradictions.

Outside the steps of the cathedral, a woman is shouting, "The monster is dead! The monster is finally dead!" I wonder: Did this

woman have a grudge against Andy? Or is she trying to become famous for fifteen minutes?

What kind of mass can you put on for Warhol? Will the Warhol public be more at ease with a black mass?

His Eminence John Cardinal O'Connor has declined to celebrate the mass. Is it in fear of turning St. Patrick's into a cathedral of sinners? Or to avoid being reminded of a priest's recent death from AIDS? Warhol is in a way the spiritual father of AIDS, casual gay sex and equally casual needle-sharing having been daily fare at his Factory. But the cardinal's cathedral has been made available for a farewell service for the shy, near-blind, bald, gay albino from an ethnic Pittsburgh ghetto who dominated the art world for two decades, hobnobbed with world leaders, and amassed an estate of $100,000,000. He streaked across the sky, a dazzling media meteor, who, in another time or place, could have been a Napoleon or a Hitler.

My face is decorated with huge, haze-crystal earrings. I am dressed for mourning as befits a Superstar, in a dramatic fake Breitschwantz fez and coat, accessorized with black stockings and long, black-laced gloves. I enter through the Fiftieth Street side of St. Patrick's on the arm of a dear friend, photographer Sheila Baykal, and proceed through the south transept. I am holding a Bible in my hand.

Familiar faces are everywhere, hundreds and hundreds of them. The cathedral seats 2,500; it will be full. The in-town *in* crowd will not miss this *in* show for anything in the world.

I am surprised to see a refreshing field of orange and pink tulips and yellow forsythia inside the sanctuary. This abundance of living greenery and sunshine color mellows the rigorous Gothic of the gray stone pillars. A spring celebration appears in order. I did not expect, at this time and place, such joy and abundance of fresh flowers. I rather expected stiff plastic flowers. Plastic is Warhol's style. Years ago he painted for me unreal, gigantic flowers against a background of fake black grass.

Kneeling in the wooden pew in the second row, to the right

of the center aisle, my mascaraed eyes closed, I question my heart for feelings about Warhol.

Did I love Andy?

Yes, for an instant.

Did he love Ultra—the me I was then?

Who knows? It was not about love.

What was it about?

My mind goes back to the sixties, right here in New York. Andy Warhol and Ultra Violet are making news. We are creating—or so it seemed at the time—the most mind-popping scene since the splitting of the atom. We are living Art in the Making. The press calls it the Pop scene. When Andy died on Sunday, February 22, 1987, the front page of the *Daily News*, New York's picture newspaper, screamed: POP ART'S KING DIES.

But wait a minute. I met the King of Pop years ago. His name was Marcel Duchamp.

To me, Andy was the Queen of Pop.

If that is the case, how could I have been *his* queen?

I was Warhol's Superstar.

The Warhol world was a microcosm of the chaotic American macrocosm. Warhol was the black hole in space, the vortex that engulfed all, the still epicenter of the psychological storm. He wound the key to the motor of the merry-go-round, as the kids on the outside spun faster and faster and, no longer able to hang on, flew off into space.

When the storm was spent, when the merry-go-round stopped, the dazed survivors—some of them will be here today—had to grope their way back into an often hostile society. I am one of the lucky sixties people who escaped death, but I have been confronted with my day of reckoning, when my wicked ways had to be abandoned if I was to live at all, let alone in health and sanity.

Lifting my eyes to the vaulted ceiling of St. Patrick's, I search heaven for meanings. Did the stars incline Andy to be the final master of his destiny? I know—for I once looked it up—that the sun was found to influence his twelfth house at the time of his

birth on August 6, 1928, at 6:30 A.M. in Pittsburgh, Pennsylvania. Andy was the sun-at-midnight. The black sun.

Mourners are still filing in. Piano music fills the vast sanctuary, Wolfgang Amadeus Mozart's "March of the Priests." I visualize Andy in chromatic ascents and descents in mid-heaven or mid-hell. Amadeus. Andy and Amadeus, parallels of destiny in a fast rise to world fame and an equally abrupt ending, both starstruck with genius and, as such, set apart, blessed, living dissolute existences and dying of negligence.

Andy Warhol, native of a Pittsburgh ghetto, was courted by capitalist patrons of the arts who, in turn, commissioned their portraits to confirm their social status as the Who's Who of the world. Similarly, Amadeus Wolfgang, native of Salzburg, darling of the court, was appointed imperial composer by the Holy Roman Emperor Joseph II.

It took only one hour for Andy to make a one-hour movie. Amadeus wrote four violin concerti, each in one day.

Amadeus, a film directed by Czechoslovak filmmaker Miloš Forman, flashes quickly to mind. For a moment I think about the short romance I had with Miloš. But I'm not here to mourn my lost loves. I'm here to commemorate Andy. The mourners have had thirty-seven days since their idol's death to empty their lachrymal reservoirs. Now no more tears are shed.

How dare I compare Andy to Amadeus? I am comparing their fame. Andy was until just over a month ago one of the best-known American artists alive; today one of the most famous dead. His fame, his influence on art, his body of work constitute a great achievement by any standard. We are all here united to celebrate Andy's passing. All is forgiven. All is forgotten, remembered no more.

What am I saying? Of course he will be remembered.

Mozart's music still echoes through the cathedral. His formal themes suggest to me the Warholian formulas. In the popular, materialistic culture of America, Warhol correctly located the center of worship: not Christ on the cross, but Marilyn Monroe

on the screen. Irreverently, Andy popped up that image, magnified it, repeated it endlessly.

Marilyn, little Mary, little Mother of God, Marilyn Magnificat, "My soul does magnify the Marilyn . . ."

Warhol, the high priest, lifting the ciborium, holds up to the congregation the blow-up of the American icon, and they bow their heads in worship of the non-virgin Madonna. (The icon was auctioned for $484,000 at Christie's in May 1988.) With the same gesture, clothed in the iconic chasuble, image-maker Warhol uplifts himself in front of the *populus*, which hails him with instant recognition.

From 1962 to 1987, for twenty-five years—not just fifteen minutes—Andy Warhol was famous. More than famous, he was both an acclaimed artist and a potent social force. He changed the way we look at art, the way we look at the world, arguably the way we look at ourselves.

Yet his art only seemed to camouflage the man. One could never know Warhol by listening to him, for he rarely spoke; by reading his books, for he did not write them; by seeing his movies, for he rarely made them himself; by watching him, for he was watching the watchers; by touching him, for he hated being touched.

This was a man who believed in nothing and had emotional involvements with no one, who was driven to find his identity in the mirror of the press, then came to believe that reality existed only in what was recorded, photographed, or transcribed. But he had to have been more than a shadow or a charlatan. Because of him, the glitterati of the world are in church today.

Yet to some, Warhol was only a brilliant con artist who concocted whatever fantasies people needed, a genius of hype and illusion, the ultimate voyeur, who exploited our young people. To others, he was a genuine talent, a genius of the first rank, who held an objective mirror to our plastic society, took America's faltering pulse, and illuminated the foibles and fixations of our times.

It might be said that Warhol was constantly working the culture to become the male Marilyn Monroe; that was his dream. Hence his fascination with transvestites. Industriously, day and night, he burnished his icon image. The primary creation of Warhol was Andy Warhol himself.

Throughout our years together, I was always asking Andy questions. He liked to be fed questions, although he did not always answer. When he did, his replies were usually brief, brusque, sometimes cryptic; rarely did he speak at length.

"Andy, I think you're an image builder for yourself and your cause. Is that right?"

"If you say so."

"What if people worship money?"

"I paint dollars."

In 1962 Andy painted *80 Two-Dollar Bills*, and in 1981 he painted *Dollar Signs*. Andy knew his market.

"Why do you dress in black leather and dark glasses?"

"James Dean."

"Where is your imagination?"

"Have none."

"Why not dress as Popeye, your hero?"

(Because I am French and at that time my English was inexact, I pronounce it Popay. He corrects me and says, "It's Pop Eye." Popeye is his childhood hero, Dean his adult idol. Andy reminds me, "Dean said, 'Live fast, die young, leave a good-looking corpse.' ")

"What do you really want?"

"Instant recognition."

"By whom?"

"The world."

Andy got his wish. He became the high priest officiant of taste, glamour, sex, fad, fashion, rock-and-roll, movies, art, gossip, and night life. He was father confessor of the lost kids with all their problems—drugs, sex, money, family. In the confessional, Father Andy, head bowed under his platinum miter, al-

ways lent an ear, never listened, just recorded. *"Tell me your sins,"* he was saying. *"I will absolve them."*

"You don't absolve, you incite," I accused.

"Ummm."

"Why do you always let people do what they want to do?"

"Mama always let me."

I look around St. Patrick's and see a woman sticking a coke spoon up her nose behind a manicured hand. I close my eyes and hear ostentatious snorting.

The pianist is playing more music from Mozart's *Magic Flute, La Flûte enchantée, Zauberflöte.* Yes, Mozartian magic molded the Warhol persona. Magic was a word Andy gargled with for hours. "Magic this, magic that. Figaro *sì*, Figaro *la*. Some have magic, some don't. It's all magic. Some people make magic, some don't. It's just magic. Magic's the difference."

Andy was the biggest magician of all.

As a Roman Catholic, Andy worshiped the Church's magic. In childhood he wore a magical gem, a Czech Urim, sewn by his mother into a secret pocket in his underwear. He sought the power of divination. He sought all power. I remember being told once that New York politicians used to call St. Patrick's the Power House. We're in the right place.

Andy and power. Maybe that's why all the girls at the Factory wanted to marry the magical albino. And all the boys wanted to get into his pants.

When Andy put his "Warhol" on, with a mere glance from his nearly blind eyes, things flashed and moved around the room. When Andy, as Disney's Snow White, donned his pale, wheat-colored wig, the Factory dwarfs, headed by Gerard Malanga, poet and number one helper (at $1.25 an hour), got to work to the sound of a rock-and-roll "Heigh-ho, heigh-ho," and away we went. Andy was our Dwarf Star. Yes, Andy was right out of the enchanting world of Disney, where instant zap transformed an ugly duckling into a charismatic magician. The reality and the myth were confounded into one.

L'enchanteur enchanté. Andy had a long ancestry of fairy-tale making. When he worked in his youth as a commercial artist for I. Miller Shoes, he revived storybook sketches of Cinderella for an advertising campaign. He wrote, "Beauty is shoe, shoe beauty." His whimsical drawings of shoes adorned with tassels, cupids, beaded borders, and diamond dust reflected mythic magic.

The art he created is magic realism. Webster's defines it: "The meticulous and realistic painting of fantastic images." Magician supreme Warhol, without a wand, struck a Brillo box into a work of art worth $60,000.

Pop goes the weasel! Out of the box, with one ferret and one gimlet eye, one grayish, one bluish, the hybrid albino, a creature of the dark, with a platinum shock of hair, cast a spell; he crystal-gazed at the culture as he translated himself into the conjurer conjured. He uttered his weasel words, "In the future, everyone will be famous for fifteen minutes," and the members of the audience cheered and applauded, dazzled with the sight of themselves on camera.

Where is Andy now?

Bargaining a portrait of St. Peter for $25,000 worth of indulgences? That's what his portraits were selling for here on earth. His approach was, I'll paint anybody for $25,000. All it required was blowing up a Polaroid of the subject, ordering a silk screen, passing a housepainter's roller with one or two colors across the screen. If you're wondering where the artistry comes in, it's all in the concept, not the rendition. It's the magic.

But St. Peter is not just anybody. In Catholicism he is the keeper of the gate. Andy always wanted to be in, not out. Andy was always concerned about the nobodies and the somebodies. He was so afraid to be a Nobody, so thrilled to be with Somebody.

There is no taking of Polaroids in heaven; the ineffable light precludes it. So how can Andy do a portrait? By hand drawing? Unthinkable for an artist who wanted to be so completely detached from his art that he refused to touch it.

But wait a minute. What makes me think Andy has arrived

at a place where he can have commerce with good St. Peter? Maybe he is now somewhere quite different. He sinned; he abetted sinners. He broke commandments. Did he repent? My Bible opens to Luke 13:3: "Unless you repent you all likewise perish."

Now, Isabelle, where is your charity? Here in this sacred place you must not withhold the hand of mercy. The Church has forgiven Andy, or we would not be here. In time and eternity, Andy will work everything out. I do not doubt it for an instant.

Of course, Andy must be loving every minute of this ceremony. I use the present tense intentionally, for Andy is watching his own memorial on the great celestial TV and is not missing a moment.

This is his kind of party. All the celebrities are here. The media people are out in full force. It is an all-star, superstar, megastar happening—the memorial mass for Andy Warhol.

In December 1963, dressed in an exquisite Chanel suit woven of gold-pink-blue thread, a black velvet bow in my hair, I step out of Salvador Dali's limousine in front of 231 East 47th Street in Manhattan. The block is nondescript and commercial. The brick building is dilapidated, the metal fire escape on its facade rusting. I walk through a run-down entranceway. With some hesitation, for it is my first time doing this, I operate a crumbling self-service elevator that is spacious enough for a truck. The gates are painted silver. On four, I step out onto a concrete floor painted silver and into a vast silver interior.

An impression of devastation immediately hits me. The raw barrenness—except for a collapsed couch large enough for a *ménage à cinq* and a broken wooden slat-back revolving armchair—makes me suspect a fire has taken place. The odor of old smoke remains. Thinking out loud, I hear myself say, "There must have been a fire here."

"No."

Against the silvery background of the wall I have not noticed my silvery host. Is it the metallic reflection of the walls or is it Andy's birthright complexion? He appears coated with quicksilver.

"Was there a disaster here?"

"No."

"It feels like it."

"Uh."

"You work here?"

"Gosh, yes."

"I thought you were a painter. In the studios I've seen, Dali's, Picasso's, you smell paint, you see canvases. Here you've only got empty space." The walls are eighteen feet high, the glittering box thirty feet wide and a hundred feet long.

"Space is where it's at."

"I see now why you call your studio the Factory."

"Oh, tell me why. I can't figure it out, except that it used to be a factory."

I think: Is he an alchemist? Or is he Ali Baba in his magic cavern?

"Where are the jewels?" I ask.

"They're here somewhere." He is referring to his paintings.

I hear the sound of tinkling coins and realize Andy is laughing. All around me, silver disintegrating walls, pipes wrapped in aluminum foil, like giant Christmas gifts, silver-sprayed file cabinets and stereo equipment decorate the loft.

Something stirs in my memory. Of course: I am back in the basement apartment of painter John Graham, with its mirror-covered walls that four years ago beckoned me into an artistic and erotic unknown. When I walked through those chimeric mirrors, I left behind forever my severely Catholic upbringing, my link to linear logic. Here in the Factory the mirrors have come out of their frames and merged into a total environment of silvery reflections and refractions. Once again I am in a place of magic,

a wonderland where you step in and out of yourself, where memory and fantasy race into each other at full tilt. I think of Salvador Dali's White Labyrinth in Spain, another abode of reverie and unreality, and of the silver outfit I assembled to astonish the master of Surrealism.

The tips of my fingers tingle with excitement. I feel my heart race. But I stay very cool. I am the elegant stranger who has ventured in out of curiosity. Will I step through the looking glass into a kingdom of illusion? I don't know yet.

Andy picks up a can of instant silver spray and touches up an inch of space, a non-silver gap between two tinfoil seams.

"Ouch, you just sprayed silver on my gold Chanel shoes."

"Oh, I'm sorry. It's the draft."

"What do you do here?"

"Gee, I don't know."

"As an artist, what do you do?"

"Look for ideas. I never find any."

Even the light emitted by the aluminum spotlight shines with a silvery glow. Or is it the glittering interior that reflects itself?

"You've covered the windows with aluminum foil. Where is your natural light?"

"Electricity is more artificial."

"You're certainly breaking with tradition. Maybe what you're creating is artifact, not art."

I think of traditional European studios, with their wide skylights to the north. Vermeer comes to mind. In the northern hemisphere, artists have always preferred light admitted solely from the north. It is more neutral in color and has fewer variations than light from any other direction.

A door opens onto a fire escape and daylight. Stepping outside, I lean on the railing and look around to reassure myself that the outside world is still the same as it was when I left it only a few moments ago. A second look confirms that there is a real silver cloud in the real blue sky. I reenter the silver loft, convinced that this hybrid albino is an extraterrestrial. I am fasci-

nated. I am determined to undress him figuratively as well as physically. What kind of lover is this gaudy deity? He must have liquid mercury for sperm.

I say, "Andy, I am an artist too. I'd like to sketch you."

"Don't bother; take a picture of me."

"It's not the same. I like the feeling of the pencil in my hand."

"Feeling?" He laughs.

"The miracle of the moment. The hand moves on the paper and a form, a sensitive form with the characteristic of the individual, comes alive. . . ."

"Photography is more real."

"But it's impersonal—you have nothing to do with it."

"It's better."

"Anyone can take a photo, but not just anyone can do a drawing that conveys life and accuracy. Like a Poussin drawing . . ."

"Poussin?"

"You don't know Poussin, one of France's greatest artists of the nineteenth century? You have no art culture."

"Don't have to know art. I make art."

"Feelings are everywhere. We can't exist without them. Here there is a feeling of silver dreams."

"That's amphetamine."

I grasp a piece of Mylar floating loose from a silver speaker. "This Mylar . . ."

"It's very high grade."

"It makes me think of astronauts. Are you a launching pad?" Andy moans.

"There's also a feeling here of memories," I say. "Do you know why?"

"No."

"Mirrors—they have the most memories." I am quoting John Graham. "This place is a giant reflector. Do you have memories?"

"No, I don't remember anything. Each day is another day."

I laugh and say, "Oh, that goes pretty far. How do you feel about mirrors?"

"I'm a mirror. Look at yourself in me."

I look at Andy, my face close to his. I look right into his eyes and I see radar. Two parabolic metal disks, revolving slowly on themselves, scan the visual field. I see two of me each time his radar lays eyes on me. I say, "I recognize you. I myself see beyond the spectrum of light."

By now I am under Andy's spell. After all, I left France deliberately to break with family and tradition. I've had my turn with Graham, with Dali, with many others. Andy is up my alley. He is an extremist, a fantasist. That is what I love. My romances have been eccentric, each a new adventure. Now I feel that this conjurer will take me to an even newer dimension. Entering a new age, a silver age, I am excited about the future. I am suddenly wild about Andy. In a low tungsten key, he is amusing, even thrilling. I must seduce him. That is the only way to find out if he is real, if he is a man or just a silver-plated robot.

"Are you alone here?"

Andy gestures to the door at the northern end of the Factory. "Billy is in the closet."

"Who's Billy?"

"Billy Name."

"That's his name?"

"Yes."

"When will he come out of the closet?"

"He's been there two months."

"Maybe he's dead."

"No, it would smell."

"How does he eat?"

"Probably goes out at night."

"What does he do?"

"He's a photographer."

I am determined to have this silver sorcerer at my feet. But how can I get him to sit on the couch? On second thought, the

couch looks too much like a run-down bed. It would be too obvious. I hear a miaou. I turn around. A silver-sprayed cat looks at me with a spaced-out expression. I go to pick it up, but I change my mind, thinking I'll get silver on my hands.

I ask Andy, "What is that strange building across the street?"

We both step out onto the narrow metal platform of the fire escape. I grab Andy. He moans. His body is cool and it seems to become colder and colder by the instant. I say, "Andy, let's make love." I reach for him, but he wriggles out of my embrace. When I move closer and try to clasp him to me, he stiffens and resists. He moans loudly. A passerby lifts up his head and screams, seeing us suspended in the air, wrestling on the perforated metal platform. Andy turns icy cold, except for the back of his neck. Believing that he is afraid of heights, I let go of my prey. Andy climbs back into the loft, white as death.

It takes me a few minutes to realize that it is Andy's hairpiece that keeps his neckline warm, the sole part of his anatomy at body temperature. It takes me several days to realize that he is not afraid of heights. He is afraid of me.

Back in the loft, we are both shaken by this non-seduction scene. I push my hair back into place. Andy's hair is in disarray. I don't mean to stare as he adjusts it, but I am unable to pull my eyes away when I see a snap, a metallic snap, embedded in the front part of his skull. He snaps his hair into place.

This lover boy is not made for love. At least not for me.

"Andy, show me your paintings," I say.

ENTOURAGE

The original Factory, at 231 East 47th Street from 1963 to 1967, is constantly visited by the police. That is easily understandable, for the door is always open, and stoned kids float in and out. Anything goes in the dark end of the loft: needles, sodomy, handcuffs, beatings, chains. The police are never able to put their finger on any precise crime. Sometimes I wonder if they're looking to get in on the action.

Plenty of other people drop by to gawk, or say hello, then rush off to print or broadcast what they see at our assembly line for art, sex, drugs, and film. Celebrities are often on hand, to party with us or just hang out. Sooner or later you might run into Rudolf Nureyev, Jane Fonda, Montgomery Clift, Tennessee Williams, Bob Dylan, the Rolling Stones, Jim Morrison, Judy Garland, William Burroughs.

But I find the Factory regulars more colorful and fascinating than the big-name visitors. The first person I learn about is Billy Name, the man in the dark closet at the rear. Is it an omen that

he is in the closet? When will he come out? His name is an alias. It is a Pop name. He took the name Name because it is basic and instantly recognizable. He is the originator of all the freak naming. As bad Catholics—and for no reason that I can explain, it turns out that we are almost all, with very few exceptions, lapsed Catholics—we get rebaptized as we enter the Warholian deep water.

Billy is an A-head. That means he is an amphetamine freak. Amphetamines are his principal food, both physical and psychological.

When Andy saw Billy's apartment, decorated with silver foil from floor to ceiling, he said, "Do the same for us on Forty-seventh Street." And so Billy moved into the dark closet in the Factory and, little by little, covered every square inch of walls, floor, ceiling, toilet bowl, electric bulbs with silvery foil or silver spray paint. He even painted the silverware. And Andy's wig went silver. The whole studio turned into a giant glaring mirror.

Billy named it the Factory—a place that manufactures people, ideas, concepts, films, even art. He became Andy's official photographer. Just as Louis XIV had Rigaud, his court painter, Andy had a court photographer. If you want your picture in the paper daily, if your existence is validated by the volume of your clippings, then you need a house photographer to keep the newspapers and magazines deluged with photographs.

Andy is not the first artist to have a house photographer. Salvador Dali always has a photographer or two standing in the wings at the St. Regis Hotel, just in case a celebrity passes through. When his mustached antenna detects a newsworthy presence within a hundred yards, Dali slides to the side of the celebrity. Snap, snap, snap, and next day his picture is in the paper.

When I eventually see Billy Name, three months later, he has three cameras hanging around his neck, and the first thing he says to me is "Krenk, krenk, krenk."

I reply, "Ku, Klux, Klan." I've never before heard whatever

language this is. I think for a moment it may be Middle Irish. After he repeats "Krenk, krenk, krenk," he cocks his head, cranks his camera, and snaps a picture of me. I get the idea.

He is also the court astrologer. I often see him with astrological charts in his hand. We are all dying to examine Andy's chart, for it would reveal his true age. We are sure he is older than he admits. We girls are not admitted into the darkroom, which is Billy's domain. Billy has the keys to the Factory—a sign of ultimate trust. None of the girls has ever had a key. Yes, even here it is a man's world—a gay man's world.

Billy is always dressed in black. He is extremely thin, with a bony face, recessed eyes, dark eyebrows, a prominent jawbone. His looks are those of a theatrical SS man. One day he says to Andy, "I see danger in your chart."

Andy says, "Huh."

Billy says, "I'm warning you, be careful." Andy never listens.

Billy, who truly loves Andy, is an artist, trained in the spirit of Black Mountain. Billy tells me about Black Mountain, a school in North Carolina started in the 1930s as an early center of counterculture, with a back-to-the-land philosophy. "All of us carried Rimbaud under our arms," Billy tells me. "We had our own system of education. Rauschenberg was there, John Chamberlain, Josef Albers. They were all freethinkers."

Billy is also a lighting designer. He brought to the Factory the mirrored ball that revolves and reflects flashes of light. Later there would be one in every disco.

The next person I meet is pretty startling. He is Eric Emerson. He is dressed, rodeo rider style, in a cowboy hat, black scarf around his neck, black leather vest. He is not wearing pants, and his exposed genitals are sprayed gold. His pubic hair, like golden angel's hair, shines beautifully, framed by black leather chaps. He is a vision of golden cherub mixed with macho far West. Or far out. His testicles are gold golf balls, so regularly textured they seem unreal. His teeth are a good white. His smile is sweet.

Eric is on amphetamine. As he walks, his golden genitalia

swing upward, seeming to defy the laws of gravity. At times he picks up his right leg, encased in a black leather boot, and raises it to the vertical, like a dancer. Then he repeats the movement with his left leg. At other times he does the split. His gold genitals land on the silver floor like shiny Christmas tree ornaments falling onto a foil-wrapped gift box. He appears charmingly deranged. He is a pretty street boy, a midnight cowboy.

"Hi, Ultra. Hi, Ultra," he says each time he does the split.

Another regular, there every day, is Ondine, an amiable, loquacious amphetamine freak. A superfluity of language flows out of him whether he is alone or in company. He keeps a journal of his drug taking. There are countless pages in the book. He listens constantly to Maria Callas records, turned up to overpowering decibels.

He has well-formed lips, the lower one sensuous, the mouth's corners turned up. He has dark hair and a strong nose. He gives the impression that he is just about to go onstage. In fact, he is always onstage, in a limbo between the real world and the world of drugs.

Ondine treats me as if we've always known each other. He says, "Please pull this tourniquet tight while I, I, I . . ." He repeats sounds and syllables when he talks, not in a straight stutter but in a kind of hesitated delivery. I hold the tourniquet in place on his upper arm. I am reminded of my school days, when I played doctor and nurse with my friends—but this is not an innocent game. Ondine closes his fist. Without looking at his arm, but looking me straight in the eyes, he swiftly plunges a shiny needle into his bulging vein, empties the hypodermic syringe of Methedrine with lightning speed, swiftly pulls it out, leaks the needle, releases the tourniquet, swallows his saliva, and the cascade of verbiage resumes.

"Dear, dear, God, how, how, how much longer do I, I, I have to go? You're pin, pin, pin, pinning me to, to, a wall of fire."

Ondine readjusts his robe. He does not wear slacks; it seems to me he has nothing under his robe. I identify his accent as a

Bronx honk. He tells me, "I live in the rough, rough, roughest part of the Bronx." He belches ostentatiously, adopting the pose of a bel canto prima donna.

"You can't stop the flow of his talk," I say to Andy.

"Ideal for recording," he replies. Later Andy records Ondine for twenty-four hours. The transcription becomes *A*, Andy's first Pop book, published in 1968.

Ondine throws his paraphernalia into a crumpled brown paper bag. I've never set much store by normality, but I've never actually met drug users before. I am both fascinated and repelled. I sense an enormous complicity of art, sex, and drugs. I notice a wasted pallor on Ondine's face. Words are pouring out of Ondine. Andy is recording him. I keep an eye on Ondine and his paraphernalia. I am literally afraid of drugs and I don't want to share this part of the Factory action.

Taylor, dear Taylor Mead, poet, vagabond, clown, actor, seizes my attention as he roller-skates into the Factory with a transistor radio dangling between his legs, dangling very low, for the crotch of his accordion pants hangs three inches below his anatomical crotch. Night has fallen, and Taylor appears as a weird, nocturnal creature. The two sides of his face do not match. One eye is bigger, one cheek is higher, his brown hair flares up to the right. As if a tide is pulling his flesh askew, his facial skin hangs asymmetrically. Goya would have loved that face.

Taylor says, "*Je parle français*," with the cutest American accent. Is he Le Poète Maudit Américain?

We sit on the couch, as broken down as Taylor. The side of his face I am sitting next to is comic; the other side is tragic. He carries a navy blue plastic airline bag from Pan Am. He reaches in with a dirty, childlike hand, pulls out a pill, and pops it.

"I was gay at nine," he says. "My mother is high society from Grosse Pointe, Michigan. I've been in and out of a dozen jails."

"What for?"

"General principles. Cops arrest me on sight."

"Sight unseen?"

Taylor laughs.

"What principles?"

"Jails down South are a piece of cake. But New York jails are a real horror."

I repeat, "What principles?"

"My poetry—they say it's obscene. Vice squads arrest me in public toilets. Drugs, defiance, the necessity to do anything, not resist anything. Cruising men. I like policemen best, the not straight ones."

He speaks sporadically, in an off-and-on manner, starting and stopping. I wonder if his erection also waxes and wanes as he approaches the anal orifice.

"What was that pill?"

"A downer."

Taylor takes out a small notebook and starts writing.

He reminds me of the French poet Verlaine, who at age thirty shot Arthur Rimbaud, by then twenty, in the wrist over a lovers' quarrel. Verlaine was imprisoned for two years. I wonder if these poets of the sixties, Taylor and his friends, are the counterparts of the French poets of the nineteenth century who hoped for a society totally without moral restrictions. Is Baudelaire reembodied on Forty-seventh Street?

I ask Andy, "What do you like about Taylor?"

"He exposes himself."

Andy, the professor of Pop, finds a pupil of Pop in Gerard Malanga, a student at Wagner College in Staten Island. They first meet at the New School, where Gerard is reading his poetry. Gerard is looking for a summer job. He has had experience with silk screens. His summer job with Andy lasts from 1963 to 1970. Gerard becomes Andy's minimum-wage assistant, at $1.25 an hour, his *homme à tout faire*. He paints for Andy, acts for Andy, dances for Andy, undresses for Andy, films for Andy, talks for Andy (as all of us talk for Andy), writes poetry for Andy, recruits pretty boys, pretty girls, and patronesses of the arts for Andy, cracks the whip for Andy, both literally and figuratively. He also photographs for Andy.

When Gerard gets up to answer the phone for Andy, he has

the most peculiar Bronx Zoo walk, swinging his pelvis from right to left. In a nasal accent cultivated in the shadow of Yankee Stadium, he says, "Yeap, hello, hi, Ingrid . . ." into the receiver of the pay phone installed on the east wall of the glittery loft. I have seen his type of face in the driver's seat, riding heavy trucks along the highways of Greece. He is at the phone again. "Yeap, Ingrid, we'll film tomorrow at three. Be here 'n' wear something sexy."

"Is that Ingrid Superstar?"

"Yeap, she's sure a Superstar, all right."

Gerard wears black leather pants, too short at the ankle, with two stretched baggy pouches below the knees. His hair is rather long, not too clean, vaguely wavy. He wears a black leather coat. I ask Gerard, "What's Andy really like?"

"He's interested in a lot of things: poetry, films, dance. Every night all or some of us go to a reading at St. Mark's or Café le Metro or Judson Memorial Church." Every kind of art you can name is detonating all around us.

The phone rings again. Gerard swings his pelvis laterally and answers. "Yeap, I'll get him." He calls out to the other end of the loft. "Andy, it's Cage." Then back to the phone. "Hold it." Gerard lets the receiver hang by the phone. He swings his pelvis back to the broken-down couch.

Andy, on the phone, says to John Cage, the composer, "Gee . . . um . . . ah . . . woo . . . really . . ." Andy listens for a long moment, then says, "Get us invited, 'bye."

Gerard gets up and flushes the toilet for Andy, who was in the bathroom when called to the phone.

Paul Morrissey plays father to the rest of the group. He is pleasant, sensible, the most normal of the crew, and takes care of business. He sees that bills are paid, papers signed, supplies delivered. He has the soul of a social worker—which he was, with a degree from Fordham College, until he became keeper of the menagerie. His uncombed frizzy hair covers his forehead. He has light eyes that constantly dart about. He is thin, tall, dressed in black jeans and a black turtleneck.

"How come everyone here has a peculiar accent?" I ask him.
"We're international."

That's a satisfactory answer if you consider the Bronx a foreign country.

Irma is her real first name, Ingrid her Factory first name, and Superstar her Factory last name, because she is chronologically the first of the Superstars. But irony rides high, for this star is resplendently ugly. She has a chin like an overshoe, tilted teeth with a wide gap on the upper left, twisted lips, a potato nose, small eyes, a bumpy forehead, and uneven bleached hair. But her eyes have a marvelous twinkle, and I think it's the twinkle that makes this escapee from Wyckoff, New Jersey, eligible for stardom. Certainly it's not her taste, for the mixed-up plaids in her jersey outfit are not outrageous enough to be truly camp.

Unable to carry a tune, she is singing away when I first see her at the Factory, on my third visit there. Andy says, "Keep singing, Ingrid, it's great."

"What song would you like?"

"Any song."

"My mouth is tired." Her voice is off pitch and out of sync with her lip and hand motions. She never lets go of the cigarette in her hand. She sings, puffs, blows smoke at the same time. She is the original singing-smoking machine. In the glare of a spotlight that would make anyone else blink, Ingrid calls out, "How am I doing?"

Without looking up from the magazine he has been flipping through for the last half hour, Andy says, "Oh, great."

I ask Ingrid, "Are you preparing for an audition?"

She looks offended. "I never audition. I'm a Superstar. I'll end up in Hollywood."

Baby Jane Holzer, a genuine Jewish-American princess, vaguely reminiscent of the divine, inimitable Brigitte Bardot, has lots of long blond hair, lengthy legs under a miniskirt, a forced smile, an air of playing at femininity and voguishness. She takes a teasing comb out of her clear plastic makeup bag and puffs up the back of her hair. With a red lipliner, she reinforces the out-

23

line of her kissy mouth. She blots her lips, puts on more crayon, blots again, pales her lips, blots again, pales again, in a ritual gesture. Her walk is that of a model on a runway. When she speaks, she swings her long blond hair from one side to the other. Her voice sounds smooth and practiced. She asks, "Oooh, what's happening, aaaaah?" but no one hears her over the thunder of Stravinsky's *Petrouchka*. She goes back to her mirror. A dropout from fashionable Finch Junior College, she wants you to understand that she is very contemporary and quite gorgeous.

Between two sniffs of white powder, Eric Emerson glances at her and says, "A straight jerk, that Baby Doll."

Runaway heiress Brigid Polk, who arrives in 1965, walks around the Factory topless, the roundness of her bare shoulders, back, stomach, breasts forming an obese pink continuum. A red rubber band holds back her skimpy mop of hair in an off-center Yorkshire-terrier hairdo. An artist of sorts, she holds in one hand an autograph book in which famous-infamous people have drawn their cocks and affixed their signatures. In the other hand she holds a hypodermic needle and smacks it through her blue jeans into her round rump, as "*Assassino!*" crescendos on the record player. By now it's *Tosca*, not a bad accompaniment for the non-stop opera that is being staged in the loft.

"Want some?" Brigid asks me.

"No, thank you," and I flee to the other end of the silver cavern.

Drugs terrify me. I smoked grass once in 1960 at a dinner party in an apartment in Paris near the Étoile. My hostess passed around a cigarette in an elongated cloisonné holder. Ready to try anything, I inhaled deeply twice. I felt nothing and took another two puffs when the cigarette came around again. Still nothing. Later, when I got to my hotel, I found I had left my keys, my purse, everything at the party. The hotel manager paid the taxi driver and let me into my room. I wanted to call my hostess and tell her I'd pick up my bag in the morning, but my mind was too

cloudy to recall her name. I was so frightened by the loss of memory that I swore never to try drugs again.

About the time I met Andy, I went to a birthday party with Dali. Someone had baked a marvelous-looking chocolate cake, very elaborate, with chocolate swirls all over the top and sides. There was a lot of giggling about the cake; I thought people were amused by the extra-fancy decorations. I ate a large piece. Delicious. A half hour later, my face began to go numb, as if anesthetized. In an hour, I had the peculiar sensation that my lips were stretched out like the lips of the Ubangi tribespeople you see in *National Geographic* illustrations. I raised my hand to six inches in front of my face, expecting to feel my lips, but they weren't where I thought they would be. Not until morning did I feel normal. Then I remembered the giggling and realized the cake had been laced with marijuana. Once more I swore never again—there was no pleasure for me in drugs and only unpleasant side effects. That's why, when I was with Andy and his crowd, I never touched drugs.

Brigid Polk and the druggies in the Factory are talking to a sexy-looking kid who stands motionless in one corner. Brigid says, "I love taking off my clothes. Everybody gets hysterical. When I pull my top off on the street, Andy gets so excited."

I wonder how "pasteurized" Andy can get so excited, so I ask him, "What excites you about Brigid's breasts?"

"Oh, she's fabulous," Andy says as he snaps a picture of Brigid's breasts hanging rebelliously far apart and looking as if they've never been fettered by a bra.

"A liberated body assumes its overfed shape as beauty," Eric Emerson shouts. "Ugly is beautiful."

"Nudity results in jail," Taylor warns.

"Which is the antithesis of liberty," Gerard reminds us.

"I'm naked—that's freedom," Brigid proclaims.

Exhibitionism is in the air.

"Catch the freaky phallic rod while you can," Brigid croons.

"Verbal seduction is no longer it," Gerard contributes.

"It's vibration that's everything," Brigid says with finality. Suddenly the discussion, or whatever it was, is over.

Her real name is Brigid Berlin; her father is Richard E. Berlin, president of the Hearst Corporation.

"That's what Andy loves," Eric tells me; "not her, but Hearst."

Of course; I should have known. Andy's secret wish is to become Citizen Kane, a tycoon of fame. He dreams of controlling the media by having his own press, which he does a few years later in 1969, when he launches *Interview* magazine. I find out before long that he identifies with every minute of the famous Orson Welles film that portrays William Randolph Hearst as an idealist corrupted by power. It gives Andy white goose pimples to have Brigid Berlin, daughter of Hearst's surrogate, cavorting around the loft, with or without clothes on. It lends tangibility to his dream of power, fortune, glory.

Like most fat people, Brigid claims she does not eat. "It's the air that makes me fat," she confides.

Oh, sure, I think.

Later, I go out on an errand and see Brigid sitting at the counter of a coffee shop, working away on a triple ice cream sundae with whipped cream cresting around the dark brown chocolate, the nuts, the red cherry, not forgetting the slices of banana and the cookies at the side of the plate. I cannot resist going in. Brigid says, "I'm not eating it."

"I know; you're drawing it in your autograph book."

Brigid gives me the look of a seven-hundred-pound canary starving for sugar. Back at the Factory a little later, Brigid is walking around with a fat manila envelope full of pills. "Distribution time," says Eric.

"Obetrol or Seconal?" Brigid asks.

"Both," says Eric.

"Duenol or Obetrol?" she asks.

"Both," Eric repeats. Everybody giggles.

Brigid is nicknamed the Doctor because she carries around

every pill ever invented; she is also sometimes called the Duchess, because she distributes her hoard with royal generosity. I call her the Rapper, because, like Ondine, she never stops talking. She raps about everything and nothing.

"People get bored with me," she says, "but I can't help it. I got to keep talking. I can't shut up. When people talk, it gives me ideas, and they have to get out of my head. I can't hold my tongue. Andy just sits there, and I talk. I get rid of a lot of frustration and anger. I scream and yell. Andy is fabulous. I love him; he's my real father. He tapes me all the time. He never listens to it. It's just a gimmick to make us talk. How could he listen to all the tapes he has? He always puts you in the spotlight. There's something childish and fantastic about him."

International Velvet is an honest-to-goodness beauty: young, slender, feminine, a real woman, the first real woman I've seen in this masquerade of misfits. Her skin is flawless pale pink, her hair abundant and dark. She has style and class. She even has a boyfriend, David Cronland, and he looks normal too. Her father is a prominent lawyer in Boston. She came to New York at seventeen to model.

I'm fascinated by her makeup. Her eyes are widened by white shadow above her lids and darker shadow in the creases of the lids. White dots at each corner of the eye create the illusion of eyes opened very wide. Alternating black and white lashes are painted on the skin of her upper and lower lids to amplify her lashes and make her eyes radiate like two stars. She has shadow on her chin and on her cheeks. She dusts talcum powder all over her face and with an extra-large round brush dusts off the surplus white until only a pale cast remains to accentuate her fairness and the transparency of her skin. She is so beautiful she looks unreal. I ask her, "How long have you used talcum?"

"All my life—first on my behind, now on my face."

International Velvet is the only Superstar in Andy's ménage who unquestionably deserves that title. She's the one who has the real potential to make it in Hollywood.

On a hot summer night, quite late, I open the door of the Factory and an oh-so-slim sylph dressed in a black leotard cut off at the knees and black desert boots stands there. A shimmering cluster of rhinestones dangles from one ear. Her hair is streaked with silver, and immense eyes engulf the world. Her complexion is milky and angelic; vulnerability seems to exude from every fine pore of her skin. Andy says, "This is Edie." Yes, I know Edie. We've already met, at a party at Lester Persky's.

Edie Sedgwick, from a Boston Brahmin family, now a flower child, a delicate flower, soon to be cut down, says, "Hi, Ultra, I love your name." She smiles as she speaks. Her voice is soft and sweet. Every twelve seconds she dances to the rock beat inside her head. She is riding high, seven floors above the ground. She is always high. Andy likes high people: they are animated and uninhibited in front of the camera. They will do anything for fun, and they don't have to be paid. Just give them drinks, drugs, doughnuts, and approval.

Edie asks me, "Where are you from?"

"Not from here."

"Same here," and she shows pearly teeth that could be jumbo white polished rice.

Andy is filming Edie's life story, starring Edie. They talk in a disjointed way about the film. It's nearly 3 A.M. My car is waiting outside. I offer to drop them off uptown. In the car, Edie glues her face to the window, her eyes open wide, as if to absorb the whole city. She gets out in the East Sixties. On the way to Andy's place on Lexington Avenue, he turns to me and says, "If Edie OD's, we must film it. Stay in close touch with her."

To me at that time, OD means only taking too many drugs and getting extra high. The kids are always saying, "Last night I OD'd, wow!" and are ready for another and bigger OD that night. I have no premonition of Edie's tragic fate.

Viva joins the Factory regulars in 1967. Her forte is complaining. She complains about having no sex, she complains about restaurants and lousy food, she complains about being de-

pressed, she complains about hating the word "artist," she complains about people hanging up on her, she complains about male stars who don't get an erection on film, she complains about male chauvinism, she complains about getting phone calls from weirdos, she complains about Andy's way of stirring people up to fight. She complains about being called a brainless nincompoop.

Andy complains about her complaining, but that is ironic, for Andy is the champion of complainers. His main lament, repeated over and over, goes like this: "Other people succeed who have no talent. Here we are with all you gorgeous people, and we can't make it. Why is that? How come? Oh, it's so hard. How can we make it? What shall we do?" On and on, for the world has not yet beaten its way to his door and showered him with money and fame.

Viva is not brainless. She attended Marymount School and the Sorbonne in Paris. Her father is a prominent criminal lawyer in Syracuse, New York. She is a talented painter. One of her large canvases hangs in her one-room apartment; it is sensitive and colorful. Viva is tall and very slim, with big blue eyes, fair skin, high cheekbones, frizzy, blondish hair, and a very personal style. Her allure is Garboesque.

As soon as I see her, I know that she will be my chief competitor for Superstardom. She has the same reaction, for we constantly upstage one another. I die of jealousy each time I see her picture in the paper with Andy. Luckily Andy has two sides, and the instant a photographer appears on the scene, Viva and I rush over. I maneuver to be on Andy's right, for then my name will be first in the caption.

When Viva complains about her relationship with men, Andy tells her, "Wait for when you're famous. You'll buy them then. Just get up there, get up there, and then you can have anybody you want."

Viva changes the subject. "Andy, I need a hundred dollars to pay for rent."

"I don't have any money."

Viva keeps on complaining.

"Viva, stop complaining. We'll make you a star."

The promise of stardom keeps the hungry actors and actresses alive and hoping. We're not actors and actresses in the formal sense—none of us attends the Actors Studio or any other serious coaching class. We don't bother with vocal lessons or dance instructions. Andy wouldn't have us around if we were more professional—he'd have to pay us. All we're acting out is our own destiny.

The one thing that unites us all at the Factory is our urgent, overwhelming need to be noticed. Fame is the goal, rebellion the style, narcissism the aura for the superstars, demi-stars, half-stars, bad-stars, no-stars, men, women, cross-overs, over-sexed, de-sexed, switch-sexed, decadent, satanic denizens of Warhol's new utopia.

Here my rebellion is accepted, even encouraged. They wouldn't tolerate me if I weren't rebellious. What's more, my rebellion is getting attention from the press and I love it. I love seeing my name and my picture in the papers and the magazines. I feel I am at last getting the love and attention I've always wanted. If need be, I'll be crazier than the others, bolder, more daring, to keep eyes and cameras focused on me, me, me.

BLOW JOB

In the fall of 1964 I jump at the chance to attend a screening of *Blow Job*, Andy's most talked about underground movie. It is a thirty-five-minute black-and-white film, made in 1963. On a Sunday night the audience assembles in the dimly lit Factory, on and around the battered couch, which is so piled with bodies it looks like a lifeboat. The images captured by the sixteen-millimeter Bolex camera are projected onto a white sheet hung between two silvery pillars. We see a rugged guy standing in front of a brick wall, waiting passively for something to happen. The shoulder of a black leather jacket comes into view at the bottom left of the screen, suggesting a man kneeling down—a perverted echo of the Eucharist, befitting our Catholic refugee camp huddled on this life raft on the Lord's day.

Then the camera shifts to the standing man, closing in on his face. For the next thirty-five minutes the camera never leaves the man's face, which is barely moving, as impassive as if dying

a slow death. If we had not seen the opening frame, we would have no idea of what is going on. The males watching the film are beginning to swallow hard. The females are holding their breath. Andy, rhythmically ruminating, is chewing gum. His chewing his cud is *Blow Job*'s only sound track.

Is it voyeurism? I wonder. Is it pornography? I'm not sure. But it is shocking in a deafening way. What is Andy up to? Does he want to show an aspect of life that is usually camouflaged? Is he promoting homosexuality? Is he only out to shock? Is it just a slice of any day's life? Why do I expect an answer?

The repetition of the unseen rhythmic gesture becomes hypnotic. I look around me to shake the spell. I see faces in the audience moving up and down in sync with the unseen protagonist. Is that what you call audience participation? The face of the fellow receiving the fellatio is only faintly moving. There is no intimacy between the two men. There is only anonymity. So much so that it is a demystification of love.

Warhol is not interested in passion, I think, but the opposite. But what is the opposite? Indifference, frigidity, iciness. *Blow Job* is a mind-numbing experience. I'm not for it or against it. I'm not repelled, not attracted, not indifferent, not captivated. The silence of the picture creates a vacuum. I begin to long for an explosion to bring an end to this submissive—what can I call it? Treatment, I guess. This treatment is as casual as hair cutting or teeth brushing. As impersonal.

Would it be more tolerable if they had passion? I for one prefer that these men not share any passion. I want passion reserved for a woman and a man. I do not want to feel bypassed. On the other hand, maybe these men are not as passionate as I am. Maybe they don't even know what is missing from their . . . treatment.

Ingrid breaks the monotony with a loud sneeze, then says, "Excuse me." All the women are relieved. You hear their sighs and a little laughter, for the timely sneeze has come at a minor paroxysm of the fellatio, which then continues as before.

Blow Job

"Who's in the picture?" someone asks.

"Two hustlers," another voice responds.

After a while I say, "That blow job is really a job."

A voice asks, "How much did you pay them?"

There is no answer.

The recipient looks like an all-American boy, an outdoor type, about to enter adulthood. He is just discovering the body he owns and can sell.

After a while Ondine says, "There's really nothing to look at."

I am beginning to feel like a Peeping Tom without a keyhole. Malanga must be having the same reaction, for he says, "The real action is taking place offscreen."

Ingrid says, "The film is a tease. The action is three feet below the camera."

She is right. Although my eyes remain focused on the face of the young man receiving the blow job, my attention is constantly drawn to the empty space on the sheet below the screen. I am being visually assaulted and insulted at the same time. It is unnerving: I want to get up and seize the camera and focus it downward to capture the action. But I can't, and that's where the frustration comes in.

Andy remains silent, impassively carrying on his affair with his chewing gum. We are nearing the end of the reel. The film is flapping. I see Eric in full action, not faking anything, just finishing a fellation on a male hustler who happens to be sitting next to him. Eric is always ready for whatever; he leaves no zipper unzipped, no button unbuttoned.

After the screening I tell Andy his film reminds me of the two Zen Buddhist monks who are walking in a forest during a time of retreat. They come upon a brook and see a naked woman standing on the bank, unable to swim across. One of the monks volunteers to carry her to the other side. He takes her in his arms and deposits her on the other bank. The monks resume their walk in silence. Twenty minutes later, one monk says, "You know we're not supposed to touch a woman while on our retreat."

33

The other turns to him and says, "I picked up that woman and dropped her twenty minutes ago. You've been carrying her ever since."

"Andy, what's the point of the picture?" I ask.

"I like things that blow up and pop up," he says.

"It would be better if this one really did blow up," I tell him.

Someone asks him who the two guys are. He tells us he had invited Charles Rydell, a well-known and respected actor, to star in his next movie. Andy told him he would just have to stand there while five guys kept blowing him until he came. The camera would be only on his face. He agreed, but the Sunday they had the camera ready and the five guys lined up, Charles did not appear. When Andy tracked him down, Charles said, "I thought you were kidding. I'd never do a thing like that." So Andy used a kid who happened to be hanging around that day.

"Andy, did you go to church before the shooting that Sunday?" I ask.

"Of course."

"Why did you go? What's the point?"

Silence.

Among the girls, we talk about *Blow Job* for days. It takes us a while to recover.

Ingrid says, "The unseen sucking drives me crazy."

I say, "Denying us the sight of the real object is what I feel is most perverse."

Ingrid says, "Come to think of it, what's avant-garde about two fairies sucking?"

I say, "Warhol deals in frustration and evasion. That's his trip. I think the Obetrol makes him evade even more."

Ingrid says, "It's a farce. Who's going to sit through all that? You wait interminably for nothing to happen."

I say to Andy, "You know that *Blow Job* is boring?"

He says, "I like boring things."

That same autumn evening, Andy has nothing to do. He asks me what I'm doing. I tell him I'm going to a party at the St. Regis to meet some rich Europeans. "Do you want to come along?"

34

"Oh, yes, yes."

This is years before Andy progresses to intimate terms with tycoons and moguls. He does not own fancy clothes. I notice, without really being aware of it, that his shoes are unshined, his tie crooked, his pants stained with paint, his wig tilted. On his own turf, Andy is the lord of all he surveys, no matter how disheveled he looks. But when we get to the party, I see him through the eyes of my European friends and realize that he is now a housefly among butterflies.

Our hosts are Prince Philiberto de Bourbon, who is associated with Van Cleef and Arpels, the jewelers, and the Marqués Cristóbal and Marquesa Carmen de Villaverde. Carmen is the daughter of Generalissimo Franco. I met them the previous summer while I was cruising on the yacht of Ricardo Sicre, a Spanish-American who has a huge floating houseboat anchored in Monte Carlo. On board I also met Princess Grace of Monaco, Orson Welles, Prince Alexander of Yugoslavia, Princess Ira von Furstenberg, Empress Soraya of Iran, and a few other royal heads, most of them crowned with a garland but without a country to govern.

I introduce Andy to my friends at the St. Regis, all of them in splendid evening clothes. They shake hands very formally, but Andy doesn't know how to treat the hands that are extended to him. He remembers from movies he's seen that hands are sometimes kissed, especially when nobility is involved, but he isn't sure who does the kissing and who get kissed. When Philiberto's hand is offered, Andy gestures halfway to kiss it, realizes he's making a mistake, pulls back, and actually blushes. This is the only time I have ever seen him blush, and I find it rather endearing. He must have something human in him after all.

To cover his embarrassment, I explain to my friends, "His name is Andy Warhol. He is an American artist." This makes no impression on anyone. We are asked what we want to drink. Andy says, "No, thanks, I'll just have a pill." He pops another Obetrol. My friends try not to stare.

Cristóbal asks me to dance. He is very handsome, with deeply

bronzed skin. As we dance, he sings flirtatiously in my ear, "*El toro enamorado de la luna,*" a song we sang on the Mediterranean. I momentarily forget about Andy. I assume he can manage on his own. But soon I spot him all alone in a corner, embarrassed and sulky. I interrupt my dance and introduce him to Alfonso Fierro and his wife. Alfonso owns a bank. They take a look at my strange new friend, and the expressions on their faces tell me that they don't approve of this ungroomed, untalkative, out-of-place character.

At dinner, several people speak of the ball they recently attended in Venice at the Palazzo Grassi and of the Feria in Seville, where Orson Welles flamenco-danced with a seven-year-old. Andy is mute. He was panting to meet these glittering people, but in front of them he is paralyzed. To make up for his incommunicativeness, I tell Philiberto, "Andy is a painter of Pop Art."

He says, "What art?"

I say, "Pop Art."

Several of them repeat "Pop Art" and nod their heads.

I tell them that Andy recently painted a Campbell soup can.

They repeat, "Campbell soup can," not quite understanding what that means.

Later, Alfonso takes me aside and says, "Isabelle, you're wasting your time. Get married to a rich man. Don't hang around with housepainters."

"Andy is rich in ideas."

Alfonso lifts his eyes to the ceiling.

On the way home, Andy says, "I watched those society people. You know, they can eat and drink and talk at the same time. They know how to store food under their tongue while they talk. If I did that I'd choke. I just don't eat when I'm with society people."

At this stage in his life, Andy is not yet a hit with the international set. But a dozen years later, these same people will pay $25,000 for portraits which that night they could have bought for a handful of crumpled small bills.

F or Andy, it begins in 1909, when handsome, blond, twenty-year-old Ondrej Warhola marries shy, seventeen-year-old Julia Zavacky, both from the tiny Carpathian mountain village of Míková in northeastern Slovakia, now part of Czechoslovakia. The wedding is celebrated with flowing bottles of spirits, trays of meat, and hand-shaped loaves of bread, with dancing and singing that lasts all day and all night. Andy, of course, is not there to observe for himself, but he has heard the scene described many times in his childhood, and he seems to like it when I ask him questions about his family. He answers in his usual verbal shorthand, then nods approvingly when I play the scenes back to him in my tzigane renditions, which are always more true than fictive.

My mind's eye sees it all as an operetta: While an elegant ball is held in the big house on the hill, ablaze with a thousand candles in crystal chandeliers, down in the hollow, under strung-out lanterns, the peasants and artisans celebrate Julia's and On-

drej's nuptials with gypsy music. Shyly flirtatious girls in long flowered dresses and with flowers in their hair dance in and out of the dappled moonlight. Strong young men with rough cotton trousers stuffed into thick-soled boots toss the girls high into the air. Stout matrons gossip behind their work-worn hands, their hair wrapped in babushkas. Older men boast of past conquests as they finger full, drooping mustaches.

Three years later, unrest in the dying Austro-Hungarian empire and the rumbles of the worldwide war that is to break out in two short years send the young bridegroom across the border to Poland and then to America, to western Pennsylvania, where he is welcomed by his older brother Joseph, who emigrated three years earlier. The Warhola brothers settle in a rugged area called Soho, outside Pittsburgh, where they labor in the coal mines. Ondrej plans to send for his bride almost immediately, but World War I and the vast postwar confusion of shifting populations in the perpetually troubled Balkan region delay Julia's arrival until 1921.

With much emotion, Julia kisses twice all the welcoming red cheeks of her now Americanized relatives from Míková, resumes married life with Ondrej, and dutifully produces a baby in exactly nine months. The boy is named Paul. Three years later, John is born. Three years after that, on August 6, 1928, without a nova exploding in the sky or magi pounding on the door, Julia gives birth to a third son, Andrew. Fittingly, little Andy is born at 6:30 A.M., as the day takes over from the night. When I think of that hour of dark giving way to light, a line from the King James Bible comes to mind: "And the light shineth in the darkness; and the darkness comprehended it not."

It is not easy for the family to comprehend Julia's new baby. Where her other sons are strapping infants even at birth, as little Andy enters the world he still looks unborn. He weighs a slight four pounds, two ounces. He has no hair. His skin is unnaturally pale. In the umbilical cord there is a knot. Julia takes the knot as a mystical sign. The attending doctor murmurs as he cuts the cord, "A Gordian knot all over again."

Andy's Beginnings

All the family gathers around Julia's bed to stare at the newly arrived alien, who stares impassively back at them.

The three boys are raised in the Greek Catholic Byzantine tradition in a strongly religious household. They attend St. John Chrysostom Church. The parents speak Carpatho-Rusyn to each other and to their older relatives and sometimes to their children.

In 1932, when Andy is four, his mother sews a Urim—a protective, magical stone—into his pocket, and his big brother Paul takes him by the hand to his first day at Soho Elementary School. Andy, undersized and a near albino, cannot bear being away from his mother. He cries so desperately that Mama takes him out of school and keeps him home with her.

Two years later, in 1934, when the family is living in a two-family brick house at 3252 Dawson Street in Pittsburgh, Pennsylvania, another attempt is made at schooling. Six-year-old Andy is entered as a first grader at Holmes Elementary School. This time his resistance is expressed in the form of a nervous disorder, a shaking of the face and hands at that time diagnosed as Saint Vitus' Dance and now called chorea.

He is confined to bed, with Mama at his side day and night, bringing him coloring books, cutout dolls, candy, crayons. She reads him the funny papers until he falls asleep. She tells him stories in her heavy Slovak accent. She sings to him in a pure, sweet voice.

For hours at a time they draw pictures together. He crayons diligently in his numbered coloring books—1 for pink, 2 for blue, 3 for yellow. Julia hands him a small Hershey bar each time he finishes a page. He says, "*Dăkujem, Mama*"—"Thank you, Mama." They listen endlessly to the radio in those radio days, laughing at the comedians, crying at the misadventures in the soap operas. At the end of the day, she tucks him in and says, "*Dobrū noc*"—"Good night."

He responds, "*Dobrū noc, Mama.*"

One of the first things Andy draws, outside of the coloring books, is a copy of a Maybelline ad starring Hedy Lamarr. In the spring, Andy helps his mother paint floral Easter eggs. Andy's

bed becomes a nonstop festival. Who would ever want to get out of such a bed? When he is ten Julia buys her baby his first Brownie camera. Fascinated by the magic of the box, Andy teaches himself to develop his own film in the kitchen sink.

Julia has all the time in the world for her Andy. The older boys are in school. Ondrej, taking what jobs are available as a coal miner, a steelworker, a construction worker, is often away for long periods at distant construction sites or inaccessible mines in the harsh mountains of Pennsylvania. In the late 1930s, Ondrej falls ill. He is chronically debilitated with a wasting sickness that seems to defy diagnosis. Julia believes he has been poisoned by water from a contaminated well in a mine. Whatever the cause of his illness, he never recovers his health. He dies in 1942, when Andy is fourteen.

On his deathbed, he calls his oldest son, Paul, to his side and asks him to take care of his mother and to send Andrew to college. Frail little Andy is the bright hope of the Warhola family. Necessity has forced Paul and John to go to work right after high school. But Andy, the last-born, the odd little fellow, is too bright, too special, to end up digging coal or pumping gas. He deserves an education. Every family has its myths. The Warhola myth, nourished through want and the untimely death of the bread-winner, is that someday the baby, Mama's special baby, will do something so amazing and astonishing the whole family will be proud of him.

At this time, in the depth of the Depression, the family is desperately poor. Andy remembers his mother adding water and more water to the soup until the vegetables swim in almost clear hot water. In between scrubbing the house and waiting on Andy, Julia augments the family's earnings by making crepe-paper flowers, pretty, bright-hued blossoms with gracefully rolled edges on the petals. She sells them door to door in her neighborhood to brighten the mantels of those hard-scrabble parlors.

By the time he is twelve, Andy has recovered from three attacks of nervous disorder and is finally attending school regu-

larly. He described to me once how every morning and afternoon he counted the eleven cement steps leading to the entrance door of their house, set between two scraggly bushes. On the long walk to school, he counted the sheets hanging from windows to dry. He liked the repetition of the sheets, like flags in the wind. "The repetition appealed to me," he said.

His schoolmates call him "Spotty." He is already losing pigment from his skin. His eyesight is very poor, his coordination uncertain. His classmates—tough, heavily muscled sons of miners and day laborers—tower over this slight, pale boy. On the playground, he hangs around the sidelines. Naturally, he is never chosen for games. Although he is repeatedly shouldered aside, he does not complain in later years of having been assaulted or even picked on. Perhaps his well-muscled older brothers protect him. Or perhaps knowledge of their existence deters bullies. Or maybe, even at that early age, Andy radiates a gentle sweetness that disarms attackers. In any event, he never suffers physical torment. "But I never had a friend," he recalled years later.

Little Andy does well at Holmes Elementary, so well he is among those selected to participate in the prestigious Saturday art class taught by Tam O'Shanter at Carnegie Museum in Pittsburgh, where fifth-to-tenth-grade youngsters from all over the area receive extensive art training. From these classes years later emerge such artists as painter Philip Pearlstein, sculptor Henry Bursztynowicz, industrial designer Irene Pasinski, painter Harry Schwalb, and, most celebrated, Andy himself.

Andy talked to me about those Saturday morning art classes in the music hall of the Carnegie Museum. I think they made a particular impression on him because they gave him his first chance to meet children from neighborhoods beyond his ethnic ghetto and to observe how the well-to-do dress and speak. Several times he mentioned two youngsters who arrived in limousines, one in a long maroon Packard and the other in a Pierce-Arrow. He remembered the mothers who wore expensively tailored clothes and glittery jewels. In the 1930s, before television and

with no glossy magazines for poor families like Andy's to browse through and few trips to the movies, the art classes opened a peephole for Andy to the world of the rich and successful. He never forgot what he saw.

In the museum class, Andy progresses from crayons to oil paints and brushes. He views the paintings in the museum. He sometimes becomes so immersed in his work that he is startled when it is time to leave.

Joseph Fitzpatrick, who taught those classes for many years, never forgot the skinny kid with blond hair who worked so industriously. "I distinctly remember how individual and unique his style was," Fitzpatrick said, and recalled how impressed he was by the boy's concentration and the delicacy of his drawing.* Andy could draw with a fine, sensitive line that sometimes broke into tiny droplets, an amazingly personal style. He occasionally outlined an object with dots and dashes, foreshadowing some of the photographic pointillism of his later commercial art.

Every week when the teacher reviews the best work, shy Andy makes his way through the crowd and blushingly holds up his drawing or painting for the other students. Their admiration is delicious to him.

In 1942 he enrolls in Schenley High School. There, he gets straight A's in art and does almost as well in English. Again, miraculously, the other students do not torment him, although he remains a loner. After school he works at odd jobs, turning the money over to Julia. When he sells fruit from a truck, the customers always buy from him. His undernourished, pathetic look is hard to resist.

He works in a five-and-dime. "The store was beautiful, like heaven," he told me years later. I can just see his eyes popping open wider and wider to take in all the goodies, the toys, the household gadgets, the toiletries, the candles, the hardware, the crockery. The array of objects dazzles him.

*Quoted by Robert D. Tomsho, *Pittsburger* magazine, May 1980.

In May 1945, just before Andy's graduation from high school, there is a moment of suspense when a birth certificate is required. It turns out that Julia had never registered the birth of her precious baby. To certify his birth at this stage, she must submit a notarized affidavit, along with the signature of a witness to the birth. On May 3, 1945, she submits her own signature and that of her neighbor Katrena Elachko. The state's Division of Vital Records accepts the delayed registration, making Andy, at last, a person and a citizen.

Andy graduates from Schenley High among the top twenty of his class. That year he does a painting, in Van Gogh style, of the living room of the family house on Dawson Street. The painting shows a couch covered by a length of fabric, an armchair similarly covered by a piece of casually tossed cloth, a rocker, a painted white wooden chair, two tilted lampshades on bases, a radio, and a foot-high Christ in white nailed to a dark wood cross. There is no art, not even a calendar, on the walls.

The house has an indoor bathtub, a luxury not enjoyed by all the houses on the block, and small front and back yards, where Julia tends her tomatoes, string beans, squashes, and onions, and joins in the chatter of the women across the fences, which is conducted in a lingua franca of Slavic, Italian, Jewish, Irish, and English.

I once teasingly asked Andy to imitate the various voices and accents. His Slavic was convincing, for that was the language he spoke with his mother. But he was not a good enough mimic to catch the rhythm of the other languages.

The summer before he enters college, Andy draws portraits of the children and some of the adults in the neighborhood. His partner, Julia, writes out the names of the subjects in her beautiful script. He sells them up and down the block.

That fall, true to his promise to his father, Paul provides the money necessary to supplement the scholarship Andy wins at Carnegie Tech in Pittsburgh, where he gets what is probably the best art education offered in the United States at that time. Still

a loner, he serves as art editor on the student magazine and in the summer of 1947 decorates windows for Joseph Horne, a Pittsburgh department store.

After graduation in 1949, Andy leaves Pittsburgh with a single suitcase and heads for New York with his classmate Philip Pearlstein. They move into an apartment on St. Mark's Place off Avenue A, on the Lower East Side. Andy is so obviously talented he has only to show his art school portfolio to get work as a commercial artist. He lays out advertisements, illustrates magazine stories, decorates show windows, and designs shoes.

His roommate, Pearlstein, is quickly recognized as a serious painter. He develops a new style known as Super Realism, in which human figures are painted in exaggerated detail. It is a daring antidote to the ruling Abstract Expressionism. Philip's success fires Andy with envy. He is making more money, but Pearlstein is gaining fame.

In 1950, I. Miller, a leading shoe chain, hires Andy as its in-house shoe designer. Andy designs fanciful shoes, which women buy recklessly. He sketches imaginative layouts and eye-catching packages. Now that he has a steady income, he sends for his mother. Julia arrives, with her flowered dresses, her flowered head scarves, her busy hands. In the brownstone town house at 1435 Lexington Avenue, at Eighty-ninth Street, Andy's first purchase of New York real estate, Julia for the first time in her life has comfort, ease, and twenty-four hours a day to mother her baby.

Andy refused to tell me how much he paid for the house, but I learned that the going price for a brownstone in that neighborhood at that time was under $25,000. At such a price, the down payment is easy and the carrying charge manageable for Andy, who is taking on free-lance assignments in addition to his job, and Julia, handy with paintbrush and pencil, helps expand his output. She becomes his assistant, filling in color, making copies, hand lettering captions, keeping track of assignments.

When Andy's colleagues drop by to sample Julia's splendid pastries, they are handed crayons, charcoal, a paintbrush, and

their visits turn into coloring parties. Vitto Giallo and Nathan Gluck are among his assistants in those years. Night after night, his friends work on his commercial assignments. He provides the food and liquor. His mother piles the plates up with her delicacies. In Tom Sawyer style, he cajoles his unpaid assembly line into expanding his production. No one complains, because he is not bossy. On the contrary, he encourages people to do their own thing, color their own way. If he likes an original bit someone executes, he copies it. Someone else's creativity becomes his creativity. And the friend whose work he cribs is flattered and honored. Always there is fun. Otherwise the workers will not return to the free-labor camp to double and triple Andy's output. After everyone is gone, he says, *"Mám ťa rád, Mama"*—"I love you, Mama." They kiss each other good night.

Sometimes I think the City of New York should have annexed Andy as a municipal resource. He would have taken everybody off the streets, created jobs, cleared the slums, and rebuilt the south Bronx. How did he acquire his astonishing entrepreneurial spirit? I think back over his life and decide he learned to maneuver in his cradle. Still a baby, he put his mother to work around the clock, nursing him, singing him lullabies, showing him picture books, coloring for him, telling him stories. Thus was the twig bent.

There's only one thing wrong with Andy's spectacular commercial success. It turns to ashes in his mind because he craves recognition as a true artist. He wants the power and adulation of shows in Madison Avenue galleries, purchases by blue-blood collectors, exhibits in major museums, reviews in highbrow periodicals. He prowls the galleries, trying to unravel the secrets of painters who have won access to their envied walls. He paints and draws constantly, fills stacks of sketchbooks, shows his work to dealers, but no breakthrough.

Andy, who is prone to hero worship, at this time has three main crushes: Cecil Beaton, Jean Cocteau, and Truman Capote—all gay, all artists, all dandies. They are his role models.

Since Truman is the most accessible, Andy, like a lovelorn suitor, stands for hours outside his door. Truman's mother has to push him aside when she goes out. Andy begins writing daily letters to Truman. He writes him for a year, until in 1951 the two meet at an art gallery and begin a long history of loving and teasing. Andy does fifteen drawings in ink to illustrate a collection of Truman's short stories. In the summer of 1952 these drawings earn Andy his first solo exhibit, at the Hugo Gallery. That show is Andy's initial small step upward from commercial art into the treacherous, elite world of Art.

Andy is increasingly frustrated by his appearance. Every day there is a new pimple on his reddish, round nose. He is getting bald. To remedy this, Andy begins with a small hairpiece. The toupee evolves into a modest-size wig. The wig makes Andy, a Leo, look like a stuffed lion. That is a fair counterpoint to Salvador Dali, the most headlined of contemporary painters, a Taurus, who impersonates a mad Spanish bull. But even with a lion's mane on his head, Andy cannot compete with Dali's mustache, which spikes upward to his eyeballs. He studies the master's technique—not so much his painting style but rather his creation of a persona.

Julia and Andy both make charming sketches of the twenty-five cats in the household, all named Sam except for the one named Blue. Some wear big hats, others are decorated with feathers, all are delightful. Two little companion volumes are published, 25 *Cats by Andy Warhol, Holy Cats by Andy Warhol's Mother*. They win a prize.

In 1956, twenty-eight-year-old Andy makes a trip around the world with Charles Lisanby, a television set designer. Andy is fascinated by Charles, for he knows Hollywood stars, in particular James Dean. Their trip is the equivalent of a proper debutante's grand tour. Andy visits the museums and monuments of the Old World. Because of tensions in the Suez area, he must bypass Egypt. He is disappointed because he envisioned coming face to face with the Sphinx.

Andy's Beginnings

(The Sphinx in Giza, the one he misses, has the head of a man—a pharaoh—and the body of a lion. But in Greek mythology the creature is a winged monster with the head of a woman and the body of a lion, which destroys all who cannot answer its riddle. What a lost opportunity for a young man whose life will be one prolonged riddle and whose sex will epitomize ambiguity. Later, Truman Capote declares that Andy is a sphinx without a riddle.)

In India and Japan, Andy is influenced by the Eastern religions. An aura of Zen envelops him. Passivity versus action, enlightenment by experience and by intuitive insight—these concepts direct him more sharply toward paradox and more firmly away from logic.

The same year, a drawing of Andy's is included in a Museum of Modern Art exhibit of famous people's slippers rendered by commercial artists. Andy is absolutely thrilled to have his work displayed under the same roof as paintings by Picasso, Braque, Mondrian, Dali.

By the end of the 1950s, Andy is the most highly regarded and paid commercial artist in New York. He collects award after award for his designs. *Women's Wear Daily* calls him "the Leonardo of the shoe." When Andy is included among advertising artists in a directory of "1,000 Names in New York and Where to Drop Them," his phone rings nonstop.

At the top of his profession, earning top dollars, he is ready to move on. Up to now he has used his undeniable and unique talent to huckster the products of others. From this point, he will concentrate on his primary product: himself.

f I were looking for a childhood the exact opposite of Andy's, I would choose my own. He is poor; I am rich. His family is confined to a narrow ethnic ghetto; mine moves about freely in privileged circles. Andy spends his entire life trying to make up for his childhood; I can't wait to escape my upbringing. He is totally enveloped by the caresses of an adoring mother; I pine for a loving touch from my austere father.

I am born—left foot first—in the town of Grenoble in southeastern France in 1935. At the age of four, I run away from home, accompanied by my four-year-old cousin, Beatrix Didier. I convince her to walk with me to Paris, a mere five hundred miles away, where she can have her hair curled like mine. We are caught by our parents four hundred feet from home, as we are about to enter the highway.

Our home in summer is La Gaillarde, an extraordinary, one-story, chalk-white modern mansion in the classic style, with large

terraces facing the Mediterranean Sea. My paternal grandfather, Marcel Collin Dufresne, designed and built it on twelve miles of coast. The mansion rises amid *allées* of mimosa and oleander. The earth is sprinkled with mica rocks, which tease me with their glitter until I collect them. At night I hear the sounds of enamored cicadas.

Next to our property is an inn called Les Cigales. Our motorized fisherman's boat is called *La Marotte*, its name painted on its side in blue and gray. Our Dalmatian dog is Taillot. Theo, the caretaker of the villa, runs the boat for us. We have a harbor with a boathouse, where we store the boat in winter.

There is a total of sixteen mouths to feed every day for the months of June, July, August, and September: my mother, father, brother, two sisters, paternal grandfather and grandmother; Lucienne, a faithful servant; Monique Didier, my father's sister; Noel Didier, her husband, and their three children; Alice Duron, my father's widowed sister, and her son, Jean.

My grandfather is nicknamed Le Beau Marcel. He is a magnificent man, with seductive, porcelain-blue eyes, a majestic, tan, Roman-emperor face. He is always dressed impeccably in a three-piece white linen suit. I believe he never worked a day in his life. We are told that at one time he was an ambassador. Could his tan cover up some gypsy blood, which I inherited? He has a passion for motorized caravans. He has built many, according to his own design. One of them unfolds and rises two stories. Another is made to fly, somewhat tentatively. His very first caravan was pulled by horses in the style of Bohemian caravans; at stops along the way, Grandfather's coachman pulled on white gloves so that the horse's sweat would not stain the Sèvres cup in which he served coffee out of a massive, engraved Louis XV silver pot.

My grandmother, Edith Collin Dufresne, is a holy woman. She goes to mass every morning at six o'clock and is back in time to serve her husband breakfast in bed at eight.

My brother, Yves, is eight years old, my sister, Catherine, is seven, and I am five. We look up to our cousin Jean, who is

fifteen. He has a girlfriend, whom he meets in secret at sunset in the woods behind the mansion. We three sneak out with my grandfather's binoculars, and sitting on the white wooden pole that has to be raised to permit entry of my grandfather's His-pano-Suiza, we inspect the jungle, trying to follow the amorous motions of our Tarzan.

My brother says, "He's over there in back of the eucalyptus tree. She's naked."

He passes the binoculars to my sister. After she has found them in this Garden of Eden, she passes the binoculars to me. I shiver. My brother tells us they are making love. I don't know what that means. I look. I think I see a snake crawling toward them and . . . Yes, I see it. I see the snake now. Tarzan is fighting like a tiger. Now she's eating the snake. My brother snatches away the binoculars.

Sometimes Jean defecates inside a bouquet of mimosa, lilies, and fragrant laurel and places it on the highway. Hiding by the side of the road, delighted, mischievous, and terrified, we wait for a motorist to stop and pick up the bouquet. Other times, led by Jean, we lie in the sun-warmed highway like dead mummies. When a car jams on its brakes a few dozen feet from us, we run for our lives.

Jean marries four times. He becomes the scandal of the whole family. Divorce is unheard of in our provincial, Catholic, bour-geois circle. Years later when he visits the family, my mother receives him very hesitantly for tea. He is now a divorced man. Unthinkable.

My father, my handsome father. He never expresses any sign of tenderness toward me or any of his children. He never holds us. Yes, he does—just one time. In 1940, when he is mobilized to fight the Germans, he affectionately kisses all of us goodbye. It may be the last time we ever see each other. When he is gone I daydream that another war will be declared and my father will again be called to arms. Once more he will have to kiss me good-bye and I will savor the sweetness of his kiss. I would give any-

thing for one of his kisses. He is captured by the Germans, held for three years in Oflag 4-D, a prison camp, and released in an exchange of prisoners early in 1944.

My mother is slender, dark-haired, very beautiful. She has an absolutely perfect nose. In summer she wears the most elegant heavy white linen suit—a straight skirt with a pleat, a tailored, padded-shoulder jacket, and a white silk blouse with real mother-of-pearl buttons. Looking at her in the summer of 1944, I notice tiny brown sun spots sprinkled over her face. Puzzled, I ask her about those spots, for they were not there the day before. My mother replies that she is pregnant—the sun gives her brown spots when she is pregnant. I feel a mixture of misery and jealousy. I am not sure if it is jealousy that she is pregnant rather than I, or jealousy of the one to be born, who will take my place as the chosen one, the baby, though by this time I am nine years old.

Now, in the present, I am told by my brother and sisters that I was Mother's favorite child. If love was poured upon me, I was never aware of it, for my need for affection was bottomless. It was my feeling as a child that from the day my beautiful sister Edwige was born, my parents never looked at me again.

My schooling begins when I am six. I commute every day by bus to a Catholic school a few miles outside Grenoble, run by nuns of the Sacred Heart. I have to wear a uniform. At seven, I begin boarding at the convent, for it has been reported to my mother that I have been making eyes at the bus driver. This is the start of my rebellion against everything: family, religion, authority, eventually society in general.

At the convent I feel abandoned, unloved, and unwanted. World War II is raging across Europe. My father is a prisoner; I've lost my father. I feel humiliated at being locked up in a convent a few miles from home. I declare my own war on the whole world. I will not trust anyone anymore. I will attempt to try everything. I must find out for myself what is true and what is false, what is right and what is wrong.

The alarm clock at the convent rings at 6 A.M. It is September 1946; I am eleven. As I get out of bed, I notice bloodstains on my sheet. I wonder where the blood is coming from. I have no wound. Did a bat attack me during the night? We get dressed and head for chapel. After kneeling, we stand to sing a hymn. I feel fluid running down between my legs. What can it be? When we kneel again, I manage, by holding my prayer book at my side, to slide my hand up under my skirt. With one finger inside my panties I feel that I am all wet. My fingers are red with blood. I want to scream. I am going to die.

The service is nearly over. Soon we will all walk by Mother Superior. I must wear my white gloves. They are part of the uniform. Without thinking twice, I lick my fingers clean before I put on my glove. While we walk two by two in orderly fashion on each side of the wide corridor, I escape the procession to run to the nearest bathroom. I look at my panties and they are bloody. I am bleeding from inside. I wish my mother were here. I wish I could call her, but we are not allowed to telephone our parents. Only Mother Superior can get in touch with them. Mother Superior is our mother while we are here, and I've transferred my affection to her.

I head for her office. The door is locked. Usually one can knock on the door and walk right in. I wonder why the door is locked. Then I hear a faint sigh. I lean against the door. I hear more sighs and out-of-breath gasping, as if someone is being choked to death. I am about to shake the door, but instead I kneel down and lift the lid of the mail chute.

In the narrow rectangular frame I see the behind of a naked body. I see the wide black sleeves of a nun's uniform floating as hands move frantically at the front of the naked body. I hear a climax of accelerated gasping, and the motions cease. The naked body rolls to its side. It is a man. I utter a scream and drop the lid of the mail slot. I run off as fast as I can. I make a right-angle turn at the end of the corridor and stop. I wonder if they heard my scream. After a long minute, I hear the door open and foot-

steps going in the other direction. I lean against the corner of the wall to look, and I see the silhouettes of what appear to be two nuns walking off in their floating black gowns.

I decide to have breakfast. As I enter the dining room, my roommates are leaving. I pick up some pieces of bread and walk off with them to rejoin the orderly procession along the corridor. I stop by the bathroom. In the toilet cubicle, I lower my panties. I gather the soft part of the bread and insert it into my soft part to stop the bleeding.

When I go home the next day for the weekend, my mother finally explains what has happened to me. She seems indifferent, amused. I am resentful. Will I have to put up with this all my life? "My dear, you've got it," my mother says. At that time it was a far greater burden than today. Then towels were used that had to be washed, scrubbed, hung out to dry.

Convent life means getting up at six, washing while wearing a white robe so you do not see your own body, going to mass, sometimes passing out because of not eating since the night before, praying before and after class, walking in silence along the never-ending corridors. Once during the war we are served a cat casserole at lunch. We know it by the shape of the head that one of us fishes out of the crock.

At night I cry silently, longing for love. I cry in my dormitory bed, under my sheet so no one can hear me. Years later I am to have a multitude of lovers, as I try to fill my endless need for love.

I am the first in my class in algebra and geometry. It is easy for me; I barely have to study. But I have no interest in history, literature, spelling, poetry. I will not even open the books, and in those subjects I am last. The nuns are puzzled. I must be bright, and yet I am so inconsistent. One day in a math exam my calculations are 100 percent right. I deserve a 20 out of 20. Mother Superior calls me into her office.

"Admit that you cheated."

"No, I did not."

"I don't believe you. I will give you a zero to teach you a lesson."

I leave in tears. Not only am I a prisoner in this convent, but there is no justice. I decide on a hunger strike. I will not eat for weeks. I become a skeleton. At Christmas I go home, hoping my mother will take pity on me and keep me with her to nourish me back to health. I am taken to a doctor, given intensive doses of vitamins and minerals, and sent back to the convent.

I make a decision. I will not stay here. I'll do everything possible to be thrown out. I hide a portable radio under my uniform and play jazz at mass. The nuns search in vain for the source of the music. They close the windows, believing that it is coming from the street. The whole chapel giggles.

I tell my schoolmates that by eating a certain kind of chocolate you can become pregnant. I skip classes. I escape into the park and sit in an apple tree and refuse to come down when I am discovered. Not only do I smoke cigars, I light each one by burning a hundred-franc note.

One night a couple of years later, I steal a bicycle in the courtyard and make my escape. Having entered the office of the Mother Superior earlier that day, during recreation, I took three keys—the key to the dormitory, to the entrance door, and to the gate—and slipped outside unseen. I ran to the locksmith and begged him to copy the keys quickly. When the bell rang at the end of recreation, I sneaked into the office and returned the original keys.

That night I tiptoe down four flights of stairs. The front-door key sounds very noisy in the calm of the night. I am sure everyone can hear it, but no one stirs. When I grab the bicycle, two black cats run off with a squeaking sound. My heart beats as if it will explode. I stop, wait awhile, look at the dark windows. I walk slowly, pushing the bicycle. The sound of tires on the gravel seems to me loud enough to wake up the whole dorm.

My eyes are fixed on the fourth-floor windows where I expect to see faces looking down. When I close the iron gate, the

rusty hinges screech in the night. I don't care if they see me now, for I can run off. I ride the bike. I am free. It's pitch dark. Where am I going?

I head to the Café Anglais, the most elegant café in town. I park the bike a block away because it is so tacky to be a kid on a bicycle. Mirrored in a window, I design two sensuous lips with my mother's lipstick and apply generous amounts of black kohl around my eyes. I open my navy blue blouse and tuck under my white collar to disguise my uniform. I am a nymphet. I am seductive. I am thirteen.

When I enter the café, men stare at me. I sit at the first available table so no one can see my flat shoes. I order whisky. It's my first whisky ever. I proceed to light my cigar with a hundred-franc note. All eyes are on me. I sip my whisky. It burns. I am too shy to look at anyone. I pretend to be very absorbed in my thoughts and gaze above all the heads, afraid to meet anyone's eyes. I ask the waiter for a financial paper and pretend to read it. I want to be free, grown up, the way men are. Halfway through the whisky, I feel drunk. I pay my check and leave. I walk, staggering, to a cross street to find my bicycle. I head back to the school.

Halfway to the convent, I am approached by a car. The driver is a man my father's age. "I saw you at the Café Anglais. Will you have a drink with me?" he asks.

I don't want him to know that I am a schoolgirl. I don't know what to answer.

"I'll give you a ride."

I get down from my bicycle. He puts it in the trunk of his car. I sit up front with him.

"Where are you going?"

I can't tell him I'm going to the Sacred Heart Convent. I say nothing.

"What's your name?" he asks. "Mine is Roger Dugois."

I recognize the name of a member of a club my father belongs to. I make up a name. We are driving. He puts his hand

on my knee, and I feel my whole world split gently, like an atom splitting in slow motion. I let him caress my knee. He explores my thigh, and I let him, with fright and delight. I have no underwear on. I like to feel the bicycle saddle between my legs.

He touches my breast, and I am in seventh heaven. He stops the car and embraces me. My first kiss—hot, humid, strange. I feel like vomiting. He spreads my legs and licks me wildly. I stretch my legs like a ballerina in a split.

He loves me, I think. Let him love me. I'll have his love instead of my mother's and father's.

He unbuttons his fly, and I see that huge thumb erected. He places it in my mouth and I choke, not knowing what to do. With his fingers he caresses me, and I come wildly.

"You're a virgin," he exclaims. "Oh, that excites me."

He forces his way into me. I resist. We struggle and fight. I bite him. He's furious and slaps me. He is strong. He twists my arms to my back. I scream with pain. To make me shut up he places his handkerchief in my mouth and pins me with tearing pain. Now I cry. Satisfied, he opens the car door, throws me out, and takes off. I lie there, sobbing and rejected.

The hallway clock at the convent strikes 3 A.M. as I head for my bed, bruised and broken.

During the months that follow I escape on many other occasions. Bicycles have been reported missing. One night as I climb up the hallway stairs the light is on and Mother Gabrielle is standing in front of me. I am wearing makeup and, of course, I have no business being out that late.

After a conference, the priest, the Mother Superior, and my parents decree that I should be exorcised.

It is in the heat of the summer. The priest opens his prayer book to the exorcism page and proceeds to read. I am held captive by two nuns in long black robes. Elaborate white ruffled coifs encircle their pale, unkissed faces. They anchor me firmly on the ground of the confessional and baptismal area, for fear that the devilish power of Satan may rescue me from their religious rite.

56

Though I remain defiant, deep down in my almost fourteen-year-old heart I waver with uncertainty at the unknown consequences of the Latin words meted out upon my head. What if it works? What if devils with flaming swords burn me alive as they exit in noisy commotion from all my orifices? What if I metamorphose into a bland, disciplined lamb? Baaaaah. I would no longer be me. As I see it, since I do not approve of the world I am born into and am not able to formulate exactly what I want to change in that world, all I can do—all I know how to do—is throw over the reins and run wild.

My mother and my father are standing as still as two statues, replicas of the Catholic-pagan idols that populate the grandiose chapel. My mother, I know, is praying. I dare not look in their direction. Drops of sweat shine on the nose and forehead of the priest. Am I incurably possessed? Or does he sweat because of the ninety-degree temperature? My eyes lift up to the windows, set twelve feet above the ground. I want freedom.

I will pretend to be tamed so that this ceremony will end to their satisfaction. The holy water sprinkled on me seems to perform its purpose. But I am already planning my next escape, this one forever.

Although I am repeatedly warned, I deliberately assert my freedom and provoke my elders, and during the next year I continue to slip out at night. Once again I am caught. I am examined by a child psychologist. I refuse to answer his questions. No one knows how to handle me. What I want is freedom to do what I want, freedom to wear lipstick. It is not the wearing of the lipstick that is important; what matters is the gesture.

"All right," says the psychologist, "we'll teach you to escape at night. We'll put you in a home to correct your behavior."

My father is driving, my mother is crying. I, too, am crying at times, not knowing where I am being driven. My plan has failed. I want freedom, and I am on my way to being locked up. I am powerless. They have won. Where are they taking me?

We drive for nearly a day without stopping, in the early spring rain. That's how anxious they are to get rid of me, I think, how

anxious to transfer the responsibility of this irresponsible child into other hands. "Let someone else take this child, it is not ours, it can't be ours, it doesn't behave the way we do," is the message I get. My father explains that I'll stay in the home for a while. Things are left vague.

We arrive at a tall, somber brownstone building isolated in the countryside. We drive through a gate. My father carries my small suitcase, containing two dresses, two nightgowns, and underwear. I am registered. My mother kisses me, tears flowing; my father shakes my hand; I am abandoned.

I am escorted down a long corridor. I hear a woman screaming. I hear a truck door slam, and from a window I see two women, handcuffed, getting out of the truck. I swallow my saliva. I start to cry. I cry endlessly.

An open door reveals my bed, covered with a brown blanket. The window is barred. Will I ever be free again? Am I here for life? I am given a metal bowl and spoon.

"No knife?" I ask.

"No."

"Why?"

"You could open your veins."

I visualize myself doing precisely that. I throw myself on the bed and howl. I wish to drown in my own tears.

I remain in that cell day after day after day, not knowing whether it is Sunday or Wednesday, May or June. Outside the barred window, the countryside is oddly unattractive. Trees are unpruned or diseased. The yard has concrete paths, on which the girls walk single file. I eventually am taken to the yard, and I, too, walk the concrete pathway before being reescorted to my cell.

I have deliberately erased from my memory the full recollection of the time I spent in the correction home. I do remember being given a book on sex education, so technical that it seems to me more like a manual for fixing machinery. The sketches of the uterus and the tubes and organs are so crudely mechanical

that at first I take the book for science fiction and then for nau-
seating realism. Though I have had a taste of sexual pleasure, or
displeasure, this book shocks me by its sheer functionalism. I am
all tender feelings, all trembling emotions. How can these ugly
organs relate to my romantic dreams and fantasies of love?

Just before Christmas 1952, my parents come to retrieve me.
That night, my brother, my two sisters, my parents, and I attend
a midnight mass in the cathedral at the Place Grenette in Gren-
oble. I kneel with my family, a broken child. Not knowing if it is
repentance or despair or the emotion of the Feast of the Nativity
or the reunion with my family or the odor of the incense that
permeates my soul in this church of our Heavenly Father, I burst
into tears. I cannot hold back my sobs. So loud are my cries that
the parishioners around us stare at my parents. Embarrassed,
my father takes me by the hand and walks me outside.

Am I trying to show my parents how much I hurt? I cannot
say, but my sobs are real.

There is only one solution. I am to be sent away. To America.

ESCAPE FROM FRANCE

sail for New York in 1953 to visit my older sister, Catherine, who is attending the Sacred Heart finishing school on Fifth Avenue. The moment I step onto the crumbling dock, I feel at home. I sniff the New York air. It smells free. *I* am free. For a while I stay in Bronxville, with friends of my family. Then Catherine and I move into an apartment on the east side of Manhattan.

When my sister finishes school, she goes to work for a year in the office of the commercial counselor at the French Embassy, on Fifth Avenue. I get a job in the office of the French cultural counselor, on Seventy-ninth Street. I receive visitors and field inquiries. It's a good way to meet people and pick up tickets to cultural events. I am invited to more teas, receptions, and openings than I can attend. Naturally, I'm more interested in the social than the desk side of my job.

I am on my own—at last. I have no plan for myself. I was raised in a family and in a time and place that never thought of

careers for women. It was assumed that I would marry and marry well. That was the main goal, the only goal. But I'm not interested in marriage at this point. I want only to live for the moment and enjoy this blessed escape from the authority of parents, teachers, nuns, elders. I want only to be free, to make romantic conquests, to explore sexual pleasures. I am eighteen and I am told I am very beautiful. I know I am wild. I am in heaven.

My sister pays the rent. I have a little spending money from a tiny inheritance. I almost never pay for a meal. If I am not invited out to dinner, I fill up on hors d'oeuvres at a cocktail party or a gallery opening. I dress like a million on next to nothing. My sister, her friends, and I swap clothing so we all seem to have extensive wardrobes. My flair for originality leads me to swath myself for evening in lengths of copper-green moiré and scarlet velvet. (A woman in sables asks me who designed my wrap.) My best evening dress, one that lasts four seasons, is a marked-down floor-length nightgown with spaghetti straps and a huge silk flower, which I remove from the waist and sew to one of the wispy straps. I add lace cuffs half covering my hands to a plain black dress that has been marked down to five dollars. I glue together two pairs of dime-store earrings to make one, spectacular, dangling pair.

Photographers follow me around as I haunt art galleries and museums. Art is my love. Back in France, whenever my family traveled my father shepherded all of us through museums. One summer when we were vacationing in the south of France I went to Vallauris, an art center near our home, and knocked on the door of Picasso's studio. Caught by surprise when he opened the door himself, I said dramatically, "Here I am." Then I found myself speechless under the blazing fire of the master's eye. He invited me to look around. I stared at the paintings, numb with the sense that I was living a moment of history. Every summer I visited museums and galleries in the south of France and in Paris. Avidly I read books about art and art history.

In New York, art becomes my entrée to meeting people. The

art scene is just getting under way, and gallery openings are festive social occasions. I am lively and speak to everyone. I make people laugh. I see someone at a gallery one day, at a cocktail party the next. We greet each other by our first names, then one calls the other, I soon become part of a crowd. As the pretty new French girl in town, I find that the city opens its doors to me. I am quickly caught up in a glittering social circle. In one way or another I meet *everybody*. I take it for granted that this is how New York works.

Soon I see my photograph and articles about me in *Town and Country* magazine, the *New York Times*, *Interiors* magazine. I am photographed at charity events wearing diamond jewelry borrowed from Van Cleef and Arpels. Someone asks me to serve on a committee, then on another. The following year I gather a table of guests. I get involved with the April in Paris Ball, the Botticelli Ball, Parke Bernet openings, the Museum of Modern Art, the Guggenheim, the Whitney. I meet the whole French colony, Baron this, Marquis that, Vicomte Tra La La. Far more exciting to me are the artists I am meeting—Barnett Newman, Andrew Wyeth, Willem de Kooning, Miró, Dubuffet, Marcel Duchamp, Man Ray, Max Ernst, Chagall, Louise Nevelson.

I soon fall in love. My first love is Antonio Pellizzari, an Italian artist who is passing through New York. Antonio and I fly to Nantucket to spend an idyllic and ecstatic week holding each other day and night at the White Elephant Inn. For years I remain intensely in love with that first great love of mine. I take time out from the New York merry-go-round to fly to Paris or Milan to see Antonio. Off and on from 1957 to 1960 I am in Paris, where I stay in the flat of my uncle, René Capitant, a former minister of education and a close friend of General de Gaulle. I do not go to see my family.

In Paris, I spend days in galleries and museums, meet dealers and artists, explore studios, lofts, and garrets. I support myself buying a few paintings by French and Spanish artists and selling them at a modest profit. In a short time, I am dealing in art. I buy and profitably sell a small, enchanting Sisley, a little

church painted from the back. I have stumbled upon an occupation that I practice to this day in an offhand way—buying and selling paintings that please me, that bring me joy while they are on my walls and profit when they move to someone else's.

When Antonio leaves me, I am absolutely desolate and live in the hope that we will be together again. Eventually I realize that I have been just a passing fancy for him; I will never be part of his life. To forget this fierce, burning love, I fall into the arms of one lover after another, or three at the same time—black, white, yellow, red.

One of my boyfriends—I meet him on a yacht in the harbor at Cannes—is an electronics wizard and a yachtsman. For a while I lead the glamorous seagoing life, follow the America's Cup races, put in at glorious ports from Newport to Palm Beach to Venice. In Venice, I am introduced to Aristotle Onassis. In Paris, he invites me to his apartment on the Avenue Foch for a drink. When I ring the doorbell, I expect to step into palatial surroundings. I am disappointed. Although the furniture is antique and probably signed—I dare not lift the chairs to check—the place is cold and charmless.

Later, I have dinner with Onassis and Maria Callas at Maxim's. Callas seems to be surrounded by a musical aura. Melodies and harmonies seem to envelop her. I think I hear classical music as we sit at our table, even though the orchestra is playing light dance music. I suspect she is rehearsing in her head and the music just leaks out.

In 1959 I fly to Los Angeles from New York with Johnny Meier, a round chunk of a man who plays court jester and promoter of dubious enterprises for many tycoons. At this point he is working on special projects for Howard Hughes and doing some work for ex-president Miguel Alemán of Mexico. Miguel is lonesome. He is retired and has no country to govern. His days are spent at the bar and swimming pool of the Beverly Hills Hotel. Because Johnny has an unlimited expense account, he is very popular. Everyone stops at our table: Natalie Wood, Orson Welles, Warren Beatty, George Hamilton.

The hotel garden is magnificent—manicured palm trees,

cactus, mimosa, begonia, in a clutter of blooms. Johnny points to a small bungalow with permanently closed shutters. It seems inhabited, but barely. "That's Howard Hughes's bungalow. Would you like to meet him?"

"Of course."

"I'll meet you there at five."

A little after five, I knock on Hughes's door. Johnny lets me in. We sit in a typical motel living room. Through a partly open door I hear a vacuum cleaner in the bedroom. "Howard is cleaning his room," Johnny explains. "You know how he is." I don't, but I wait to see what will happen.

The sound of the vacuum stops, and I hear a strange rhythmical shuffling. A man enters the living room, his legs slightly apart. Each foot is encased in a box of Kleenex. Clean tissues surround his immaculate socks. His dark gray pants are rolled at the bottom as he silently slides across the floor. The Kleenex boxes, I am told later, are to prevent contamination from the floor. He wears an immaculate white shirt buttoned to the top and holds a sheer white veil in front of him in the provocative manner of a belly dancer.

This weird-looking person sits beside me at arm's length; Johnny is on my other side. The side-by-side seating is to keep us from aiming germs at one another. I feel I am at confession.

Johnny says, "Howard, this is my friend Isabelle Dufresne."

My tongue is paralyzed. How can I talk in this pew position? "Would you like a drink?" Johnny asks.

"I'll have a large fresh coconut milk, no ice, please."

Hughes says, "Get me my sterilized water in the icebox and a sterilized glass."

I say to Hughes, "I like your shoes."

He sneezes, pulls out some Kleenex from the box under his right foot, and blows his nose. "This permits me to have dust-free feet," he explains. "I pull out the top layer of tissues every hour. Most germs are absorbed through the feet. The pores are open because of perspiration."

Howard is attractive in a strange, spooky way.

Back in New York in 1959, in the elevator at 4 East 77th Street, on my way to a show at the newly opened Leo Castelli Gallery, I meet John Graham, a painter. I am coming in, he is going out. I am still, in many ways, an infant playing at being grown up. He is seventy-eight; I am twenty-four. Or is he 2,078 years old? For all I know, he may be.

He is struck by my youth and beauty. I am intrigued by his eager interest. He escorts me to the show. We exchange views on modern art. He is the author of *Systems and Dialectics of Art.* He is an aesthetician, a connoisseur, a collector of African art, an early supporter of contemporary American artists. He serves as a link between the European art world of the 1920s and 1930s and the contemporary New York art scene. Because of his phenomenal knowledge of art, he is hired to build collections for private individuals.

On our way out, he invites me to his basement flat. I accept. When I arrive, he kisses my feet, we make love, I am enchanted, I stay for a week. The walls of his apartment are covered with mirrors of all shapes and sizes, from all countries and centuries. They are convex, concave, unframed, framed in gold and ornate carvings. "Of all objects, mirrors have the best memory," he tells me.

Graham is a diabolical-looking man. He has a shaved head, a Cossack mustache, pointed ears. He wears a seersucker suit when he goes out. At home he wears a loose, sarong-type skirt. Sometimes he goes bare-chested. At other times he wears a plain shirt with rolled-up sleeves.

The apartment is full of marvelous objects. There are Greek statues, a bronze horse by Donatello, precious and semiprecious jewelry, enough Egyptian artifacts to fill a small tomb, African masks, magic wands, dozens of crystal balls, a sparkling, old-cut diamond necklace with stones as big as duck eggs. He knows the history of every object. He shows me file cards that catalogue the staggering collection.

I see his unfinished shocking-pink self-portrait, in which his delirium and fanaticism pour out with every brush stroke on the large canvas. We practice prana yoga in the lotus position, naked on a tiger skin, facing each other and staring into each other's eyes. He attempts to psychoanalyze me in order to reveal my psyche to both of us. We invoke the spirit of the Ancient of Days, in the shadowy light of that basement room. When he says he is hundreds of years old, I believe him. He tells me that he removed the right shoe of Marie Antoinette and kissed her foot, to the bewilderment of the whole court of Louis XVI.

We talk for what seems like days on end. He claims to speak twenty languages, including ancient Aramaic. We never stop talking, mostly in French. We talk about art, we talk about obscure Oriental religions, we talk about the great mysteries, the laws of phenomena. He cooks for me, using laboratory glassware—"That's where you can create life," he says—while the phonograph plays Pergolesi's *La serva padrona.*

Graham paints me, courts me wildly. He wants to marry me. I laugh. While this magician at times seems ageless, he is an older man, much older than my father. His sexual powers, once phenomenal, I am sure, are now waning. At times he cannot make love to me. But the minute I step out the door, he becomes terribly excited and calls me back, lifting his skirt to show me his erection. He explains that he deifies me too much to touch me until I threaten to leave.

We travel together to Mexico, where, in San Miguel de Allende, his friends show me some of his early, Picasso-style works. I follow him to Paris. He wants me to take him to meet my family. But I cannot bring together this wild creature and my very proper parents. They would never understand. Their toes would curl up inside their custom-made shoes. They would upbraid me for days for keeping such peculiar company—if they would receive me at all, for I have not been home since my furious departure after my father led me, sobbing uncontrollably, from the cathedral in Grenoble.

My tormented relationship with Graham lasts on and off for two years, with many stormy breakups and contrite reconciliations. He dies of leukemia in London in 1961. I have a letter from him, dated the day of his death, in which he eerily depicts in detail his passage from this earth. After his death, he comes to me in dreams, brandishing a flaming sword and threatening to slice me to threads for not having submitted unconditionally to his will. Some time later, I give the hundreds of love letters he wrote me to the Smithsonian Institution in Washington.

I soon fall into a passionate affair with a very rich, married man who owns a chain of department stores. I don't give his wife a second thought. I am too dazzled by the fact that he pilots his own plane, in which we dart off to Palm Beach or Los Angeles whenever we please. His limousine is at my call. He is attentive and wildly sexy.

I describe this conquest, as I do all my adventures, to Véronique, a worldly, "older" French woman, already past thirty. I meet Véronique through my sister, who by now is married, has a child, and is back in France. Véronique is a marvelous confidante. Nothing shocks her. When I show her a charming pearl bracelet my Mr. XYZ has given me, she is not pleased but indignant.

"Isabelle, why don't you grow up?" she scolds. "Don't you ever think of your future? This very rich man gives you a little bracelet! So? What about security? What about when you lose your looks? Make him give you something serious. If he loves you, he will do it."

I am startled. I'm used to getting gifts from men who admire or love me—small pieces of jewelry, flowers, a beaded evening bag. How can I ask for what Véronique calls a "serious" gift? For all my high living, my expenses are low. But maybe Véronique is right. My mother, I am sure, would be saying the same thing, except in terms of marriage. Perhaps I should at least try.

In a hesitant way, I open the subject with Mr. XYZ. To my surprise, he seems charmed. He appears to take my request as

an indirect sign of my devotion. The next thing I know, I am in his lawyer's office, we are signing papers, and I am the owner of a small apartment building on the east side of Manhattan, worth about a million dollars. He explains that I won't actually get any income from the building at this time, because of a complicated situation having to do with mortgages and depreciation. I accept his explanation.

The main thing is that now I own a beautiful little building. A lover has given me a truly serious gift. I can't believe my good fortune. I feel richer than a Rockefeller. For a season I overwhelm Mr. XYZ with love and affection. I discover that just feeling rich is an aphrodisiac. I am in superheaven. Best of all, for all his generosity, my benefactor is too busy to require a great deal of my time. I continue as a free spirit, for I am not ready to be pinned down to one man.

One night I dine at the "21" Club in New York with George Jessel, the aging comic, who loves to be seen with pretty young girls. On our way out, George stops to buy a cigar and bumps into Richard Nixon. "Good evening, Mr. Vice President. I'd like to introduce a fine French girl, Miss Isabelle Collin Dufresne. Can I trust you two alone while I turn my back to select a cigar?"

Nixon swallows me with his eyes and does not let go of my hand. I am still shaking hands with everyone, an old French habit that I eventually give up. "I wouldn't trust myself for a second," Nixon says. He has the grim look of Judas in Da Vinci's *Last Supper*. His wife and daughter catch up with him. He lets go of my hand with a quick wink at me.

The next year, 1960, Mafalda Davis, once a lady-in-waiting to the Queen of Egypt, asks me to stop by the St. Regis Hotel to deliver an eighteenth-century Russian enamel spoon to Salvador Dali. I have never met Dali, but of course I know he is the flamboyant master of surrealist painting. The moment we exchange glances we are certain we are made for each other. I tell him that I, too, paint a little, a very little. He invites me to come back to his studio at five, after his siesta. "We'll draw an extraordinary model," he says.

D ali's studio is a suite in the St. Regis, separate from the suite he lives in. An immensely tall nude female model is reclining on a couch draped with burgundy velvet; the fabric shimmers under a lamp shaded by an antique shawl. A large lobster shell, dipped in a bath of gold, rests on the arm of the couch, ready to be incorporated into the portrait of *Venus Awaiting a Phone Call*, the about-to-be-painted masterpiece.

Large drawing books and pencils are waiting for us on the seats of two armchairs. Dali adjusts the model's blond angel's hair, which flows to below her navel. Then he raises her arm, treating her like a docile mannequin, and places a handful of dried ants in the blond fur of her armpit.

Dali says, "*Je sors la peinture de la routine.* I pull art out of daily life. The armpit offers a hollow suavity." Then he places a telephone next to Venus's hipbone and sets the lobster on top of the receiver, a decorative handle.

Immortal Dali is now drawing a sublime nude, with dizzying

velocity. His rapid strokes on the paper sound like quick, light whiplashes, *tac, tac, tac*. In a swift line he contours Venus, puts her hair in place, *tac, tac, tac*. The ants appear to be busily chewing the furry weeds, *rac, rac, rac*. He wrests a living Venus from the virgin paper. His drawing is completed at lightning speed.

I painfully apply my modest skill to draw legs, torso, neck. Dali looks over my shoulder and says, "Not bad, not bad." He pulls the drawing from my hand and—*tac, tac, tac*—finishes it, signs it, and keeps it.

Venus is getting dressed. Dali kisses her on the forehead, and she leaves. He says to me, "Let me draw you. Would you pose for me?" My clothes fall off. I recline in the warm mold of Venus. Dali approaches to rearrange my untamed hair. He gives me a quick kiss on my lips, briefly stinging my cheeks with the pomaded points of his stiff, upturned mustache.

Perched on the very edge of his chair, with one knee to the ground, he devours me with thunderous, fiery glances, and with the precision of a clockmaker—*tic, tic, tic*—he sketches me. A mirror on the back wall reflects our *tableau vivant*. He shows me the sketch. I admire the astonishing way, with a few strokes of an ordinary pencil, he has conveyed shadows, reflections of light, and has captured my whole personality. He says, "Born an impressionist, I refused my father's advice to be taught how to draw."

He slips to his knees at my side and says, "*Jouons à nous toucher les langues*. Let's play tongue touching." Under his spell, I let him again sting my cheeks as his beautifully curved lips meet mine. His tongue, tasting like jasmine, touches mine, sending me into a zone of bliss where flesh rejoices.

"*Mon amour*," he says, "*bonjour*."

I feel like a billowing net below the ocean of his passion. He seizes the golden lobster and caresses my midriff with it. He turns its tail along my thigh, inflaming my imagination. I raise myself to embrace him completely. With a touch, he signals, "Not yet." He drops the lobster on my mount of Venus. He moves to kiss my knees. I hear him say, "*Isabelle, la catholique, je t'adore*."

I raise myself again to take him to me. Again he signals, "Not yet." I am boiling with passion. I think: This is a lobster trap. Nothing is normal about this man.

He must read my mind, for he now caresses me with the jointed armor of the lobster tail. I begin to wish we could make love like two ordinary people. When will this amorous torment end? "I adore your papyri," Dali says. Papyri is the plural of papyrus. I don't know what part of my body he is referring to.

Trapped under his lobster claws, I am his erotic prisoner. His lips near the legs of the crustacean, he says, "*René Thom, le père de la théorie des catastrophes—*"

The telephone rings, making us both jump. As he reaches to grab it, his mustache hooks the lobster's antenna. The creature dangling at his chin, he says, "A-l-l-o." Then he snatches at the lobster and throws it across the room. It sails right out the open window. The love scene has ended. The good thing about it is that it is safe—there is no way I can get pregnant.

That evening we have dinner at La Caravelle. On our way in, paparazzi snap our picture. Dali talks nonstop over the grilled wild mushrooms, the duck with plums, the Nuit-St.-Georges wine. He says, in French, "The magic of divine Dali, me, the illusionist, stands on a sheet of glass stilted by steel poles, making believe, reassuring yourself. . . . My rhinoceros horns are indestructible, they endure the persistence of memory."

I am intoxicated by his words. For dessert, Dali orders chocolate profiteroles for me. "*Comme toi, chaude et froide,*" he explains. Out of the blue, he says, "Freud's brain is like a snail without condiments, tasteless from a gastronomical point of view." He tells me that in 1938 he took a train across half of Europe to meet Freud in London. "I wanted to psychoanalyze him, using my paranoiac critic method. He would not let me." I give a brief sigh of thanks.

The dessert is delicious, icy and hot at the same time. Dali touches my elbow and says, "Your elbow is as edible as the heel of a loaf of bread."

I reply, "Your lips are as edible as peeled muscat grapes."

"No," says Dali, "as Phidias' testicles, which I am now painting."

As we leave the restaurant, Dali signs the tablecloth instead of the check. He says, "Let's have lunch tomorrow and every day." Paparazzi photograph us again. I realize how famous Dali is.

I move into a small room, a former maid's room, at the St. Regis for the winter, to be near Dali. Yes, he has a wife, the sinuous Gala, whom he has painted many times. Dali took Gala away from the French poet Paul Eluard. In between, Gala took the painter Max Ernst away from his wife. Now Gala is busy with young boys.

I am dazzled by the elegance of Dali's suits, the drama of his cape, the symbolism of his Fabergé gold-knobbed cane, which he holds up in a pontifical gesture. My ear delights in the way he overpronounces every vowel, adding a few of his own on top, so that the word "limousine" comes out "li-moi-ri-si-ne."

When Dali enters a room, every head turns to take in his famed mustache and his luxuriant dark hair, falling to a tie patterned in gold brocade. His tawny leashed ocelot prances ahead of him. He travels with a bizarre entourage of dwarf hermaphrodites, cross-eyed models, twins, nymphets, incredible beauties, always offset by a single creature of surpassing ugliness.

In the spring of 1962 I fly with him to Paris and stay at his hotel, the Meurice. We then fly to Cadaqués in Spain to spend the summer. In the fall we fly back to Paris for the height of the season and live the life of millionaires, then on to New York. A surreal friendship unfolds. We share art, fame, ideas, politics, literature, people. Our lovemaking is Daliesque, theatrical, inventive, but never penetrating in the conventional way. I eventually realize that he has a fear of impregnation verging on the paranoid.

At the Hotel Meurice, on the Rue de Rivoli, Dali occupies a magnificent first-floor apartment that was formerly reserved for King Victor Emmanuel of Italy. Many other royal heads of state

have occupied this suite. The living room ceiling is richly orna-
mented with a fresco of white rococo cupids. There are engraved
mirrors seventeen feet high, a white stone balcony overlooking
the garden of the Louvre. Rich, faded gold silk covers every wall.
The doors are immense, carved out of wood. The room is a relic of
turn-of-the-century splendor.

I stay in a much simpler room, on the fourth floor. The ele-
vator I take is pure 1900 filigree. An attendant in livery opens
the ornate door of forged steel and bronze. Inside, the lift is dec-
orated with metallic bouquets of iris worthy of Violette-le-Duc,
restorer of Notre Dame. A Louis XV armchair, upholstered in
deep burgundy damask, gently welcomes my behind, and like a
rocket in slow motion I am lifted to a soft landing at my floor.

Before my daily lunch with Dali, the hotel florist supplies me
with a fresh camellia crown, which I wear over my chocolate-
colored corkscrew ringlets of hair. I have made this uncut, un-
combed, unbrushed hairdo famous, and it in turn has made me
famous. An 1885 plate of Cupid hunting, in a Pre-Raphaelite book,
served as model for my flower crown.

Dali is very fond of my hairdo. It frames my face romantically
and is not touched by modern fashion. So adorned, one day I
meet Dali in the company of Prince Dado Ruspoli, an Italian no-
bleman, in the lobby. The three of us are driven by a Russian
taxi driver to the restaurant Lasserre. We take a small elevator
to the second floor and find our table, set with stunning sterling
silver and fresh flowers, where we are warmly welcomed almost
daily for lunch.

I look around the elegant room and see André Malraux, the
minister of culture, having lunch with Marcel Achard, a play-
wright, and another gentleman. Dali writes a note to Malraux:
"Bravo for digging Le Louvre to its roots. Now it can stand. Bravo
for lightening those historical facades to give Paris a clean face."
(Malraux has just excavated the foundation of the Louvre and
refurbished the outside of many of Paris's ancient stone build-
ings.) I am to deliver the note.

Dali says, "Keep your face still when you deliver it, for his face has a nervous twitch."

I deliver the note and say in stately tones, "The cathedral is not just architecture, it is a drama, a struggle against gravity." I figure this is what you say to a minister of culture. He nods gravely.

We order caviar and blini, and ortolans, tiny birds cooked whole, guts and all, to be held by the beak and swallowed. The wine is Château Petrus 1947. I cannot get those roasted feathers into my mouth, but Dali not only adores this curious delicacy, he discourses on the supplicating, fixed white eyes, the perfect shape, the delectable taste of the infant birds. When an ortolan disappears beneath Dali's ornate whiskers, I feel I am lunching with a large cat, right out of *Alice in Wonderland*. For dessert we have lemon soufflé with raspberry sauce and a marvelous wine with the bouquet of violets that I sip with pleasure, although I normally do not drink.

As we leave the restaurant, three photographers snap our picture. Next day it appears in *France-Soir*.

Dali returns to the hotel for his siesta—that's how he keeps going well into the night with sparkling energy—and drops me at Roger Vivier, the custom shoe and boot maker. I order the most expensive silver leather boots, with square toes and two seams running from tip to top. My feet are measured with infinite care and sketched. The boots resemble the foreleg of a horse's suit of armor. I pay seven hundred dollars for the pair, *une foile financière*, never to be repeated. (I use the money from the commission I receive from selling a Dali sketch.) They turn out to be so excruciatingly painful that I only wear them about three times.

The boots are bought to go with my silver outfit—silver metal miniskirt, silver blazer, silver stockings, silver boots. Sometimes I paint my front teeth silver, streak my hair with silver spray, and wear silver eye shadow. I carry a sterling-silver attaché case. I also have a silver evening coat with a silver-fox collar, silver underwear, handkerchief, nightgown. Make no mistake about it:

I will be noticed. I crave recognition. Recognition is as necessary to me as oxygen. Without it, I will wither and die.

Why? you may ask. I can't really explain. In part, it's the giddiness of youth. In part, it's the ambience I'm caught up in—you can't be drab and mousy and spend your days and nights with Dali. Perhaps it's because I have not yet developed any inner strength, and to make up for the vacuum inside I must plaster the outside with ornament upon ornament. It will be a long time before I reach my introspective days.

At five that afternoon, Dali and I are to have tea with the Duke and Duchess of Windsor in the tearoom of the Meurice. The Duchess and I arrive first. We sit at a table, order tea and toast. Wallis Windsor looks like a cartoon of the Duchess of Windsor. (Why shouldn't she, for that is who she is.) I feel I know them both from their press photographs. Here she is with her hair neatly parted, not too long, not too short, skin well attended to and carefully powdered.

"How did you enjoy your cruise?" the duchess asks me.

I have just returned from a cruise aboard the yacht *Malanée*, owned by movie mogul Sam Spiegel and manned by a modest crew of 101. Greta Garbo, Prince Alexander of Yugoslavia, Baroness Helen de Rothschild, and Brigitte Bardot are frequent guests aboard.

I tell the duchess that Sam, the overweight parakeet, wanted me to share the grand bed in his cabin with him and a blond bombshell.

"How did you escape?" she asks.

"I told him I don't like bombs or blondes."

The duchess is wearing a gold wedding band and a diamond-and-sapphire ring. I know she was born on June 19, a Gemini on the cusp of Cancer; her stone is the pearl. I tell her she should wear pearls every day of her life.

"Is there any truth in those superstitions?" she asks.

"They are based on scientific facts," I tell her with faked assurance. "You must lack calcium. Pearls are composed chiefly of

that mineral. By wearing pearls, you absorb tiny doses by osmosis. That gives you better balance and a better destiny." Look to whom I'm offering a better destiny.

"I never wanted to be Queen of England," she says, coming right to the point. "It's the duke who lacks calcium. Ever since I've known him, he wakes up with stiff joints."

Dali arrives with the duke, who also looks like a cartoon of himself. His face remains unlined by the passage of time. He has an absent, noncommittal expression. His beautifully cut suit has a tiny red stripe against a background of dark and light gray. He does not say very much. The rest of us make vapid conversation about the comings and goings of the beautiful, name-brand international people.

The first time I visit Dali at Port Lligat on the Costa Brava, in 1962, I am amazed by his house. A multilevel agglomeration of purest white-chalk fishermen's cottages, it looks like a miniature Moorish fortress. I call it the White Labyrinth. As I approach the narrow entrance door, it opens. Inside, I fall back at the sight of a gigantic, ten-foot-high white bear glaring down at me. His eyes glitter and his fangs gleam. He is the protective guardian of the house. I am very excited at the thought of seeing Dali again. We have been apart for all of three months.

Tristan und Isolde in the Furtwängler recording fills the corridor with a sense of boundless delight. Like a magician, Dali appears. He is magnificent. His skin is a golden tan. His immensely vivid eyes are an indefinite hazel color. The tips of his mustache are erect to the sky. His teeth are evenly distributed. His lips are perfectly proportioned. His nose, too, is perfect.

He is wearing a black cowboy shirt trimmed with white and twinkling multicolor flowers in a mingling of gypsy and American wild West fashion, black pants, and marvelous Spanish espadrilles made in Catalonia of beige cloth, with black ribbons tied around the ankle.

Dali leads me along unevenly curved stairs to a small whitish patio. Delicate white jasmine in bloom delights my senses. Dali

selects the most beautiful blossoms, kisses them, gets on his knees, and with a theatrical gesture presents me with the heavenly flowers. From the patio, a wide panorama of azure sea reminds me of the first day of creation. The sun shines with golden brilliance for us. I see the curve of the earth.

Arturo, Dali's *homme à tout faire*, announces lunch. We both place jasmine behind our ears, so that all through the day the divine scent follows us. The dining room is a tiny six feet by four feet, no bigger than a scatter rug. Against one white wall there is a built-in cement bench, in front of it a table a foot and a half wide. Dali slides into a tiny chair that fits into an excavated niche in the opposite wall. We are lunching in a dollhouse that is as unreal as if it were inside our heads.

We are served raw sea urchins, chocolate chicken, and crystallized ants. Dali holds up a spiny sea urchin and says in his unique phraseology, "Shape is always the result of an inquisition process of matter. Freedom is shapeless. Morphology, a word invented by Goethe, has infinite consequences."

Late that year, 1962, back in New York, Dali bursts into my bedroom at the St. Regis, walks to the window, opens the drapery to let the sun flood in, and says, "Get ready. We are having lunch at Le Pavillon with two Nobel Prize winners, Crick and Watson. They know all the secrets of DNA. Be ready in fifteen minutes." Swiftly Dali draws a double helix on my wall with a Magic Marker and signs it. I am thrilled at meeting the American genetic researcher James Dewey Watson and his English counterpart, Francis H. Crick, of Cambridge University, who have revealed how genetic material in living cells duplicates itself. The newspapers have been full of their accomplishment.

In the limousine, driving the two blocks to the restaurant, Dali cannot contain his excitement. "Those two geniuses will go down in history, just as I will. Their discovery is superior to the invention of fire and the written alphabet."

At the restaurant, our two geniuses are young and puzzled at Dali's appearance and English. The menu is in French. Dali

orders puree of string beans for them, claiming it will nourish their own deoxyribonucleic acid. He pronounces it "Deee-oxyy-rrriiii-bouo-se-nuclickkk acid. I can read in their eyes that they find Dali's genetic code another puzzlement. "He's coded in Catalonian," I explain.

Dali takes a lobster out of his pocket. Crick and Watson drop their forks. Dali says, "I have dipped this lobster in a bath of gold to suspend it in immortality."

This can't be the golden lobster of our first meeting—that one left by the window. Perhaps this is a descendant. Dali places it on the table as a centerpiece. Crick looks at Watson. Dali continues, "The laws of heredity are of divine origin. Your discovery is the most important since the famous painting by Dali of *Soft Watches*, which was a prophetic announcement of your cracking the genetic code." Dali frequently speaks of himself in the third person.

Dali points to my face and says, "Gentlemen, can you improve in any way on the beauty and perfection of this face?"

Crick says, "The right eye is not the same as the left."

Worried, I look into my compact mirror and start laughing. In my haste to put on my makeup I glued false eyelashes on only one eye.

Dali explains that he is fascinated with scientific literature and read recently that the urine of geniuses contains a large amount of nitrogen. I tell our Nobel Prize winners, "He once talked me into drinking his urine to raise my genius level. All I got was pimples." Crick and Watson suddenly remember they have a plane to catch. They make a hasty escape.

In the limousine ride back from Fifty-seventh to Fifty-fifth Street, Dali says, "The day will come when I will be able to reproduce many little Dalis, all comparable in genius." I meditate on the displacement of God from the center of the universe.

One day in 1963, as I am having tea at the St. Regis with my phantasmagoric companion, a near albino wearing a synthetic shaggy wig—white on top, silver in the middle, and black

underneath, with rattails hanging lopsided on the side—approaches our table. The little man, with one blue eye and one gray eye, clay skin, chalk complexion, a glazed, hollow stare, and a hipster naïveté, greets Dali.

Dali introduces us. "Isabeau, I'd like to present Andy Warhol. Andy, this is La Comtesse Isabeau de Bavière, née Collin Dufresne." In an odd, almost irresistible way, I like the little cartoon man. I feel as if I know him. I feel drawn to him.

"Oh, you're so beautiful," Warhol says, "you should be on film. Can we do a movie together?"

"When?"

"Tomorrow?"

ULTRA, THE GIRL IN ANDY WARHOL'S SOUP

Andy lures me to the Factory with the promise of putting me in a movie. I soon discover he makes about fifteen such promises every day. It's his way of opening a conversation. His movies, I also learn, are quickie underground movies, shot in shaky black and white with a single hand-held camera; the action on the screen takes as long as the action in real life. Everything about the production is rankly amateur. But his friends, followers, and members of the "in" public who want to be shocked with nudity, homosexual sex, and anything outrageous flock to tiny underground screening rooms to see these films.

Andy tells me I need a new name. I can't use Isabelle Collin Dufresne. No one can spell it, pronounce it, or remember it. Besides, the stars of his underground films have catchy names—International Velvet, Ingrid Superstar, Ondine. He suggests Poly Ester or Notre Dame for me. I tell him I'll find my own name.

Ultra, the Girl in Andy Warhol's Soup

While reading an article on light and space in *Time* magazine, I come across the words "ultra violet." They leap at me. I cut them out with the gold scissors I use to cut the split ends of my hair.

I say the name out loud several times: "Ultra Violet, Ultra Violet." I stretch it out, pronounce it in five distinct syllables. I emphatically prolong each vowel. I tap the tip of my tongue forcibly against my teeth to give the consonants a staccato sound. It comes out: *Ul—tra—vi—o—let*. By luck or by choice, my name contains the five magical vowels. Vowels shine as jewels compared to the dull consonants. Vowels are the coloratura, the very hue of language.

Repeating my new name evokes dreams of verbal alchemy. I shake hands in poetic fervor with that thief of fire Arthur Rimbaud. The legendary poet, fed on revolt just as I am, feasted in his "Sonnet des Voyelles" on the color of each vowel: "A Black, E White, I Red, O Blue, U Green." Yes, my friend Arthur, my name is colorful. Even you would approve it. I anoint myself Ste. Ultra Violet. I speak my new gospel: "And God created vowels, and men gave name to the consonants." I am drunk with delight.

I announce to Dali my choice for a born-anew name. He is not exactly sure about it. It sounds a little too scientific to him. He thinks I need something more romantic, more classical. He wants to rebaptize me Isabeau, which is neither male nor female. He often calls me Isabeau de Bavière. I repeat "Ultra Violet," drawing out the vowels into an exaggerated aria. This time he laughs. Now he approves.

Andy thinks Ultra Violet is really funny. "It will be an ear-catcher," he says.

Once I adopt my *nom de plume*, or better yet, *nom de guerre*, I have to live up to it. My first aim is to upstage all the other Superstars. It is not my nature to be one of a crowd. I must stand out. My name gives me a head start. I can be ultra anything. But first, of course, I have to begin with the color. That means my

collection of dark brown wigs, which I wear to dramatize certain outfits or to substitute for a trip to the hairdresser, is turned over to a theatrical beautician, who dyes them various shades of violet. I mean violet—not modestly lilac or sweetly mauve. *Violet.* You can't miss me in a mob.

In my fanaticism about health—I'd rather drink carrot juice than wine—I always try to avoid chemical cosmetics and seek out edible items to use on my skin and hair. Through the years, I've broken and scrambled dozens of eggs over my head for shampoo, added a dash of rum to camouflage the egg aroma, and squeezed on lemon juice as a natural rinse to achieve a high shine. Now I fill the sink with violets, run hot water over them, boil them, squeeze them, all but stamp on them, but to no avail. I cannot coax out of the petals a convincing violet tint. I make a foray to the greengrocer's and come home with samples of purple broccoli, dark red grapes, beets, cranberries, red plums— anything that has a red-purple hue. Then I experiment.

Cranberry juice or liquid cranberry jelly proves most satisfactory on my hair. It gives a vibrant red sheen to my dark brown hair, which I wear loose and wild. I wash it in the red juice, shake it out to dry, never let a comb near it, and glory in my snaky ringlets, untamed by human hands. Using fresh beets on my cheeks and lips, I achieve an alive transparent tint.

To renew my lip color during an evening I pull out of my gold mesh evening purse a gigantic fresh beet with the green leaves still dangling on their red stems. With a tiny gold knife I slice a morsel from the beet and rub it on my lips and cheeks in full view of the staring onlookers. The shade it imparts is neither red nor pink nor orange but an out-of-this-world rouge-violet. Try it sometime. I take the beet and the leaves home and eat them the next day. And more than once, when there is a long wait between meals, I head off starvation by nibbling a few mouthfuls of the white rice powder that I dust on my face from a beautiful cloisonné compact.

For my eyes, I forgo the natural approach and buy false lashes

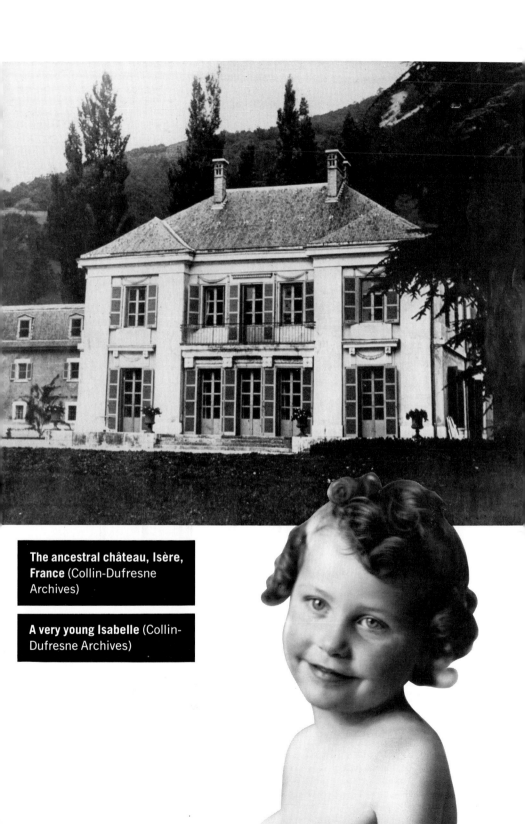

The ancestral château, Isère, France (Collin-Dufresne Archives)

A very young Isabelle (Collin-Dufresne Archives)

COMMONWEALTH OF PENNSYLVANIA

DEPARTMENT OF HEALTH
VITAL RECORDS

DATE OF BIRTH	8-6-28	FILE NO.	D211046-28
PLACE OF BIRTH	PITTSBURGH	DATE FILED	5-2-45
COUNTY OF BIRTH	ALLEGHENY	DATE ISSUED	11-16-87

SUBJECT ANDREW WARHOLA

SEX MALE

FATHER ANDREW WARHOLA

MOTHER JULIA ZAVACSKY

The Original of This Certificate was a Delayed Registration and was Recorded in the State Division of Vital [illegible] the Following

AFF OF JULIA WARHOLA, MOTHER PGH, PA NOTARIZED 5-3-45

AFF OF KATRENA ELACHKO, PGH PA NOTARIZED 5-3-45

This is to certify that this is a true copy of the record which is on file in the Pennsylvania Department of Health, in accordance with Act 66, P.L. 304, approved by the General Assembly, June 29, 1953.

Charles Hardester

CHARLES HARDESTER
STATE REGISTRAR

H105-053 REV 1-86
WARNING: It is illegal to duplicate this copy by photostat or photograph.

36531

Andy's birth certificate

FACING PAGE, INSET: **Andy and the Girl Next Door, 1938** (Courtesy Paul Warhola)

FACING PAGE: **Andy at sixteen** (Courtesy Paul Warhola)

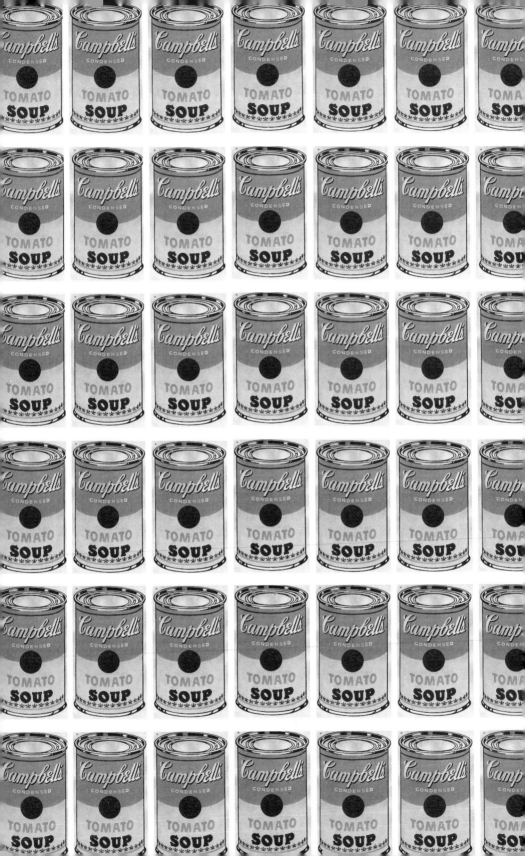

ABOVE: Ultra Violet as Isabelle Dufresne, society belle, *Town & Country*, 1964 (*Town & Country*)

LEFT: Dressed to go out, 1965 (Angelo)

FACING PAGE: The meteoric rise of a soup can

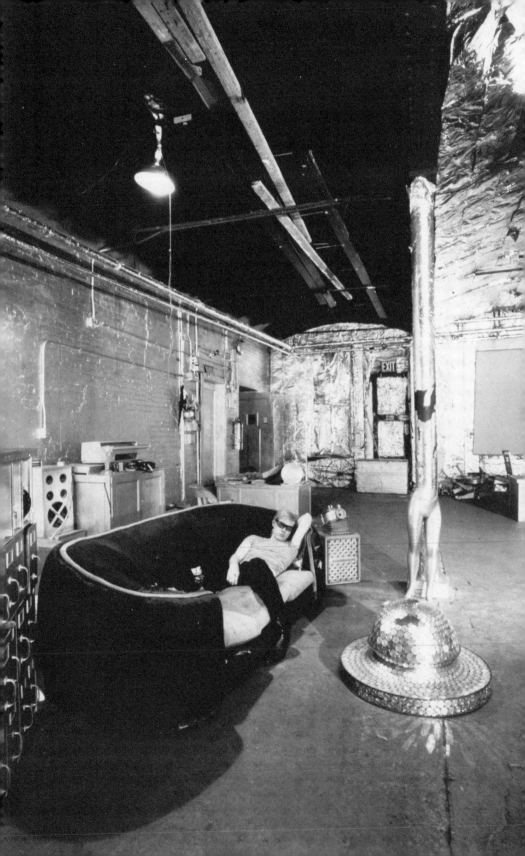

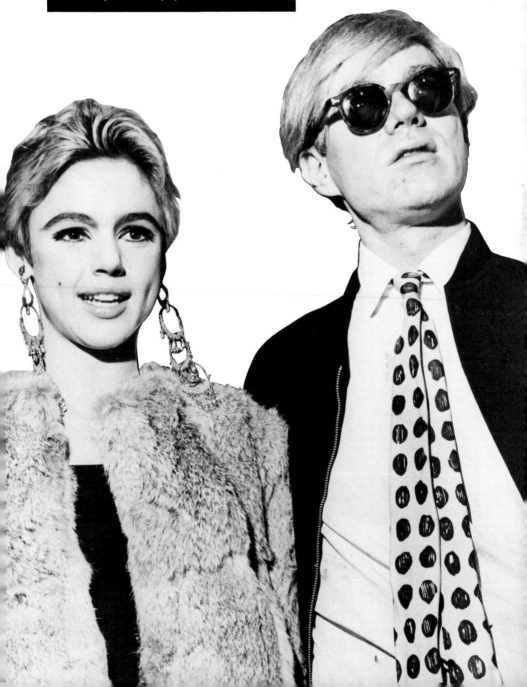

Andy with Edie Sedgwick at Warhol's first museum exhibition, Institute of Contemporary Art, 1965 (Courtesy Philadelphia Newspapers, Inc.)

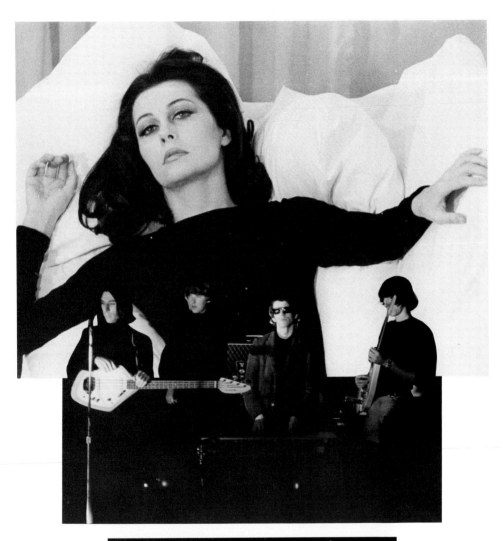

Ultra in her all-white bedroom (Adelaide de Menil)

Lou Reed and the Velvet Underground (Lisa Law)

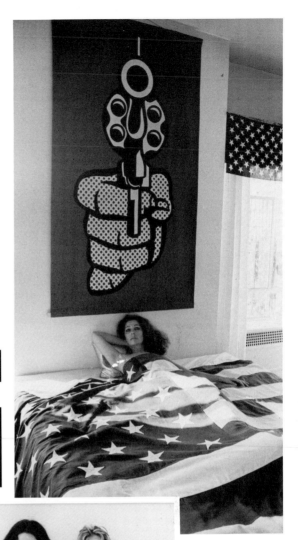

Shoot 'em up (David Gahr)

The Factory regulars, as seen by Cecil Beaton, mid-1960s (Courtesy Sotheby's, Inc., New York)

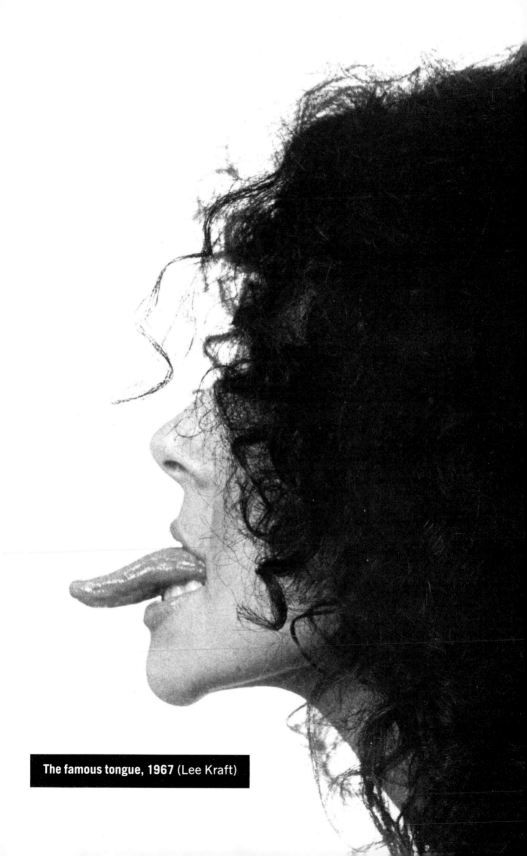

The famous tongue, 1967 (Lee Kraft)

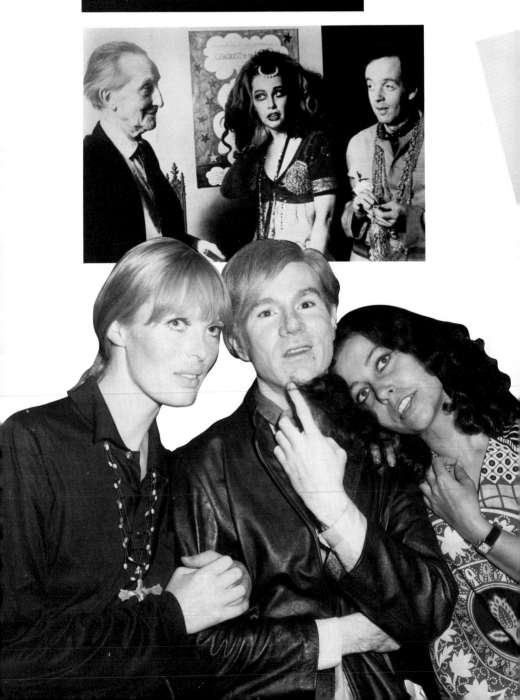

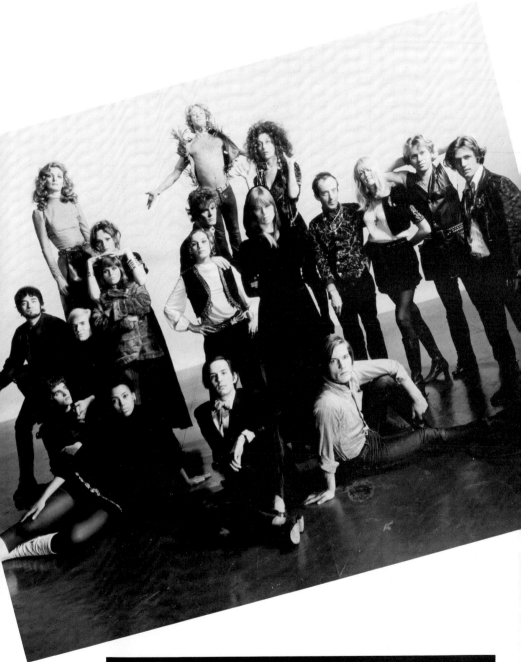

The whole entourage, 1968: *Left to right: top row,* Viva, Eric Emerson, Ultra Violet; *middle row,* Ondine, Andy Warhol, Claris Rivers, Candy Darling (behind Rivers), Geraldine Smith, Paul Morrissey (behind Smith), Nico, Taylor Mead, Ingrid Superstar, Louis Waldron, Gerard Malanga; *bottom row, seated,* Jay Johnson, unidentified woman, Fred Hughes, Joe Dallesandro (Photograph by Philippe Halsman, 1968, copyright © 1988 by Yvonne Halsman)

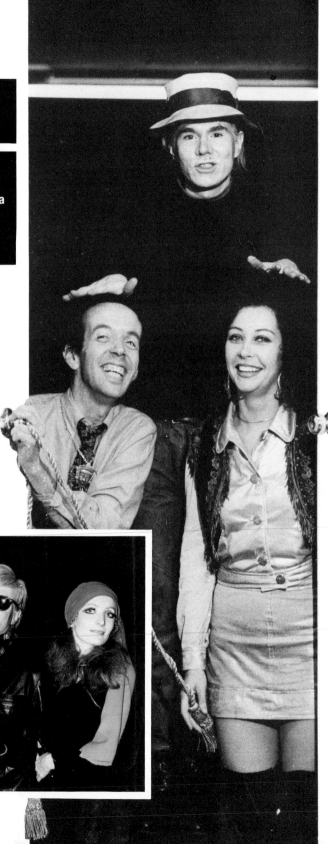

And a good time was had by all: the Factory, 1968 (David Gahr)

INSET: At the 1968 premiere of *I Love You, Alice B. Toklas!*: Ultra as a blonde, Andy, and Viva (UPI/Bettmann Newsphotos)

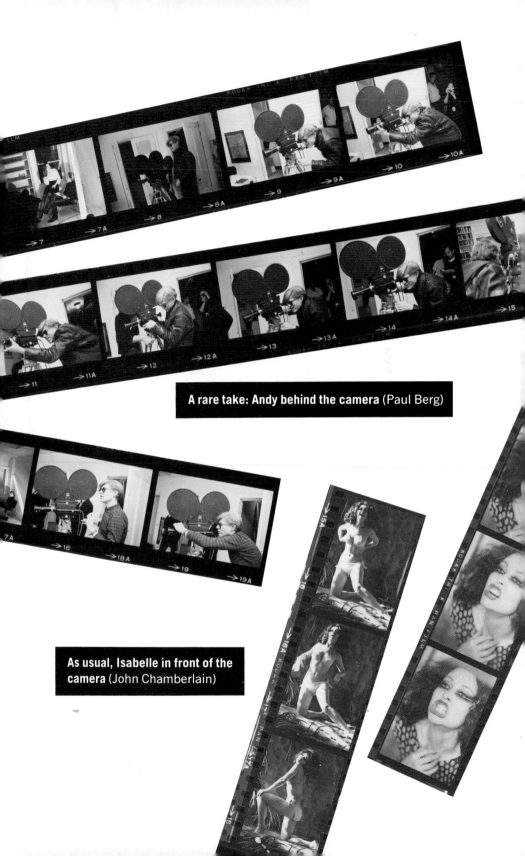

A rare take: Andy behind the camera (Paul Berg)

As usual, Isabelle in front of the camera (John Chamberlain)

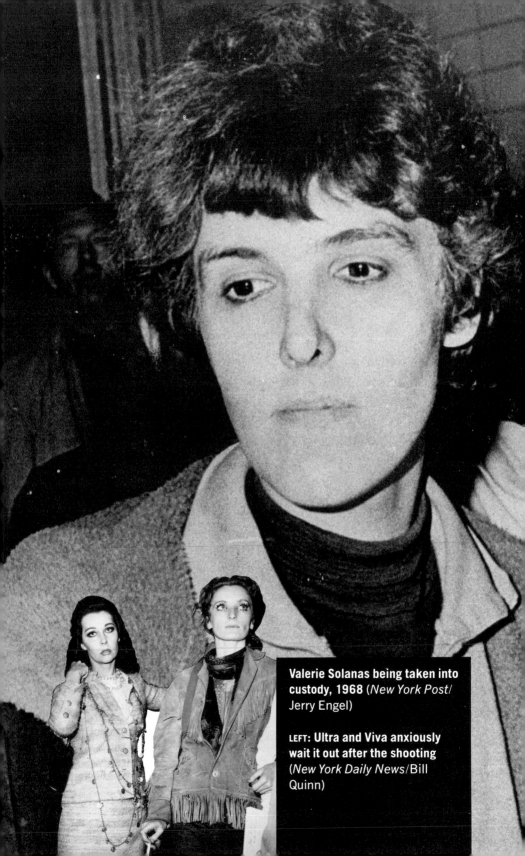

Valerie Solanas being taken into custody, 1968 (*New York Post*/Jerry Engel)

LEFT: Ultra and Viva anxiously wait it out after the shooting (*New York Daily News*/Bill Quinn)

by the yard. I glue a four-inch strip on my upper and lower lids, letting it run all the way back to my hairline, as if the lashes were born out of my corkscrew hair. With my centipede eyes, I conquer hundreds of hearts. And on rainy days, when the dampness turns my Medusa locks into a huge ostrich feather duster, I enhance the effect by wearing white ostrich feathers in my hair. At the Parke Bernet Gallery, Seventy-sixth Street and Madison Avenue, at a showing of the paintings of Nicolas de Staël, which is accompanied by a piano recital of Chopin ballades by Philippe Entremont, my extravagant horsetail plumage catches the eye of a *New York Times* reporter and results in a beautiful photo of me in the Sunday paper.

Naturally, my wardrobe needs to be violet as well. Andy takes me to a thrift shop on St. Mark's Place, the street where the flower children acquire their poetic gear and where the fad of ransacking attics for the finery of yesteryear is getting its biggest impetus. Old clothes from the 1930s and '40s are piled high on makeshift counters, some of the items beautiful, and some just funky. I select a vintage dress in violet velvet, priced at ten dollars, and try it on. I pirouette in front of Andy. He nods his approval. "Buy it," he says.

"It's great," I tell him, "but look, it's torn at the bottom." I lift the hem to show him the ragged area.

"That's the torn look," he declares—and a new fashion is born. As I come out of the store, resplendent in dated violet velvet, shredded around the edges, all heads turn toward me, and three cars hit their brakes with loud squeals as the drivers fix their eyes on the torn look instead of the red light.

You must remember that this is the early '60s, and most people still dress in staid and conventional ways; only a few daring souls show up in public in outfits usually reserved for masquerade balls. When I look in the mirror, I am electrified by my own image. I feel as if I've plugged my fingers into an electrical outlet. As Ultra Violet, I can feel the jolt of the volts coursing through me.

When I march into Dali's apartment in my violet finery, he offers me a box of candied violets, real violets, dipped in sugar that takes on a violet aura, and a box of chocolate ants, real ants, embalmed in chocolate.

I hesitate to pluck a flower from the field of boxed violets. I feel like a cannibal eating my own kind. But I delicately pick one—it is delicious. The chocolate ants are something else. They are Dali's signature—I always tell him they must be the ants that crawl over the watch in his most famous of paintings, *The Persistence of Memory*. I know I am expected to eat at least a few of the ants, so I bravely put one in my mouth and listen to it crackle between my teeth. I have difficulty swallowing it. I imagine the little creature pushing its legs backward in my throat to avoid its fate. It finally goes down. Its friends in the box— there are an awful lot of them—I will offer to my friends to test their daring.

Soon people send me violets for every occasion. Bouquets of them come from known and unknown admirers. I keep them all. When they dry, I tape them to the frame of my front door. Their color turns to dark amber-rose with streaks of mauve. The door becomes a magnificent floral archway. It's the closest I get to nature in New York City.

More and more I identify with the violet. I surround myself with the odor of violets. I blend violet essence with a drop of patchouli or rose geranium to make the violet scent more intriguing. When I was a child, my mother treated my sore throats and other illnesses with herbal medicines. Back then I read endlessly in her herbal books about the properties of plants. Now I wonder if she ever soothed my childhood illnesses with violets or dosed me with violet infusions.

I go to the library and pull down a copy of Culpeper's *Complete Herbal*. I read that the violet "eases pains in the head, caused through want of sleep. A dram weight of the dried leaves or flowers purges the body of choleric humors, if taken in a draught of wine. The herbs or flowers are effectual in the pleurisy and all

diseases of the lungs, hoarseness of the throat, pains of the back and bladder."

Clearly, I am a cure-all.

But beyond the pharmacopoeia, the violet has a remarkable effect on me. It releases me. Deep inside, I am both daring and timid. I love to smash rules, to amaze, to shock. But at the same time, I am often shy. I hesitate to speak up in a crowd. I rarely argue with people. This conflict between bravura and reticence persists all my life. I feel a duality in my nature.

Ultra Violet becomes the unleashed exhibitionist, the mad, heedless creature, chasing headlines, totally uninhibited (most of the time), an unabashed freak. She will do anything. At a party in Los Angeles in honor of David Bowie and me, I hold a press conference, reclining in Eve's outfit, my body totally immersed in a bath of milk. That's Ultra in the milk bath, not Isabelle. Ultra adores the provocation of being naked, yet not visibly nude to the naked eye.

Andy and I are invited to the opening of a Twentieth Century–Fox film. We both want to look smashing, because we are searching for money to produce our films. Andy says, "Wear what makes you look best."

I reply, "I look best with no clothes on."

"So wear nothing under your coat."

That's what I do. But even as Ultra, I dare not check my coat.

Unlike ultra violet light, which is beyond the spectrum and therefore invisible, I am visible but beyond the permissible, with my Egyptian wildcat makeup, my tousled hair, and my provocative attitude. I hear of an Ultra Violet cult. In the street I see a mushrooming of Ultra Violets. In Italy an artist proposes a shrine to Santa Ultra Violetta.

Ultra will do anything for publicity. In his 1980 book, *Popism,* Andy states: "Ultra was popular with the press because she had a freak name, purple hair, an incredibly long tongue and a mini-rap about the intellectual meaning of underground movies.

85

She'd go on talk shows 'representing the underground,' and it was hilarious because she was as big a mystery to us as she was to everybody else. She'd tell journalists, 'I collect art and love.' But what she really collected were press clippings."

Ultra becomes so famous that in time she nearly obliterates Isabelle. In 1968 my Turkish friend Ahmet Ertegun, who, with his brother, founded Atlantic Records, the foremost recorder of rock groups, picks me up in his antique limousine, a special *carrosserie* Rolls-Royce. Ahmet is as striking in appearance as his car. He has a shining, hairless head and a dark, triangular goatee. His car is midnight brown, vintage 1959. I'm astonished at the beauty of the automobile. "It's nothing special, just a stock limousine," Ahmet tells me.

"That's hard to believe," I say as I admire the inlaid-wood bar, the velvety beige upholstery, as comfortable as a luxurious down couch. The front seat is leather—to withstand constant use by the driver. Ahmet introduces me to Prince Rupert Loewinstein, another prince without a principality. We drive to dine at the home of Betsy Bloomingdale, of the Bloomingdale chain of stores and the Diners Club, and a dear friend of Nancy Reagan, at that time the First Lady of California.

Ahmet, who knows me in both my incarnations, introduces me as Isabelle Collin Dufresne. I am dressed as Isabelle, in a conservative black dinner dress, elegantly understated, my hair braided in a chignon. At the dinner I am seated next to George Plimpton. At the height of the animated conversation, Betsy's voice rises over the others, and the guests around the small tables lean forward to hear her story.

"Guess who I saw today at Café Figaro," Betsy says. "I saw Ultra Violet."

There are oohs and ahhs. Betsy goes on: "She was unbelievable. Her hair was violet and"—her gesture extends the width of an umbrella—"was like a wild nest for a huge jungle bird. Her eyes"—she points to a purple orchid in the floral arrangement—"were wilder than this orchid. Her clothes were torn, and

you could see pieces of her skin underneath. She was covered with gold chains and gold medals and gold coins, and as she walked she jingled. She . . ."

This is going too far. Ahmet tries to break in to explain. But Betsy keeps right on. "I tell you, she was bizarre. She kept being paged, and each time they called her name, all the heads turned to watch her untamed walk."

Now I speak up. "Betsy, I am Ultra. I—"

She thinks this is a wonderful joke and continues to describe my extravagant appearance. I try again to get a word in. Then I give up. She is my hostess. I really shouldn't ruin her story. Ahmet is rolling his eyes and suppressing his laughter. Later, we laugh all the way home in his Rolls.

In the 1980s the Ultra/Isabelle confusion surfaces again. I am driving to New Jersey in the company of Philippe de Boissieu, the nephew of French President Giscard d'Estaing. I am to interview Michael, a gentleman farmer and owner of two cows, on behalf of Stuart Mott, an heir to the General Motors fortune, who maintains a suspended Babylonian urban organic farm on the terrace of his Park Avenue penthouse. All that is missing in his Garden of Eden are the passengers from Noah's Ark. Michael wants to sell Mott the cows.

I fall in love with the cows at first sight, but I know they will never pass the stuffy board of Mott's building. I begin speaking with Michael, who mentions that in town he lives on East Sixty-sixth Street, next to Warhol's town house, and knows the whole entourage.

"Whom do you know?" I ask.

"Andy, all those girls, Viva, Ultra Violet."

I say, "Ultra Violet, how is she?"

"Oh, she's dead."

"How did she die?"

"Probably an overdose."

"What did she look like?"

"Oh, she was beautiful, a sex kitten, like a more beautiful

Hedy Lamarr. She was Andy's favorite. She represented him on TV."

I say no more. Later, to spare Michael future embarrassment, Philippe tells him that the woman to whom he described Ultra Violet is the real, genuine Ultra Violet herself. Michael rejects the idea. He thinks it's ridiculous. Maybe he's right, because by that time—by the 1980s—Ultra Violet is no longer the girl in Andy Warhol's soup, and Isabelle, the grateful survivor of the sixties, has become a person so different, so reincarnated, she is almost unrecognizable.

I actually meet Andy Warhol before I know his name and before our introduction by Dali. In 1961 I sit at the counter of a luncheonette at Eighty-eighth Street and Madison Avenue, next to a blondish young man. He has a child-like face but an unearthly pallor. I read the menu disapprovingly. I still hate New York food. Back in France, I was upset at the French obsession with food. I railed against two-hour lunches and three-hour dinners and endless, boring talk about flavors, ingredients, vintages, taste nuances. Life had to hold more meaning than the silkiness of a sauce.

Not until I get to New York and sample its tasteless fare do I forgive my countrymen. Here, the eggs do not taste like eggs. Butter does not taste like butter. Tomatoes taste like the packages they come in. I must say that in the intervening years, American food has improved enormously. But then I was justifiably full of scorn. At the luncheonette counter, I rattle the menu in annoyance and start a one-sided conversation with the ghostly

young man on the stool next to me. "Gastronomy is foreign to Americans," I say.

He nods.

"What are you eating?" I ask.

"Chicken soup."

I order a tuna fish sandwich. When it comes, I glare at the limp white bread and the puddle of mayonnaise. I ask the young man what he does. "I'm a painter."

"I paint too. What do you paint?"

"Not much. I'm looking for ideas."

I point to the Campbell soup cans arrayed neatly on the shelf. "Why don't you paint a soup can?" I ask idly. The words just come out. But as I say them, I think that's what Americans deserve, a boring, banal can of soup.

"Hmmm," my countermate says.

I am not aware that the stranger next to me has already painted a can of Del Monte peaches and that his own momentum is about to lead him to soup cans, Coca-Cola bottles, dollar bills, and postage stamps, with or without my prompting. I don't see him again until Salvador Dali introduces him to me, saying, "I'd like to present Andy Warhol."

In the Factory, Andy always works with loud rock music on. In rock, repetition is the leitmotiv. Not only does the rhythm, led by the drum, a replica of the heartbeat, pound at regular measures, but the other instruments create melody in a repetitive cadenza. Andy does not hesitate to repeat himself. He paints forty-eight Marilyns and two hundred twenty-four Campbell soup cans, and in the movie *Sleep*, the sleeper sleeps, sleeps, sleeps, sleeps, sleeps, sleeps until the viewer nods off.

But Andy never really paints a painting. In his own words, he *does* a painting. One day in 1964 we are sitting on the broken-down couch in the Factory. Andy, as always, pretends to be short of ideas. "What shall I do?" he asks.

"A painting."

"What subject?"

Piles of silk screens are stacked along the west wall of the loft. I spot a large screen, about six feet by twelve feet, that depicts in dark ink the background of two flowers side by side, each about six feet in diameter, one larger than the other, and barely touching. We unroll on the floor some virgin canvas, on top of which we lay the flower stencil.

"What color?" he asks.

"Make it violet, since that's my name and I'm a flower myself."

Using a can opener, he lifts the top of a gallon can of deep violet Benjamin Moore paint. He adds a dollop of white and with a roller, applies it to the screen over one of the flowers.

"What about the other flower?" he asks.

"Orange? That's complementary to violet."

He opens a premixed can of orange paint and rolls the color back and forth across the other flower. The whole process takes a few minutes. We remove the silk screen and see those two colorful flowers pop out at us from the canvas.

I feel my heart jump with the excitement of experiencing the creation of this large Pop Art painting. I ask him if he'll give it to me. After all, he's never paid me for the films we are doing together. No, he won't give it to me, but he'll sell it cheap, below his dealer's price. We agree on $2,000. I write him a check on the spot for $1,000 and later give him another $1,000 that I scrounge together. I still have the two receipts, on each of which he scribbled, "Two flowers, sold to Isabel defraine, $1,000."

In 1970 Gordon Locksley, a Minneapolis art dealer, offers me $40,000 for the *Two Flowers*. In 1975 I am offered $125,000 by Ivan Karp of the O.K. Harris Gallery. In 1980 Andy tells me the painting is worth $200,000. I don't know how much the scribbled receipts are worth. The painting hangs in my living room. It costs me a fortune just to keep it insured.

Today when I look at it, I marvel at what I see. First of all, it is beautiful, very beautiful. But what is it? What does it show? Those are not two flowers that Andy picked in a garden or saw

91

in a vase. He first spotted them in a photography magazine. He enlarged the photograph (later he was sued by the photographer), then ordered a silk screen made from the photograph. Of course, he learned all about screens and multiples and blow-ups and colorization in his days as a commercial artist. Unhesitatingly he absorbed and transformed these techniques.

When I study the flower painting even more closely, I wonder what kind of flower I see. Is it buttercup, cosmos, anemone, poppy, apple, peach, or pear blossom? It can be any of these. Andy does not care to be specific. Is the flower small and blown up? Is it large and exotic? Is it edible or poisonous? Is it in a vase, at a florist's shop, or in the field?

The flat, solid color makes the painting unreal. Real flowers have different shading around the pistils and stamens. So I come to the conclusion that these flowers are not live. They are plastic, can be mass produced, and will last forever. Thus we come to Andy's idea of "plastic inevitability," a state of affairs beyond surrealism in which the fake is more real than the real.

By this time it is common for artists to use photographs incidentally in their work. It is part of the art of Rauschenberg and Duchamp. But for Warhol, photography is not just a helping hand. It is a replacement of the chosen object. The photograph *becomes* the painting. The photograph is processed onto the canvas and colored in. There is no *original* painting; from the start, there are multiples. His paintings are mass produced. Theoretically, they are produced by the artist. But not always. Before long there is a scandal. Eager "volunteers" turn out dozens of Warhols without his knowledge. They are identical to the other multiples. But the signatures are forged.

Who is to say the unauthorized paintings are fakes, for they are exactly like the "originals." But they are bootleg paintings. I tell Andy to number his paintings, in order to control production.

On a day in 1965, Andy moves toward the west wall of his vast, silvery loft. A large silk-screen painting of an electric chair leaps at me. The chair stands by itself in the middle of a silent

room. An aura of mystery surrounds it. The room takes on an extraordinary meaning. It is a stage set for death. The viewer cannot help but think about who sat on that chair last.

The design of the chair is both functional and elegant. It is inspired by the mission style, a kind of Gustav Stickley design. The leather straps caress the floor. Somehow the chair looks noble. What about an electric bed? I wonder. Have they thought of it? Wouldn't dying in your sleep be more unnoticed, even by the sleeper? But the government has decided against that. Maybe dying in your sleep is too casual, too unaware; it is not capital punishment.

I ask Andy, "Is there more than one manufacturer of electric chairs?"

"Gee, I don't know."

"Are they signed the way a Thonet chair is signed?"

He shrugs. "Just a serial number."

I look again at the painting and say, "I like it. You are up-front."

"What do you mean?"

"The death element is obvious."

"Gee."

"It's honest subliminal advertising."

"What do you mean?"

"You know how Madison Avenue uses death symbols to lure the customers."

"No, tell me."

Andy loves to play dumb—the village idiot, the global idiot. When he first uses this technique on me, I naively explain, on and on. Then I realize it's part of his flattery. He wants you to think he's learning from you. Later, I see he takes it a step further—he actually learns many things that way.

So I explain: "I've read somewhere that sex and death are the greatest motivating forces for people. Advertisers constantly use symbols of sex and death, usually hidden or subtly disguised." I pick up a magazine from a cluttered tabletop and flip

through it. "Here, take this ad for Scotch. There are a bottle, two glasses with ice cubes in them, two hands, one reaching for the bottle, the other for a glass."

Andy nods. He loves someone to tell him a story. He is eight years old again, and his mother is reading to him from a comic book. I'm enjoying myself too at this point, as I launch into a description of how the two hands seem to touch or even caress. In fact, the woman's hand suggests that she is holding a phallus—the circular glass. I point out that if she were really holding a glass the way her hand is shown, she'd get a cramp.

Then I go into the ice cubes, how ice crystallizes in crisscross strokes, and these have been exaggerated by the commercial artist into skulls and crossbones in a way that is not discernible to the eye but can be read by the subconscious. Then there is the way the male hand is holding the bottle—it suggests a subliminal ejaculation. The model was probably carefully chosen from among hundreds because his wrist hairs curl in the manner of pubic hair. The consumer, unaware of any of this symbolism, is irresistibly drawn to the photograph and the product.

"Where'd you hear all that?" Andy asks.

He knows perfectly well what I'm talking about from his own days in the advertising world. I bet he was a master of the subliminal touch.

"And death," I go on. "For some people the pull of death is as irresistible as sex, especially people who buy cigarettes and alcohol. Of course, the death symbols are hidden. But you're upfront with your death symbols, your electric chair. Does the public know what you're up to, or will you tell them?"

"You're getting too smart."

"What fascinates you about capital punishment?"

Andy doesn't answer. I point to the leather straps that float on the left side of the chair. "Do you see any symbol in that strap?"

"I'm not big for that stuff."

"It's an S-and-M attachment."

"Gee, you're right."

"Do you suppose other countries use the electric chair?"

"I don't know."

I figure that only an advanced country can afford it because it requires so much electricity, massive amounts that dim the lights throughout the prison at the moment of execution so that inmates roar and growl and shake their metal gates. It amazes me that a country as liberal as the United States allows itself to take on the burden of capital punishment. "How do you feel about it?" I ask Andy.

I get the usual shrug. "And you?" he asks.

"I guess I'm for it as an abstract sanction, but I'm against it on a one-by-one basis."

While we are talking we are moving through the studio.

"Here's some more of your fascination with death." I point to the big silk screen of an atomic mushroom. "This one is obviously about sex too."

The global idiot: "Sex?"

"Come on; your mushroom looks just like a penis in eruption."

Andy: "Gee."

"Is that why you selected the subject?"

"Ultra, you x-ray everything."

"You know, you're the first to take subliminal advertising and Pop it up into fine art. You know you're doing that, don't you?"

We come to one of his Marilyn Monroe portraits. I say, "She was so beautiful and sexy, yet as vulnerable as a child. Gossip says she was having an affair with John F. Kennedy. Do you think it's true?"

"Sure."

"When did you first paint her?"

"The day after she died. I ordered a silk screen made from her photograph when I heard about her death on the radio."

"You didn't waste any time."

"Timing is all."

"You mean timing is art."

He's right. Her death was in the news. It was on people's minds. It was commercial. The moment she was dead was the time to immortalize her.

Ingrid joins us as Andy picks up a small silk screen of Marilyn, about forty by forty inches. Then he looks among the paint cans and chooses a fairly dark green. "Do you like that for the background?" he asks.

"It's too dark," I say.

Ingrid disagrees. She says, "It should be dark."

"No," I say, "it should be more tender, the way Marilyn was, a kind of Veronese green."

Andy peers into other cans of color and comes up with a green just a little lighter than the one he originally chose. I add, "Yes, that's a good color, especially with the blondness of her hair and the pink of her skin. It's like the color of one of those sweet Italian cassatas. It's delicious, like she was."

He applies it with a roller to the entire background and then with a small brush to her eyelids. He backs up and says,"Yes, that's right." Then he turns to me and intones, in a singsong voice, "You know what, Ultra is a violet, is a violet, is a violet."

We keep moving through the studio, and soon he pulls out a huge, menacing painting, *Red Race Riot*. It consists of repetitious images, some the same, some different, all violent. Policemen with attack dogs are battling blacks. The repetition produces an action painting. My eyes move quickly to grab each frame. I feel myself becoming the action, getting involved. But what is he saying? Is he making a statement about blacks? About the police? About violence?

"Do you care about blacks and their problems?" I ask.

Bored with this conversation, Ingrid drifts off.

"It's from a photograph that was on the front page." He is so noncommittal, so amoral, he does not take sides. To me, he has delivered an apocalyptic message of the times. To him, it is only a masturbatory gesture.

We come to *Ambulance Disaster*, a picture painful to look at.

"Rauschenberg has that one."

". . . the match case, *Close Cover Before Striking, Pepsi-Cola*. That's a gorgeous painting. I think it's a masterpiece of commercial art."

"Well, thanks, Ultra."

"Were those paintings painted by hand?" I mean with paint and brush rather than with a roller.

"Half and half."

"Did you use ready-made letters?"

"Sure we did."

"Who's we?"

"Helpers."

A few days later, in my neighborhood supermarket on Eighty-eighth Street, I see a woman stacking her cart with Campbell soup cans. I watch her pile up several dozen cans. I wonder if she runs a boardinghouse. I ask her why she's buying so many. Without an instant's hesitation, she says, "They are works of art."

"How do you mean?"

"Andy Warhol copied them. I display them on my shelves, next to my books."

I am stunned. The next day I take Andy a whole shopping bag of soup cans and ask him to autograph them. He is delighted when I tell him about the woman in the market. Unfortunately, over the next few weeks some visiting friends eat the soup. I should have saved the empty signed cans. I could retire on them.

"Duchamp used a lot of words in his paintings. His *Mona Lisa* has the letters 'L.H.O.O.Q.' Do you know what that means?"

"Something about fucking."

I go on: "The letters sound like '*Elle a chaud au cul.*' In English that means 'She has a hot ass.' All the viewer has to do is read your paintings."

"Yep; if you want to know all about my paintings, just look at the surface. There's nothing behind."

I have just read an article by the critic Clement Greenberg about the flat painting technique used in Pop as opposed to the highly visible, active brush strokes of the Abstract Expressionists. "What's so important about flat painting?" I ask.

Andy just stares.

"And why do you put words in paintings? Is it to create visual noise?"

He stares some more.

"I bet you think visual noise will make real noise and get you the attention of the press."

"Oh, Ultra."

I am reminded of a story about Dali. I tell Andy that when Dali got to this country, one of the first objects he made was a chocolate cup and saucer, a piece of edible art. It was displayed in the window of a Fifth Avenue store. Dali didn't like the way it was shown. It was supposed to be suspended in the air. But there on Fifth Avenue, for all to see, it just sat on a table. Dali complained to the window display people. They refused to make a change, and on a Saturday at noon, with crowds of people on the avenue, Dali hurled a large rock through the window. Of course, he stopped traffic. He was arrested. The next day there was a huge headline: MAD SPANISH ARTIST, WITH POINTED MUSTACHES, SMASHES FIFTH AVENUE WINDOW. From that day on, his fame in the U.S. was assured.

As usual, Andy is mesmerized by my story. "Oh, how great," he says.

"You put words on a Dick Tracy cartoon, on Popeye—"

Earlier that day, in our tour of his studio, we'd stopped in front of a photograph of his *32 Soup Cans*, made of thirty-two panels, each twenty by sixteen inches, each depicting a different soup: Vegetable Bean, Chicken Vegetable, Turkey Noodle, Cream of Chicken, Clam Chowder, Beef Broth, Bouillon, Cream of Mushroom, Split Pea with Onion, Minestrone, Chili Beef, Black Bean, Green Pea . . . I'd felt compelled to read the names of all thirty-two varieties. "You just paint what's in front of you at mealtime," I'd said.

Now, at the lunch counter, Andy says, "I like this food. I eat it. I paint it."

"Chagall does the opposite," I say. "He makes cows and roosters dance in the sky to the sound of his green violin. He kisses his beloved and waltzes with her above the rooftops. Do you know that when Chagall was head of the art school in Vitebsk, he enrolled all the town's housepainters, their children, and their wives?"

"That's a good idea. People who paint houses should be paid more than artists because it's more work."

"People say you were once a housepainter because you use a roller."

"Barnett Newman paints walls with a stripe on them and gets away with it."

"Gets away with what?"

"He paints a wall in one color with a black line and sells it for forty thousand dollars."

So much for trying to discuss higher values with Andy.

I review in my mind's eye the actual paintings of the meal placed before Andy, and I come up with a surprising discovery. All four paintings contain words, the brand names of the products, so they have quadruple impact on viewers—visible, audible, edible, and readable. "You really pound it in," I say.

Andy is silent for a while. Then he says, "John Cage uses graffiti sounds in his pieces and Merce Cunningham uses everyday noise in his dances."

It shows a white ambulance that has just crashed into a car. A body has been ejected through a window. Even though the body is half covered, it hurts one's sense of being to look at it. There are two versions of the picture in juxtaposition, one above, one below. The crash is doubled, magnified. An ambulance crashing twice as it transports a victim is Popped up into dramatic fury.

Why does Andy pick these subjects? Because he understands the shock value of death and its subliminal message. But being Warhol, he takes it all one step further. Aware that his art is advertising, he goes on to create subliminal art. He deliberately takes the objects that people are fascinated by and turns them into art.

That evening we stop at a coffee shop on the way to the Cinematheque, the loft in SoHo where his films are shown. We sit at the counter on high chrome stools covered with green vinyl. I study the menu for something that will fit my fanatical standards about organic and unprocessed foods. Andy doesn't bother to wait for me to make a choice. While I am still reading, he orders Coke, cream of chicken soup, peaches in syrup, and coffee. By the time I give my order, his food is already in front of him and he has started to eat.

"That waitress has no sense of etiquette," I say, not wanting to direct the rebuke to him.

"What do you mean?"

I glance from the empty space in front of me to the food before him.

"I know all about etiquette," he says huffily. "I illustrated Amy Vanderbilt's *Complete Book of Etiquette*."

Then he notices that I am staring hypnotically at his food. "Something wrong?"

"Look at what you have in front of you—four of your paintings."

There, neatly arranged on the plastic counter, are Andy Warhol's *Coke Bottle*, 1962; *Campbell's Soup*, 1962; *Del Monte Peach Halves*, 1962; and *Martinson's Coffee*, 1962.

"Hmmm," he says. "Is that why they taste so good?"

A wave of energetic idealism sweeps the nation at the outset of the turbulent 1960s, as the torch is passed to the new, young president, who exhorts us at his inaugural: "So let us begin anew." The words are new; they seize us, thrill us.

In not much more than a blink of an eye, we go from racism to civil riot, from gin and whiskey to marijuana, speed, and heroin; from Eisenhower, the father president, to not trusting anyone over thirty; from no more war to slaughter in Vietnam; from saluting the flag to burning it; from culture to subculture; from acoustic to electric; from marriage to open sex; from straight to gay; from the underground to the moon, where we walk with pride. Even the Catholic Church abolishes centuries of tradition and translates the mass into English.

Martin Luther King articulates the dream of a beleaguered black population. The South erupts in protest and counterprotest, urban ghettos burn, campuses explode, women find their

voices. Change breaks out on every front—sex, race, music, youth, religion, politics, dress, art.

Rock music and folk songs hasten the rhythm of change. Joan Baez and Bob Dylan popularize the song of protest. The Beatles ensnare the whole nation. The age of Aquarius dawns, to peak at the end of the decade, in 1969, when 400,000 young people in jeans, feathers, beads, flowers gather for three days of rock, blues, dance, alcohol, pot, protest, nudity, and love.

Alone and far from home, hippie kids vibrate to the new music on the sidewalks and park benches of New York's East Village, where the sound of Warhol's rock group, the Velvet Underground, bellows out of the Dom, his unholy multimedia cathedral of rock music, psychedelic lights, and hallucinating drugs.

The Velvet Underground plays so loud you never hear the music. Andy first ran into them at a downtown club. He offers the standard invitation: "Why don't you come by tomorrow?" They show up at the Factory, more spaced out than anyone in our crowd. They're all thin, dressed in black, and they look as if their only food is amphetamine wafers.

Andy signs them for a week at the Cinematheque, to play while Andy's films are being shown. It's like the old days at the silent pictures. Some of our pictures are silent and on some the sound is so poor that anything that covers it is an improvement. When you come out of the movie house, your head echoes for days and you have trouble hearing anything but an ambulance. The Velvet has already played backup and made tapes for other filmmakers. But Andy blows up the idea bigger, better, and louder by having the musicians play live on stage while the movie is being shown.

The Velvet, with its name changed to the Plastic Inevitable Plus Nico, opens in April 1966 at the Dom on St. Mark's Place, which Andy is running as a club, screening room, and hot spot. John Cale composes songs and plays the electric viola. He has had classical training and is very innovative. Lou Reed is the guitarist and songwriter. Mo, short for Maureen, is a girl drummer, a first at that time. She has a look of total innocence.

Nico, the singer, has a unisex, atonal voice. She looks like a girl, with long blond hair, a well-designed, pretty mouth, high cheekbones, long lashes, and pale, luminescent makeup. But when she sings, it's hard to be sure of her sex. You're not even sure if she's singing, so little life comes out of her mouth. Still as a statue, she repeats in a low, low register, in a strong German accent, words you cannot comprehend because of the loudness of the band.

When you go to the Dom on St. Mark's Place in the Village, you step into a magical cave. Long lines of limousines form outside. If you don't have a limo, you may as well skip it. *Everybody* mixes together: art people, society people, film people, drag queens, druggies, voyeurs, tourists, rock freaks, kids, kids, kids— a potpourri, which in French means rotten pot.

The decibels are so deafening that talking is out of the question. That's why Andy loves it so much. On the stage, we project our movies through various colored gelatins to make the image all blue or all red. Andy has trouble telling the gels apart. Sometimes Gerard Malanga does his provocative improvised sadomasochistic whip dance. He is so clumsy I am embarrassed. Mary Woronov, a great-looking, tall woman, jumps onstage, jiggles, stares menacingly, shows her teeth. The kids scream on and on. The music overrides the screams, so the kids scream still louder and louder.

Andy and I watch the whole scene from the balcony. Ingrid Superstar and Eric jump onstage to dance. The sound of the whip cracking on someone's back is amplified with a mike; so is the stomping of black leather boots, and the rattling of chains to the rhythm of drums and tambourines. To add to the vision of hell, strobe lights, the first in town, assault your sight, making you blink eighty times in thirty seconds. Swirling patterns of dots and stars carry you away to a phantasmagorical landscape.

Ondine, the Queen of Drugs, and Brigid, the Duchess, patrol the crowd and shoot up anyone who offers a hip or an arm. There's a choice of amphetamine, LSD, acid, home-made speed, Methedrine, Obetrol, Desoxyn, heroin, and Placidyl. Desoxyn is the

most expensive. Drug addicts in a hurry get poked right through their pants or jeans. It takes someone with a good technique to be able to shoot through jeans. The stabbing of the needle has to be assertive, no halfway poking. Ondine's hand has a tendency to shake, but practice makes perfect. One time, Ondine punctures an artery, and his jetting blood hits a light, projecting gore onto the screen. The kids love it.

Life was cheap in the sixties, as it always is in time of war, whether Vietnam or the Drug Holocaust. Uncle Sam ships off his sons to Deathland to be blown asunder by grenades; in clumsy brotherhood in the motherland, the kids left behind blow their minds asunder.

But it's not for me. I remember my terrible experience with LSD two years earlier. In the hotel suite of European friends in New York, someone slipped LSD in a goblet of red wine the hostess was passing around. Though I took only a sip, the acid exploded in my head, bringing on such screaming hallucinations that I was taken to Lenox Hill Hospital, medicated, and kept in the emergency room for several hours. Violent disorientation and distortion of vision continued for nearly two days. I decided once again that my body was unusually sensitive to drugs.

The revolution we are living is visible in the clothes of the Dom's patrons. Some are more undressed than dressed. A guy in thigh boots sweeps the floor with his long coat. He looks like a Nazi. Andy tells me, "He's just wearing a G-string under the coat." Two girls go by. One wears a huge antique hat heaped with feathers, an Edwardian blouse laced to her neck, a full skirt to the floor, gloves covering every inch of her arm. The other, in a striped mini, has a tiny star covering each nipple. The designer Rudi Gernreich comes to the Dom, watches the teenagers, then the next summer produces the completely topless bathing suit. Other designers bare the other end.

The Velvet Underground is doing with music what Andy is doing with images. They repeat and repeat and repeat the same word or phrase until someone screams out, "Shut up!" Lou records a song, "Do the Ostrich." Those are the entire lyrics. He

screams the words over and over until the director of the recording session makes him stop.

Minimal music echoes minimal art.

The early reviews put down the Velvet. Critics call them antisocial, vicious. Their sound is raucous, harsh, coarse, raw, like the grinding of stones. "They are too far out for most people," Andy says, "but they're fabulous." Andy, as usual, is right, because their style is the precursor of what later is called punk and heavy metal, and for years to come the Rolling Stones, the Beatles, David Byrne and the Talking Heads, and many lesser groups will be influenced by the Velvet Underground.

The Velvet is the first group to do feedback—tape the music while it's played, then play against their own tape. It's exciting for the musicians and cranium-splitting for the audience. Sometimes we run one film on top of another so there is more to watch and two sets of images to further excite the brain.

At the Dom, Andy and I and some of the others have a marvelous time playing with the lights. When you hold a spotlight in your hand, you're part of the show. You're rocking with the music. We are hypnotized by the lights; the musicians do the same with their music. Cameras are flashing, the movie is going, sometimes piggybacked, one on top of another, the sound is blasting, the lights are pulsating. If your mind hasn't already blown, it certainly will soon.

The amazing thing is that while Andy doesn't seem to be doing much more than hanging out, somehow he assembles all these people, figures out what they should be doing, pushes them to perform beyond their normal ability, devises new ways to augment the sound, intensify the visual impact, and heighten the frenzy.

Lou Reed says, "Andy works all the time. He seems to just stand around while others work, but he's the mastermind behind all of us."

I am fascinated by Nico. I see her as Andy incarnated into a singer. She is as lifeless as he is, although I once saw her shed slow tears while singing at the Dom. I traveled with her to San

Francisco for the filming of segments of *I a Man*, in which we both played ourselves. Although we shared the same room, I never had a conversation with her. She has a darling four-year-old son, Ari, who is having the best time of us all. When she and Andy first meet, neither knows what to say. They just stand there and feel each other's vibes.

A conversation between them goes like this:

Nico: "Hi, Andy."

Andy: "Oh, hi."

Silence. After a while, Nico: "Andy."

Andy: "Hmmm."

Nico: "I . . ." Silence.

Andy: "What?"

Nico: "I . . . thought . . ." Silence.

Andy: "What?"

Nico: ". . . thought you . . ."

All the while, Andy is flipping through the pages of the current *Time* magazine.

Andy: "What were you saying, Nico?"

Nico: "Nothing."

What Nico is trying to tell Andy and eventually does tell him the next day is that she would like him to design the cover for the album she is doing for Elektra Records. He never does, but sometime later he autographs a color Polaroid he took of me with an apple stuck in my mouth, which illustrates the cover of the album I make for Capitol Records.

Nico is the girl on whom Andy silk-screens the word FRAGILE in a window happening at the Abraham and Straus department store in Brooklyn. It's a promotion to sell a two-dollar paper dress with a do-it-yourself paint kit. It turns out to be a do-it-yourself promotion for Andy.

A hundred spectators gather inside the store and outside. Gerard, dressed in baggy leather pants, holds a metal frame that contains the silk screen, while Andy pours reddish-purple paint through it. The crowd giggles. Little Ari sprays spinach-green paint on his mother's stockings. Nico reclines on a platform as

the word FRAGILE is printed repetitiously on the front of her dress from the hip down. On the loudspeaker, Nico's monotonous voice is barely audible against the amplified guitars and male voices. She's singing "All Tomorrow's Parties." A matronly woman in the crowd scratches at her ear in a vain effort to clear up the sound.

Andy grimaces with pain when a microphone is placed in front of him and he is required to speak. Faintly he says, "Nico is the first psychedelic singer with the Velvet Underground. They do two hours of songs with only buzzing from a burglar alarm in between." The spectators look baffled. The matronly woman scratches her ear again. Shyly Andy takes out of the pocket of his leather jacket some larger-than-life stick-on paper bananas and pastes them on Nico's dress.

A thin woman calls out, "I thought he was going to paint something by hand. That's what I came for."

A store employee takes the mike: "It's to show you how you can do it yourself. The dress Mr. Warhol has just executed will be donated to the Brooklyn Museum of Art."

The crowd looks disappointed. Two-dollar paper dresses are not about to sweep the world, but Andy does take one home to his mother.

The Velvet Underground has a moment of peculiar triumph when it plays at the Delmonico Hotel for the annual dinner of the New York Society for Clinical Psychiatry. Dr. Robert Campbell, chairman of the dinner and director of the psychiatric unit at St. Vincent's Hospital, has invited Andy and the Underground to give some shock treatment to the 175 well-dressed shrinks and their perfumed, carefully coiffed wives. Over roast beef, the doctors are bombarded by the decibels of three fire engines and blinded by stun-gun lights. Gerard does his whip dance. Edie shakes her butt. Four Freudians and one Jungian walk out, needing first aid for their eyes and ears. One Fifth Avenue practitioner regurgitates his roast beef, and several analysts are heard making appointments with each other for the next day.

The movie is the logical development of Andy's art.

The canvas, the silk screen, the photograph are not enough for him. They provide a static image: They do not move. He wants more. He wants to see the image explode into action. He begins with very simple one-reel movies in black and white. He moves on to three reels, later to color, sound, longer films. The movies are always experimental and often innovative. They look for juxtapositions. The early movies have no plots, very little story. There is no editing—the action takes place in real time. A fifteen-minute movie takes fifteen minutes to make and to play to the audience. Most are spontaneous. The actors make up their own dialogue in catch-as-catch-can takes of daily life.

The actors are people around the Factory, kids who drop in, underground actors, preferably nonstop talkers, amphetamine heads who can't shut up. Anyone who appears in a movie is automatically a Star. Make two movies and you are a Superstar.

No one on earth can resist starring in a movie. Andy uses

this bait to haul in the fish. He meets a pretty girl and says, "You're so beautiful—would you like to be in a movie?" He meets a pretty boy and says, "You look great—would you like to be in a movie?" He meets a rich society matron and shrewdly changes pitch: "We need a fabulous apartment for our next movie—could we use your place?" They all, or very nearly all, say yes.

All through the sixties, his circle enlarges; the Factory becomes a magnet, attracting more and more people. The more movies he makes, the more money he needs, the greater the frenzy and excitement. The loft is jumping. The Stars and Superstars are jumping. The whole world wants to explode with us. It is a fabulous, mind-bending time.

I am at the center of it, flying in and out of Andy's world and my other worlds. I spend time with Dali, see Mr. XYZ, go to cocktail parties and charity balls with my European friends, travel back and forth to Europe, and design my ultra violet wardrobe. I live every day to the hilt and beyond, stimulated, euphoric, on my steadily mounting natural high.

I try to figure out what makes Andy so attractive to me, to all of us, for we are drawn to him in an almost supernatural way. Part of his appeal is his uncanny ability to concentrate on you and convey the feeling that at that particular moment you are the only person in the entire universe. When he speaks to me, he makes me feel I am the one and only person he takes advice from, the only one who has the answers to his questions, the only one he wants to be with. Even after I become aware that he treats dozens, maybe hundreds, of people with that same compelling immediacy, I still feel its power.

Another part of his appeal derives from his enigmatic quality. He is enigmatic to the point of making me wonder sometimes if he is alive or dead, if he is really a fellow earthling or a weird creature from outer space, if he is a fool or a genius. He acts like an idiot when he says repetitiously, "I don't know what to do; everything is so hard." Yet he is clearly in charge of a complex, many-sided operation dealing in art, music, movies, and hype,

and he is able to command without pay the loyalty and services of scores of talented, creative, if sometimes crazed, people.

Finally there is his art itself and his place in art history. Art is my form of worship at this point in my life. Andy's art is a far cry from that of both the old and the modern masters—the Raphaels and the Légers—yet it has its own special beauty and power. With his silk screens, his multiples, his grocery shelf subjects, his crayon box colors, his deliberately flat surfaces, his insistence on taking the mystery out of art, he is creating a new aesthetic. And I am, we are, right here in his atelier as he shakes up established values in the visual arts.

I am thrilled to be part of that show. I feel wonderfully liberated among the iconoclasts around him, for we are all equal—there are no saints, no sinners among us, no one is making judgments. We are free to be our worst selves or our best selves. And if that weren't joy enough, *we are in the movies*!

Ironically, the early movies are stupefyingly static. *Empire State Building* shows the Empire State Building, with the camera substituting for the artist's brush strokes. It is not a tour through the building or a history of its construction. It is a picture postcard of the building transferred to the screen. *Kiss* is a kiss. *Taylor Mead's Ass* is precisely that. There's not much more action in *Vinyl, Apple, Nude Restaurant.*

We screen *Sleep*, made the week before—fifteen minutes, black and white, eight millimeter. The sleeper sleeps. That's all. The only sign of life is a pressure point at the throat, which pulsates. Otherwise this could be a film about death. Is not death an extended sleep? The movie is a sleep inducer. Eric and Ondine fall asleep, and so do I. Of course, we are all short of sleep. Ondine is going on his sixth day without sleep. Before I fall asleep I look at Andy. It's hard to tell whether he is asleep behind his dark glasses. He is always in a state of limbo—always between reality and dream.

The press calls the movie "a real sleeper." We all agree. Our movies are better slept through than talked about. It is a much bigger event for me in 1966 when a movie, or part of one, is shot

110

in my apartment. We are making a movie to be called 24 *Hours*, which will last for twenty-four hours on the screen. This one, at least, will have some action. Parts of it are being shot in various locales. Right now we are lounging around the Factory, deciding where to shoot next.

Andy is talking on the pay phone. He says, "Fame is when you market your aura." I have heard him say this before. Most of us are sucking on gum. Andy is sucking a magnet. How do I know? I offer him some gum, and he says, "Wait a minute," and spits out a tiny piece of dark gray metal.

"What's that?" I want to know.

"A magnet."

I don't question him any further. I figure it's to augment his magnetism.

Paul Morrissey decides to shoot that night at my apartment. I am living at the moment at 860 United Nations Plaza, the tall, handsome, just completed building on the East River north of the United Nations, which houses many well-known tenants.

"Your building is fabulous," Andy says. He is referring to the celebrities. That's what interests him.

"Bobby Kennedy just gave me a lift," I say. Andy has to know all about it. I tell him that I was waiting for a taxi under the canopy over the circular driveway. It's often a long wait. Kennedy was waiting for his car. He asked, "May I drop you somewhere?"

I noticed his wide, blue, unevenly set eyes, recessed in his overtanned face, his mechanical-looking teeth, the deep pores on his nose, very clean pores. I accepted his offer. He sat in front with his driver. I sat in back, alone. He asked, "Are you visiting?"

"No, I live here."

"I haven't seen you before."

"I just moved in. We're doing a movie tonight in my apartment. Would you like to come and be in it? Anyone can be in it." I thought how pleased Andy would be if I could round up Bobby Kennedy for the cast.

He gave me a masculine half smile. When he dropped me at "21," I handed him my card and said, "Remember the movie."

"Will he be in the movie?" Andy demands. "Gee, that would be great."

"Maybe, but I doubt it."

I go home to get ready.

At midnight the doorman calls on the house phone.

"There's a group of people here. They say they know you." I detect disdain in his voice.

"I know them. It's OK."

A few minutes later, my doorbell rings. Andrea Wips, a cute blond groupie, comes in, her Lolita breasts clearly visible through her transparent dress. Chuck Wein, an underground movie-maker, wearing a greasy black leather cap, carries bags of lighting equipment: lights, a boom, electrical cords. With his immaculate, white-cotton-gloved fingers, the elevator man picks up the tattered end of an extension cord.

Edie, so high she floats several inches above the thick carpeting of the corridor, wafts in. Paul has on dirty sneakers. Andy, wearing his dark glasses in the middle of the night, looks more like a phantom of the movies than a real person. In fact, he startled one of the white-gloved hall attendants, who thought for a moment he was seeing a ghost.

"Oh, this is great," Andy croons.

The building is so new, my walls and doors have not yet been painted. The doors are still marked in large letters, "Front door," "Hinges on the left." The walls have streaks of concrete sticking through the plaster. Andy mutters, "Fabulous."

There is no furniture except for a bed and a huge foam-rubber cutout by sculptor John Chamberlain, which can be a floating raft, a platform, a love-in, whatever you want.

Andy turns to me and says, "Ultra, you have to get undressed."

I am startled. We have not discussed my wardrobe. Or lack of wardrobe. I am torn. I am supposed to be the wild, daring, uninhibited Ultra, who does anything, *anything*. I enjoy the tease

of my see-through dresses. But I am not comfortable undressing down to the skin in front of this crowd and in front of a camera, which will show my nakedness to the whole world. Is it the way I was raised? Is it original sin? Is it the eyes of the beholders? Yes, I think, that's it. It's all the dirty eyes converging on my pubic hairs. If the eyes are clean, it is different. Conflicted by my bashfulness and my desire to shock the bourgeoisie, I snap at Andy, "You are using me."

He snaps back, "No, you're using me."

There's no point in continuing this discussion. The cinema must go on. I look in my bathroom for large Band-Aids to tape over my nipples. Of course, I don't have any. I call down to the doorman and ask if he has any tape. He says, "Yes, but it's locked in the office." Tomorrow won't do. I think of using gaffer tape, the tough silver tape the sound men use on their equipment, but I'm afraid it may pull the whole nipple off when I remove it.

Meantime, International Velvet has arrived and is rolling around on the Chamberlain couch, getting higher and higher. The camera is rolling too. I'm glad they've started without me. The movie has no plot or story. It is just the present, our present, whatever we are doing. It is a slice of time, or slice of flesh. Later, this segment will be pieced with other segments to form the complete twenty-four hours.

I must say it is not inhibiting to work with Andy in a film, for you never know if you're on or off. You never know whether the camera is rolling or stopped. The prevailing attitude is: Come on, loosen up, don't be chicken. I finally take off my clothes and sit on the couch, showing my back, not my front. I am angry at myself for being embarrassed, and I'm angry at Andy for putting me on the spot. The one thing it never crosses my mind to do is to show the whole scurvy crew to the door. That is unthinkable. Monstrous as they are, they are now my family, my life.

The doorbell rings. Andy comes alive. "I hope it's Bobby Kennedy." I hope it's not. I put on a robe to answer the door. It's John Chamberlain, dead, roaring drunk.

A moment later, the doorman calls up. Andy says, "This time

it's Bobby." The doorman is apologetic, but a tenant has complained about the noise. I turn off the blasting radio. Chamberlain passes out on his floating raft. The movie ends when the film runs out.

When we are invited to the screening of the twenty-four-hour movie that takes twenty-four hours to view, we all go to catch up on our sleep.

In the spring of 1968, the Factory people go wild with excitement. We learn that some of us are to appear in the film *Midnight Cowboy*, starring Dustin Hoffman, Jon Voight, and Brenda Vaccaro. Now at last we're in the big time. It makes perfect sense to us that we should be cast in important roles—haven't Rossellini and dozens of other European directors taken people from the streets, peasants, fishermen, complete unknowns, given them lead roles in major films, and catapulted them to fame? Here is the break we have all been waiting for—out from the underground into real money and real stardom.

Our first disillusionment comes when we learn we're not to appear in the main film with the Hollywood luminaries but in a film within the film, a black-and-white, eight-millimeter underground movie that is shown at a dissolute party scene in a downtown loft. We are bitter at first. Don't they trust us? Don't they think we have enough talent to appear with the Hollywood people? Eventually we calm down. We'll be playing ourselves, and we'll get a chance to show a very wide audience how talented, how remarkable we are.

In *Midnight Cowboy*, Viva is cast as Gretel, Taylor Mead as Peter Pan, Amanda Tree and Paul Jabarra as party guests, and I am a Superstar. When we report for the first day's shooting, on June 28, 1968, at the Filmways Studio in East Harlem in Manhattan, Andy is not with us. He is in intensive care at Columbus Hospital after the attempt on his life by the crazed Valerie Solanas. Jed Johnson, a sweet, naive boy who has recently become Andy's roommate, brings us daily reports of Andy's progress. Jed has curly hair, baby skin, blue eyes, an innocent look, a childlike

voice. He seems pure and clean. He is devoted to Andy, and they stay together for ten years. He is the keeper of dogs and in charge of the filmmaking. Much of the joy has gone out of our Hollywood debut, but we must carry on, for ourselves and for Andy.

Our part of the shooting lasts two weeks. Hollywood logic requires that I wear a blond wig. Things turn out a little better than we hoped, for Viva and I actually do appear in a scene with Voight and Hoffman, when the corrupted Joe Buck (Voight) takes the innocent Ratso (Hoffman) to the loft party. I contrast John Schlesinger's firm-handed direction with the disorder of our filmmaking.

One scene is shot in my Pop bedroom, where the bed is decorated with a giant American flag and the wall is hung with a Roy Lichtenstein felt banner depicting a huge revolver aimed point-blank at the observer. I bought the Lichtenstein for a song from John Chamberlain at a time before the Pop artists entered the museums and escalated their prices.

At the end of the shooting we all wind up at Elaine's on Second Avenue and Eighty-eighth Street. Elaine, all two hundred plus pounds of her, does her own x-ray search of each arriving customer, turns away the nobodies, sends the minor somebodies to the less desirable tables and the headliners to the privileged sections. The meals at Elaine's are what we call "fairy portions"—small and overpriced. Nobody goes there for the food. We go to see and be seen.

It is at Elaine's that Andy promises me, "You'll be the star of *I a Man*."

"Am I to play the man?"

"No, Tom Baker plays the man."

The movie is to be shot in California. Nico, Paul Morrissey, Andy, and I fly to San Francisco, where Tom meets us. I am filled with excitement. Stardom at last! But my hopes are dashed when I realize I am not the lead. I am one of seven girls flirting with Tom. As usual, there is no script.

"What do I do?" I ask Andy.

"Nothing," he replies. "Just blow hot air on Tom's feet."

That's my big role—as one eighth of a stinker.

One day in 1967, our visitor at the Factory—which is now located at 33 Union Square West, in a large loft with a rear screening room, a mirrored front office and a no-nonsense, high-tech atmosphere—is Mario de Vicchi, a film distributor and self-proclaimed coproducer with Fellini of *La Dolce Vita*. Mario tells us he and Fellini took their first acid trip together in 1961. Whenever Fellini comes to New York, good friend Mario searches frantically for Felliniesque characters for a circus-type party, pretending these monsters, whom I help him recruit, are his closest and dearest friends.

When he calls, he says to me, "Ultra, do you know anyone so fat you can't see his eyes? Any encephalitic dwarfs? Bald hermaphrodites? Hunchback white Negroes? Bilingual lepers?" I describe bizarre types I run across in my night travels. Mario tracks them down.

This collector of untyped casts tells Andy how much he admires his films. "What are you doing now?" he asks.

"Looking for money," Andy says.

"That's no problem."

Andy's face brightens. For our visitor, Jed Johnson screens a scene from *Lonesome Cowboy*. In it, Viva, half naked, is abandoned by her cowboy friends after being raped. She is on the ground, cursing, her legs spread apart, her crotch exposed.

"Great," says Mario. "I want exclusive rights to distribute that film."

A year later, Mario introduces Andy to Alberto Grimaldi, an Italian producer. Grimaldi arranges to distribute *Trash* and *Eat* in Italy and brings together Andy and Carlo Ponti, Sophia Loren's husband. Ponti is instrumental in getting the money for Andy to make *Flesh*, starring Joe Dallesandro and a baby. Wouldn't you know—the naked baby steals the show.

HIGH LIVING

If I left France to see the world, I am succeeding. I live my life among headliners. By 1964 I live it with elegance in my room at the St. Regis Hotel, to be closer day and night to the surreal master who is my obsession, and I have at my disposal a Lincoln Continental with a violet stripe on each side below the windows and my logo, an interlocking UV, on the doors. A small sketch of me by Dali decorates the ceiling behind the driver's head. The car is another gift from my still adoring Mr. XYZ, the generous donor of the apartment building I own.

I have an arrangement with an unpaid driver named Joe. He is on call when I need him, but when I am away, at home, or busy for several hours—spending the day at the Factory or going to the theater—he hires out the car and his services. At the beginning, Joe and I are both happy with this system.

But I become more and more dependent on the car. It picks me up at five in the morning when I come out of Le Club, takes

me to breakfast at the Brasserie. I leave there at six-thirty to stop by the flower market to buy fresh flowers for the day. The car takes me home and goes to pick up my laundry while I bathe and get ready for a 10 A.M. drive to the gym before going to the Factory. Later, I am driven to a rendezvous with Mr. XYZ, on to dinner with Andy, a party with someone else, back to Le Club. Chauffeuring me becomes a twenty-four-hour job for the driver, who takes catnaps between my appointments and has no time to drum up other business.

No wonder then that one morning my car is not in front of my hotel. I phone Joe and say, "I need my car at once. I'm going to a Merce Cunningham rehearsal."

"OK," he says, but no car appears. After three days of phoning and no sign of Joe, I take a taxi to Spanish Harlem to look for my car. I spot it two blocks from Joe's door. I guess he isn't getting enough sleep. I'm too selfish at this point to be concerned that he's not making a living. I use my duplicate key to get into the car and drive downtown.

I find another driver, same arrangement. The car becomes my ambulant living room. I even make love in it, despite the lack of a partition, window curtains, and tinted glass. The folklore at the time is that immediately after you make love you are resplendent, oozing eroticism from every pore. The trick is to make love on the way to a party so that the semen in you is still fresh. The logistics of the situation requires sex at great speed. One partner looks out the window, smiling beatifically at passersby as the driver zooms through amber lights to avoid at all costs a standstill of any kind. During one unavoidable stop, I find myself smiling at a well-known art dealer I have just done business with. He approaches the car to greet me. I crank down the window one inch, throw my fur coat over my partner, and yell, "Don't come closer—you'll catch my measles."

Andy and I go to the ballet with Louis Martin, a socialite and sometime impresario, who knows many show business people. He takes us backstage to meet Rudolf Nureyev, and we all go

out to supper. I am mesmerized by Nureyev, thrilled to be near him, he is so beautiful, so Russian. I run into him again a few days later at a party given by Monique Van Vooren, the actress and singer, who is in love with Nureyev. After about our fourth meeting, Nureyev dances into my orbit. He is magic, magic, anytime, anyplace. In bed he is a star. I love to touch his skin. I like to go to his dressing room and see him half naked. He is made of one piece of solid magic.

The members of the ballet troupe live by a strict discipline. Every day they rehearse from one to four in the afternoon, rest from four to seven, then get ready for the curtain at eight. They are as ascetic as monks.

Meanwhile, Rudy, superstar, superman, rehearses like a man, fucks like a beast, and dances like an angel. I tell him, "You Russian peasant, how can you make love before a performance? What gives you the strength? Is it the borscht? The yogurt? The vodka?"

"No, darling—my well-shaped balls, full of sperm!"

After a performance we go to El Morocco. Rudy asks me to dance. I adore being in his arms in a roomful of glittering people. But I am full of terror. Suppose I step on one of his multimillion-dollar toes? He is oblivious of my concern. He holds me with such power, yet such lightness, that there is no danger of mis-stepping.

He is never in love with me; I am never in love with him. We are both in love with pleasure. We are a perfect fit. At the end of the season, when he leaves New York, it is over. Meeting again, we do the noncommittal two-cheek kiss and turn away.

One day, Andy and I meet Yoko Ono and John Lennon at Phebe's Place, a restaurant on the Bowery. Andy is hoping to design a cover for John's new album. Yoko wears black pants, a black top, and a large belt of ammunition. I am shocked by the ammo belt and wonder what she can be advertising or promoting. Why else would this outspoken advocate of peace—"Make

love, not war"—carry bullets around her waist? But we are in a time of such explosion and confusion that white becomes black, yes means no, and bullets speak peace. Maybe she would argue that the weapon belt is a reminder of the atrocity of war.

Yoko is very reserved during our meeting, says only a word or two. John is much more natural and open. He wears beige army pants, a T-shirt, and Top-Siders. He carries the magic of Beatlemania on his shoulders. He has a kind of likable British arrogance. He says at one point, "You know, at the height of our acclaim, we were more popular than Jesus."

Andy reacts with his usual "Hmmm." Yoko nods her head. Andrea Wips wanted to come with us. Andy did not let her. She'd get drunk and misbehave. Andrea was very upset. She said, "Everybody hates that Jap, she's so tacky. She broke up the Beatles. She is the black pest with her conceptual nothingness."

Andy just said, "What's tacky about her?"

"Everything."

"Tacky" is a word Andy uses often for people he thinks are not for real. It is ironical coming from a man who is himself "naturally synthetic."

At the restaurant we are photographed, Yoko, Andy, and I. She holds a catsup bottle in her hand, her conception of Pop.

He doesn't get to design the record album jacket.

I meet the self-appointed American high priest of drugs, Dr. Timothy Leary, a former lecturer at Harvard University, at a plush Park Avenue apartment. He promises the assembly of socialites and intellectuals an expansion of consciousness and an ecstasy revealing itself from within through the use of drugs. He tells me, "LSD is Western yoga."

Handsome, slim Timothy Leary slides his words out of his smiling mouth. His credo is "Turn On, Tune In, Drop Out." I photograph him, dressed in white, meditating next to a bumper sticker inscribed, "Have a marijuana. I've gone to pot."

Andy's drug of choice is Obetrol, a kind of speed, which he pops into his mouth as casually and frequently as someone else

sucks breath mints or cough drops. It keeps his eyes open, but otherwise has little visible effect. He stays cool, remote, observant, mechanically wielding his tape recorder or his camera, always the calm epicenter of the hurricane around him, always at ground zero.

I try every way I know to persuade Billy Name, the resident astrologer, to let me see Andy's horoscope. He refuses, so I work out an informal one myself. Andy was born August 6, 1928, under the sign of Leo. His leonine image is uncanny—a nocturnal mammal of the cat family with a tawny body, tufted tail, and shaggy blackish or dark brown mane in the male. That's Andy's whitish, yellowish, brownish, silvery wig to a T.

At one point he owns some twenty-five cats, and it takes the mastery of a lion tamer to be surrounded by freaks, to come out with Pop Art, to anoint himself Pope of Pop. Later, he paints portraits of lions and lionesses of industry and finance.

"One must certainly have the lions of the moment at one's party," wrote Vita Sackville-West. Warhol becomes the whole party. A party without him is not a party. He seizes the lion's share, the largest part, gets all the credit and takes all the receipts for films that are collective works. Although the sixties are a time of communal living, communal love, and sharing your bread with everyone, Andy, in the words of the writer Jean Stafford in another context, "slyly sneaked the lion's share of buttered toast at tea."

That's our Andy, all right.

On occasion Andy comes with me to tea at Dali's, and one day in 1965 Dali takes us upstairs to his studio in the St. Regis. The room is filled with his toys: stereopticons and boxes of cards to view in the machines, photographs of exotic places and beautiful people, including dozens and dozens of himself, stacks of back issues of *Scientific American*, dried flowers, a white plaster Venus de Milo, yards of red velvet, a cardboard pyramid, live leeches in an aquarium, several gold-dipped lobsters, crabs, and sea urchins. Andy stares in fascination at this accumulation of

odd objects. He plays with a foot-long, helium-filled silver blimp attached to a string. "Oh, how great!" he exclaims. "Where did you get this?"

"At Schwarz's toy store," Dali tells him.

A little later, on our way to F.A.O. Schwarz, Andy says to me, "Leave Dali. He's too old, and he's not with it."

"He's still getting plenty of press attention."

Andy grimaces.

In the toy store we buy two blimps. I don't think much about the purchase until the next year, when Andy's show at the Castelli Gallery features his Flying Pillows. Bigger than bed pillows, the helium-filled rectangles of silver Mylar are clearly derived from the toy blimps. They have the dreamy beauty of indoor clouds. One wafts gently out the gallery window; several turn up as props the following season in one of Merce Cunningham's ballets; but four do not bring an estimated price of $20,000 at auction at Sotheby's in the spring of 1988.

Leo Castelli is the best art dealer of our time. His big, wide nose is too large for his tiny face, but it carries this short man forward, sniffing art and money a mile away. Leo always speaks to me in French and hugs me warmly when he sees me. I knew him way back in his Paris days, when he was associated with the remarkable dealer René Drouin in an interior design firm. He is amused that I have become Ultra Violet. One day I ask him what he thinks of Andy as a painter. He says in a straightforward way, "It will be hard to place him in art history. It is still too early to tell. But one thing is sure: he's a genius at publicity."

On April 1, 1965, Andy and I are on our way to see Si Newhouse, publisher of *Vogue* magazine and head of the whole Condé Nast publishing empire. I met Si through René Drouin when I was collecting art in 1961.

"Introduce me to important people so they can produce a film for you to star in," Andy has said. I organize the meeting. Si occupies a duplex penthouse on East Seventy-third Street. He is a short man with a grin. He lets us into his handsome modern

living room. There are three piles of *Vogue* back issues. He shows us his paintings: Liberman, Olitski, Cuixart, Lichtenstein, Stella, many more.

In front of every painting, Andy stops, exclaims, "Oh! How fantastic!" Andy always compliments everyone, anytime, about anything. Whenever I take Andy to a film premiere and introduce him to the director, he inevitably says, "Oh, it was fantastic!" Later, on the street, he tells me how bad it was.

Si is as curious to meet Andy as Andy is eager to meet Si. "Where is art going?" he asks Andy.

As usual, Andy does not know what to answer. Si offers us cocktails and canapés. Andy says, "No, thank you." He prefers a pill and pops it down his throat with a sip of soda. "Soon we will all live on pills, no more food," he explains.

Si asks Andy what he is working on. "My next show will be of people. I will exhibit Ultra, Brigid, English Ivy, International Velvet."

Si does not understand. Is Andy putting him on? I hasten to explain about the names of the Superstars. Andy will pin us to the wall or rent us to collectors for the weekend. It is getting late. We must go. Si is too wise to back a Warhol film. But ever since that day, Andy is a favorite of *Vogue* and later of *Vanity Fair*. So it is a worthwhile visit for Andy.

One evening I am chatting at the bar of the elegant Le Pavillon restaurant with its proprietor, Henri Soulé, New York's premier restauranteur. In walks Frank Sinatra. He stares at me. I look back at him. We exchange charged glances. The words to his song "Strangers in the Night," pound in my head. Our glances hold. When I was sixteen I had a crush on Ava Gardner. I identified with her. I've been told I look like her. Is it my resemblance to Ava that magnetizes Sinatra?

This time my courage wavers. I drop my eyes. Sinatra walks on. I often wonder: Was he really interested? What if I'd encouraged him with a coquettish invitation? Was I spared ecstasy or grief?

I think of this near miss some time later, when Sinatra is courting Mia Farrow. She is one of the Dalinians, a member of Dali's circle of admirers, a highbrow version of Sinatra's rat pack. "Should I marry him?" she asks. She is not even sure that his intentions are matrimonial. "How do I get him to propose?"

"It's very simple," Dali says. "Wear one green and one red sock."

"What will that do?"

"It's an eye-catcher."

Mia is used to Dali's riddles. She sits there looking like a frail blossom. She has long, silky blond hair. She wears angelic white. Her skin and eyes are transparent. She follows Dali's instructions. A few days later, she is wearing a child-size diamond bracelet around her tiny wrist. Sinatra has given it to her. We decide he must be very much in love.

"Now," says Dali, "to make the final catch, wear your shoes inverted."

We don't understand at first, then we realize he wants her to wear her shoes on the wrong feet. "But that hurts," she protests.

A year after their marriage in 1966, Sinatra, Mia, Dali, his wife, Gala, myself, and Chici, Dali's ocelot—what a collection of Italian-sounding names!—are having drinks in the King Cole Room of the St. Regis. I am wearing a violet dress, a violet smile, violet hair, and violet socks. Sinatra looks me over. "You look like a violet flag."

"I am."

"What country?"

"Ultraland."

He decides not to ask me any more questions.

In November 1967, my debut in the New York theater produces much excitement. I love the discipline of reporting every night to the Ridiculous Theater on the Bowery, where I play Natolia, a queen from Saturn who speaks Middle English, and Ondine plays Zabina, a queen from Mars, in Charles Ludlam's play *Conquest of the Universe*. The curtain does not go up until On-

dine, in full view of the actors, inserts a needle into his arm, pulls it out, and gives the actors' blessing, "Break a leg." I respond, "Break an arm." Then we go on.

On November 21, I invite Marcel Duchamp to watch my performance. The box office attendant runs back to tell the cast, "Duchamp is here." Ondine screams, "Who the hell is Duchamp?" After the show, Marcel embraces me while puffing on his cigar. He says, "It's a collage from Brecht, Shakespeare, Adolf Hitler's writing, TV ads. I love you in it." He had to love it, for in the *Wall Street Journal,* John O'Connor writes, "The colorful chaos is a direct descendant of Dada."

In the *Village Voice* on November 30, Michael Smith writes, *"Conquest of the Universe* is an explosion of talent that leaves the mind in tatters. Vaccaro [our director] has assembled an astonishing cast, many of them ex-inmates of Andy Warhol movies, and they produce countless flashes of brilliance. . . . Ultra Violet is brilliantly funny as the Italianate Natolia."

A year before, Andy introduces me to John Chamberlain, maestro of the wrecked automobile. His assemblages consist of smashed car parts. He is one of those apache types who always appeal to me. In fact, he is a nearly full-blooded American Indian. I take him on, extract him from his slob clothes—dirty pants, out-of-shape sweatshirt, clodhoppers—outfit him in black patent-leather moccasins, orange corduroy pants to counterpoint my violets, and a jacket almost as long as an artist's smock. A little later, when I introduced Chamberlain to Dali at tea, Dali says, "That one is a chimera."

He is absolutely wild about me. He photographs me a mile a minute. We fly to Mexico to film *The Life of Hernando Cortez.* Taylor Mead plays the conquistador in a gay, laid-back, gringo style. I play his spouse-mistress. The highlight of the film is John's performance. Dressed in silver and violet lamé, his face half covered with wide aviator glasses, he roars up a gigantic cedar tree to reach his love—me. The camera swirls as it films our flaming, torching, electrifying romance in the sky.

One night I even lend him my car, the beautiful limousine put at my disposal by Mr. XYZ.

A few nights later, when I am at supper at Park Avenue in the Seventies, I hear a phenomenal crash from the street. Somehow I know it's my car. In a half hour, there is a call from the nearest hospital emergency room. John and his passengers, one of them the painter Neil Williams, are cut, bruised, and bleeding. The car is a total wreck. John does not have the elegance to sign the crushed metal, which today would be worth something in the six figures.

I flee to France to escape John's wrecking hand. I call him from there. "John, I'm pregnant by you."

"That's your problem," he replies.

I hang up, dazedly dwelling on the glaring contrast between aesthetics in behavior and aesthetics in art. I question my relationship with John. The meteor has burned out. I get an abortion.

A little later, John softens, but only for the wink of an eye. He offers me a sculpture, his version of the Winged Victory of Samothrace. While he is away, I go to his loft to claim my consolation prize. It is too big to take out through the stairway or the elevator shaft.

Andy, with his superb sense of commerce and timing, tells me, "Get it out of his place. Squash it, bend it, but get it out now."

I don't have the heart to mutilate the work—I respect it too much. I wait for John's return. Warhol is right—it is only an Indian gift. John changes his mind. I never get the sculpture, which I really would have loved. Would I have loved the child? Not really, for I would be a mother with a heartless bosom, and the child would have no father.

I do not stop to mourn my lost baby. Almost immediately I have another loss to contend with which, at the moment, looms larger in my life. Mr. XYZ does not take kindly to the destruction of his car. He has other complaints as well. At first he is amused

by my transformation into Ultra Violet. But as my clothes grow more flamboyant and my name or picture appears in the paper more often in connection with some new Pop outrage, his affection chills.

"I think you should keep away from those Warhol people— they are a bad influence," he says.

That's all I need—to be told what to do, whom to see. It's the nuns all over again, giving me orders. I flare back at him. He walks out. A door slams. A door is closed for good.

A few days later, I search among my papers for the deed to my apartment house, to see where I stand. I can't find the document anywhere. I am always careful with important papers. Where can this one be? I play back in my mind that joyous moment when I signed the papers in Mr. XYZ's office and then went to tell my friend Véronique of my good fortune. Dimly I recall that his attorney kept the papers for recording. I was to receive them later. But in my euphoria I never kept track of "later." And now, obviously, it is too late. The bitter truth dawns. I never owned anything.

I laugh ruefully. My shrewd lover never intended to let that paper out of his hand. After I signed it, he either locked it in his own safe-deposit box or tossed it into his wastebasket. Well, I felt rich, very rich, while it lasted. One thing I won't do: I'll never tell Véronique of my failure as a gold digger.

TRANSVESTITES

When I meet Jackie Curtis in 1967, she appears to be a girl, but she has the body odor of a man. Each time she lifts her arm, the thick male hair of her underarm exudes a male scent. Her meticulously overpainted dark red lips and heavily shoulder-padded low-cut dress recall a 1940s movie star. Her eyebrows are carefully plucked. Her beard is barely visible, bristling up through pancake makeup and pimply red skin. I learn that she is having her facial hair removed at an electrolysis school, where unskilled students practice on her.

I ask Jackie about her childhood. She was raised by her mother and two aunts; the three sisters were completely in love with the movies. She shows me a dog-eared album filled with stills of Mae West, Joan Crawford, Garbo, and dozens of others. "This was my education," she says. I see a photo of Mae West cut from a magazine. The head has been amputated and replaced with a cut-out of Jackie's face.

"How strange."

Jackie turns the page and points to a similarly decapitated Joan Crawford with Jackie's face. "My mother and Aunt Josie did that. We worshiped the stars. It was not a dream. We entered the silver screen."

Jackie was born a boy with a chunky body and a psyche that fluctuated from masculine to feminine. When she/he took diet pills to lose weight, Jackie became a svelte woman. When she/he stopped the pills—they were speed—the body became heavy and mannish again. From year to year she/he went back and forth from male to female. Now, as a performer, she plays both male and female roles, but her public prefers her as a female. That, of course, means more speed. She raises her arm to fix her thick, flowing locks. I am intoxicated by the sweaty male odor.

We are going to Slugger Ann, a bar on Second Avenue run by Jackie's grandmother. As we cross Tenth Street, a kid yells, "Yaaah, queen in drag."

In a soprano male voice, Jackie shouts, "Little cocksucker!"

"What kind of name is Slugger Ann?" I ask.

"My grandmother was a dance hall performer. It runs in the family."

At the bar I meet Candy Darling, who is working as a barmaid. She is wearing a bra and shorts, and in the see-through bag she carries I spot a Tampax. Her red-lipped smile reveals many missing teeth. "Candy is my new name," she explains in a whispery, soft voice, like a low-volume Kim Novak. "I was born Jimmy Slattery. I'm from Massapequa, Long Island. I belong on the screen. I was born to be a star. I'm in Jackie's play *Glamour, Glory and Gold*. I inspired her to write it."

Jackie, I discover, is also a playwright. *Glamour, Glory and Gold* has just opened. All about glamour, glory and gold, it has become a camp treat and has launched the acting career of Robert De Niro, who plays ten roles. According to Jackie, De Niro begged on bended knee to act the ten roles. The *Village Voice* has given him a rave revue.

Candy keeps talking, without any encouragement. "I'll be

anything but a man. I'll be a lesbian. I'll be beaten up by men for not being a whole woman. My breasts are sensational. There are none better in town." When she raises her bra to show me, the fairies in the corner of the bar don't bother to look up. "I go to this dating agency on Park Avenue. We all meet there for our hormone shots. I love it when my stockings run. I love all the problems women have."

I point to the Tampax. "Are you menstruating?"

"No; I carry it to minimize my flaw."

"What flaw?"

Jackie explains that Candy refers to her penis as "my flaw" and always carries a Tampax, letting it fall on the table so that men can be reassured of her femininity. Candy is retrieving her fake eyelash, which has dropped onto a customer's plate. As Candy picks up her lash in front of the traumatized customer, she says, "Even Garbo had her girdle."

By this time we are having drinks, and Candy is munching on a Wonder Bread sandwich. I see her sandwich progressively getting redder and redder. Jackie, too, is staring.

When Candy notices blood on her hand, she screams, "My God, another tooth. I'll be toothless soon!"

A little later, Holly Woodlawn joins us at Slugger Ann. Holly, no beauty, has a prominent nose, a receding chin, and a friendly, inviting way about her. The three of them form the odd trio. I ask Jackie if Holly has had breast transplants too. She laughs. "Not transplants, implants; hormone implants." Yes, twenty-five-year-old Holly is growing breasts.

Holly is a highly praised courtesan. She is much sought after, for there are a lot of men out there, men leading seemingly normal lives, who will part with a good deal of their money to indulge their strange whims. She is also an off-Broadway actress and has appeared in the Ridiculous Theatrical Company with Charles Ludlam and John Vaccaro. She tells me that she knew she belonged on the stage when she saw Elizabeth Taylor in *Cleopatra*.

"The movie was shit, but I love Hollywood shit," she explains.

Coming from a European childhood, never mesmerized by the movies, and not parked for hours in front of Hollywood reruns on the TV screen, I find it hard to understand the total infatuation with the silver screen I see around me at the Factory and here with these three. Of course, I am delighted when Andy invites me to appear in a movie; but my head is not saturated with dreams of stardom, and I am not addicted to fan magazines. Jackie and Candy say in unison, as an incantation, "MGM, RKO, Paramount, and Twentieth Century–Fox will call us. We'll be stars. We'll be famous forever." After a while, Candy says, "Hollywood is taking too long to get in touch with us. We'll make films with Warhol. If you are a Warhol Superstar, you have it made."

Another day, over beer and potato chips at Slugger Ann, Holly says, "Andy creates his own Hollywood. I am the sultry Hedy Lamarr, Candy is Kim Novak, Jackie is the Joan Crawford type, and Joe Dallesandro is the Clark Gable. And you"—turning to me—"are Vivien Leigh."

Confused about who is what sex, I ask Holly, "Would you call yourself a transvestite?"

"Honey," she says, in her whispery, affected voice, "call me anything, but call me."

Jackie does not want to be upstaged by a discussion of Holly's gender and credits. "I've had six husbands," she says.

"Six husbands and no wives," I tease.

"Always husbands, whether I'm a boy or a girl," Jackie insists. "I fell in love six times, and now I'm on my seventh."

I find this whole situation burlesquely bizarre, but I go along. "Hey, Ultra, would you act in my next play?" Jackie asks.

"Sure, I'd love to."

Holly, Candy, and Jackie have been invited to appear in Warhol movies. Candy is exploding with excitement. "He is the biggest thing since Cecil B. DeMille," she gushes. "My mother always

knew I'd be a movie star. She dressed me as a girl, but my father always called me 'the boy.' Now I'm going to be photographed as the most perfect hermaphrodite." (In 1970 Richard Bernstein photographs her naked on a bed of clouds, with long white hair flowing from her turban. Her nymphet breasts and her demi-erect penis leave viewers with mouths agape.)

In 1968 Candy and Jackie both have small parts in *Flesh,* the first of Andy's more professional movies. In one scene they are sitting in ladylike poses on a couch, reading old magazines out loud, while a blow job is being given to Joe Dallesandro by Geri, a topless go-go dancer.

At the informal screening of *Flesh* at the Factory, Candy wears rags. I'm not sure whether they are the latest fashion or just rags. I ask her when she first met Warhol. "I'm going to meet him tonight for the first time."

"What do you mean? Wasn't he there when you made the movie?"

"No, he wasn't. Isn't that strange?"

It would have been strange four or five years earlier, when Andy handled the camera himself for his simple, black-and-white home movies, but as his movies have gained in complexity they have passed from Andy's hands to those of Paul Morrissey and others with real professional skills.

A few days later, Candy calls me at two in the morning. She has been thrown out of her hotel room for not paying her bill. She wants to stay with me. I can't say no, for we are part of the same band, Warhol's band. Candy arrives, tipsy, wearing a long, black satin décolleté dress torn at the rump, long white tattered kid gloves, a white moth-eaten ermine wrap, and an almost Marilyn Monroe wig.

I give her my guest bedroom and run a hot bath for her. "Oh, you're so kind," she says. Not really. I'm worried about ticks, fleas, who knows what germs she's picked up from her partners of the night. I go to sleep. At noon she has not yet surfaced, so I quietly open her door. She is as frightening as a de Kooning

woman. Her head is tilted back and sideways, her mouth a grimacing pit bordered with three menacing lower canines. Her runny mascara blackens her cheeks, her purple lipstick is smeared. She is naked, one voluptuous pink round breast exposed. Her legs are wide-spread. Her hated male organ sticks out like a water-spouting gargoyle. I don't intend to check under it for a female orifice. Some things are best left unexplored. I look for a breathing motion. There is none. I can see the headline: HERMAPHRODITE FOUND DEAD IN UPPER EAST SIDE PENTHOUSE. Candy calms me with a random rattle. I close the door and decide she cannot stay another night.

When she finally awakens at 4 P.M., she spends an hour putting on her glamorous face, whispers, "Thank you," and runs out the front door for another hot night on the town.

At the formal opening of *Flesh* at the Garrick Theater on Bleecker Street, where it runs for six months, October 1968 to April 1969, Candy, at twenty-five, is at the height of her glory. Her teeth have been fixed. She uses good makeup. The press goes wild over Candy. In interviews she recites a long list of films she is planning to appear in, but none of it is true. She dreams up titles as she speaks: "Beyond the Boys in the Band, The Valley of the Fags, Blonde on a Bummer, Sandwich à Trois . . ."

Warhol is thrilled by the success of *Flesh*. He sees it as a documentary of boys who spend their lives trying to be complete girls, working double time to get rid of the stigma of male organs. Sexual ambiguity always fascinates him. He judges correctly that the public is ready to blur the lines between male and female. He is getting thousands of dollars' worth of publicity from the film. I am as caught up in the success of it as he is. But I am not as caught up as Candy. She really believes in her momentary fame. She is convinced she is already a star.

In 1969 the trade papers announce that a movie is to be made of *Myra Breckinridge,* Gore Vidal's best-selling novel about a starstruck transvestite. A nationwide, highly publicized search for the screen Myra continues for many months. Candy desperately

wants the role. She repeatedly calls the producer and the director, bombards them with letters telling how she has lived the part of Myra and knows the 1940s movies even better than Gore Vidal. When Candy learns that the role is going to Raquel Welch, something in her is destroyed. Her dream of Hollywood dies.

To have or not have a vagina is the main question in *Trash*, the 1970 film in which Holly masturbates with a beer bottle and convinces a welfare worker she is pregnant. She is obviously a boy, but just as obviously appears to be a girl. A born comic, she keeps the audience laughing nonstop.

I ask Holly how much she was paid for *Trash*. "One hundred and twenty-five dollars when I signed the release," she says.

"How long did it take to film?"

"Six days." I figure that's just over twenty dollars a day. Some salary for a Superstar!

Jackie, Holly, and Candy all appear in *Women in Revolt*, made in 1972. Jackie insists that Andy be at the camera. She refuses to go on unless he is filming. Luckily Morrissey is standing by and realizes Andy is putting the film in backward. Even though everyone knows that Andy does not move the camera or operate the zoom, his presence inspires the actors. Without Andy, there is no performance, no electricity, no magic. The camera might as well be out of film.

It's one of many whirlwind days in mid-1968 when Andy and I stay up twenty-four hours without sleep. Andy's uppers keep him going; all I need is my natural high. I drift into the Factory in midmorning. We're supposed to be shooting a movie, but nothing is happening. Gerard and a young kid hold silk screens in place; Andy works over them with rollers of cerise and persimmon paint. Rock music blares. I flip through the latest fashion magazines.

Ingrid arrives. We thumb through the magazines together. Now Gerard strings cables across the floor. It will be hours before anything happens. I make a call at the pay phone and take a cab uptown. Dali and I have lunch at the Pavillon with Verushka, a Russian-born model who is a *Vogue* favorite. She is wearing a black muslin see-through dress with seams running from waist to neck that center over her breasts so they hide one fifth of each nipple. Men stare at the hidden part and women stare at men staring. I have to laugh—our downtown way of

dressing has reached high fashion circles. Dali is wearing a gold lamé vest and a white ruffled shirt. I am wearing what is for me a conservative outfit: a violet mini with violet shoes and violet hose, which will not be changed until tomorrow at this time.

Dali holds forth on the rhinoceros's horn, reputedly the world's most powerful aphrodisiac. He says, stretching out each vowel, "There is not a day I don't thank Sigmund Freud for his great truths. Thanks to him, in all my paintings I manage to paint a rhinoceros horn. Even in my famous *Bread*, there is a rhinoceros horn resting in the basket. I have to give you some powdered horn someday."

"Thank you, but I don't really need an aphrodisiac," I say.

Dali continues. "When I was ten, I prayed on all fours in front of a table made of rhino horns."

Verushka does not seem to know what to make of all this.

I take out my pad and pencil and say to Dali, "For that article I'm writing for *France-Amérique*, I need to know your definition of surrealism."

"To transcribe thoughts spontaneously without any rational aesthetic constraint, to apply a paranoia critique to liberate men from the tyranny of the rational world."

I tell him, "I guess I was born a surrealist but never knew it."

He goes on. "Neglecting neither blood nor excrements, nor atheism nor the immaculate intuition, I add my Mediterranean hypocrisy, capable of perversity. But André Breton expels me from the group because I am too surreal. The most important thing for me is to commit the maximum number of sins."

"I, too—" I begin, but Dali is not stoppable.

"Soon I knew the Nietzschean Dionysus was my guardian angel. . . ." I try to follow word by word his surreal monologue, but soon I let it envelop me like music. "Eventually I return to the truth of the Apostolic Roman Catholic religion, which meets my Dalinian cosmogony with its limp watches that prophesy the disintegration of matter, its hallucinating phosphenes, reminiscent of my angelic intrauterine lost paradise."

I contrast this flood of tangled rhetoric with Andy's halting silences. Andy—oohhh! I look at my watch and run.

It's nearly three when I get back to the Factory. "Where have you been?" Andy asks. "You're not in the picture."

"What did you shoot?"

"Your big scene."

Ingrid shakes her head. "They ran out of film. They haven't done a thing except bitch at each other." One of the kids comes in with film. When the camera is loaded, Paul tells us to look busy. Three pretty boys entwine themselves on the broken-down couch. We number ten now, some strangers, Ingrid, Eric, me, and the three pretty boys, who have taken off their pants and entwined themselves even more tightly.

Andy, clicking his Polaroid, exclaims, "Fab! Great!" I go back to flipping *Vogue*. Maybe I'm on camera, maybe not. There's no way to tell. His phone rings again and again. Kids doing term papers call in to speak to Andy. Whoever answers the phone pretends to be Andy.

At four, Andy and I go uptown to meet Truman Capote for tea in the Palm Court of the Plaza Hotel. I notice Truman's round, rolling eyes, his pinkish skin, his grown-up baby look. He has an air of false naïveté. He is wearing a pale gray Borsolino hat, traditional gray pants, a brown jacket, and a red scarf. The conversation turns to the concept of yin and yang, two forces always in opposition and yet always complementary. It is a favorite subject of mine. While Andy is reloading his Polaroid, I say, "Yang is the masculine, active principle, as in light, heat, dryness. Yin is the feminine passive principle of darkness, cold, wetness. *In Cold Blood* is a yin-yang title."

Truman's novel based on a real-life murder in Kansas has had a long life atop the best-seller list.

Andy remarks, "Made lots of yang money."

I believe deeply and passionately that every human being seeks the opposite of his or her innate essence. The act of intercourse is the ultimate and glorious union of opposites. This is why I have so much difficulty with the idea of homosexuality. The ab-

sence of opposites appears necrophilic to me. I have the eerie feeling that my two escorts will die long before I do.

With that thought in mind, I ask Andy to stick out his tongue. From its appearance I can make a diagnosis. Andy hesitatingly displays a whitish tongue. I say, "A white tongue is an early sign of stomach trouble."

Andy responds with his usual "Gee."

I ask Truman to show me his tongue. He hesitates, then has difficulty stretching his tongue out straight. It trembles; it has a deep middle crack.

I say, "There is trouble in your nervous system or brain. Watch your heart."

As I stick out my tongue, the waiter drops his tray in a shattering of broken glasses. He is horrified by all three tongues, especially mine, which is obscenely long. I can extend my tongue a full six inches. It has been photographed many times as a rare specimen. I have received fan mail from a man who claims his tongue is far longer than mine.

We all pack in our tongues and walk out without paying the check.

While we wait outside for a cab, we spot a strange creature standing in the circle of green facing the Plaza on the Fifth Avenue side. A tall, thin man gesticulates in slow motion, as if floating in air. A crowd is observing the expressive motion of his limbs. "It's t'ai chi, an ancient art of self-healing," I tell my companions. Truman waddles off in his duck walk, Andy and I go up to Seventy-eighth and Madison, where we catch three different art openings in the same building.

The galleries are so jammed with people clutching plastic glasses of white wine and jabbering to each other and to us as we shoulder our way to the rear gallery and then back to the large front room that it's impossible to see the paintings. Looking at the paintings is not the idea. People are here to see each other and be seen and to buttonhole an errant curator or museum official or to say at the next stop, "Oh, I just said to Joni Mitchell

. . ." or "I just saw Andy Warhol . . ." People crowd around Andy. They want to be near him, to touch him. They all have something to tell him.

Andy and I are invited to Jasper Johns's for dinner. We taxi to Canal Street and the Bowery. Jasper lives and works in a building that used to be a bank. He is a serious painter who can take things as ordinary as flags, targets, maps, and the numbers we've all looked at a million times and give them beauty, depth, and aliveness. Andy is envious of Jasper and his friend Bob Rauschenberg. Bob pioneered Pop Art in 1958 when he created a kind of collage with a hole into which he inserted four Coca-Cola bottles. Bob and Jasper are already famous and making big money.

Andy by now has had shows at the Ferus Gallery in Los Angeles and the Stable Gallery in New York. He has shown at the Sonnabend in Paris and in Philadelphia has had his first museum show. His name is known, his face is always in the papers. He is a celebrity in New York. But five-figure success—$25,000 and up for a canvas—and kowtowing by major museum directors still elude him.

Andy once asked Emile De Antonio, an art champion of the fifties and sixties, "Why don't they like me?"

Standing nearby, I heard Emile say bluntly, "Andy, you're too swish and you're a commercial artist and you collect art." At that time, about 1963, collecting was suspect in an artist—it was the province of museums and collectors. Andy's commercial career was already well in the past, but among art snobs he remained tainted by it, although enriched with its money. And while the post–Abstract Expressionist sensibility was quite a homosexual one, Andy's gossipy style was not taken seriously—at first.

Food is the show tonight, not art. The buffet begins with fern buds, the tightly curled tops of wild ferns, cooked al dente with currants, pignolia nuts, and spices. I am enchanted. Dozens of other foods are set out on an improvised table under the twenty-one-foot ceiling—cold lobster terrine, a jellied consommé, a

smoked salmon mousse surrounded by tiny shrimp, sauced Mexican style with a coulis of green tomatoes, many marvelous-looking breads, an Alsatian tart of apples, heavy cream, egg yolks, sugar, and cognac baked to a lush custard. The incredible spread has been prepared by Frank Lima, a poet, dancer, and chef, born in Puerto Rico.

I am so preoccupied with the food that I barely notice the ten other guests, who are concentrating on the booze, which flows in torrents. The legend was that unless Jasper and Bob were drunk out of their skulls, they couldn't paint a thing. They're busy now reinforcing the legend. The food is wasted on Andy. It is too complicated for him. He is tongue-tied in front of his host. Jasper has eyes that reflect, absorb, shine, capture—in a word, they see. He has a bad complexion, an intense expression. Isn't Jasper the name of one of the Three Kings? Isn't it an opaque variety of quartz? This Jasper radiates warmth and power. We hang around for a while, then Andy says, "See you tomorrow," his standard farewell, and we leave.

We walk a few blocks up the Bowery, sidestepping the bums sleeping on the sidewalk and bypassing the panhandlers. Lights are on in the windows of the grimy lofts above us. Artists have been moving into the low-rent space. The neighborhood is on the move. Andy stops growling about his envy of Jasper and Bob and turns on his real-estate head. "We should buy here," he says. "Look how wide the street is." It's true—the Bowery is probably the widest avenue in Manhattan, although at this moment the vilest, with its soup kitchens, flophouses, and population of derelicts. An odoriferous drunk staggers against me.

"Would you want to live here?" I ask.

"It's a good investment," he says stubbornly.

We pick up a cab and head north to Chelsea, where some kids are having a party on a roof. Up six flights of creaking wooden steps permanently steeped in the fragrance of boiled cabbage, we emerge into the party area, where the fumes of marijuana engulf us. The scent is so strong it must blanket the whole neighbor-

hood. Recognizing some of the kids, Andy says, "Can we film on your roof?" The youngsters in their sandals and black turtle-necks cluster around him. Andy listens rather than talks, but he seems much happier than he was earlier.

I inspect the buffet, set on boards mounted on wooden horses. The well worked over spread is served from original wrappings. Pretzels and potato chips nestle in torn bags that blare brand names. Heinz catsup, Gulden's mustard, Hellman's mayonnaise bottles huddle together. Bud and Miller cans lean against Pepsi bottles. Schrafft's ice cream melts in pink rivulets down its card-board carton. It is a Pop collage, a Pop landscape.

"Andy, look."

"Looks great," he says.

Now it's on to a quick stop at the Peppermint Lounge, on West Forty-fifth Street. A couple of kids join us, and we all squeeze into a cab headed uptown. The Peppermint Lounge, run by the genial and publicity-wise rock-and-roll singer Chubby Checker, is the birthplace of the Twist, a fast, gyrating dance that is rou-tinely denounced from pulpits as a shortcut to hell, but every-one's doing it. We grope through the dark to a round table where Andy is supposed to meet some people interested in investing in his next movie. He is always looking for investors. He's been promised two thousand dollars, to be delivered tonight. At the table, two men are talking about interest rates and currency ma-nipulations; the two women with them are flashing their dia-monds and clutching their minks, although it is much too late in the season for furs. They look at us coldly but make room at the table.

"Are you sure this is the right place?" I half shout at Andy over the insistent music.

He is very sure. Nobody pays any attention to us. The kids light joints. I try to make introductions. "This is Andy Warhol," I say, "and I am Ultra Violet." Complete silence. "Andy is here to discuss his next movie." More silence. "Are you the inves-tors?" I ask the men.

141

"Hey, I heard of you," one of the women squeals. "You always wear purple. Gertrude, look—this is the actress who wears purple." Close enough. I'm wearing a lilac mini. "Gosh, imagine meeting you." The men, wreathed in cigar smoke, go on talking about the vagaries of the financial markets.

Andy stands up. "Let's go," he says. We wriggle out between the jammed-together tables and chairs. My toes are tapping. I'd really like to dance to the fast-paced music. We lose the two kids.

"What about the two thousand dollars?" I ask. Someone's made a mistake, but Andy isn't one to admit an error. It's time to move on anyway.

Max's Kansas City is where the Pop scene, Pop life, and Pop Art fuse. It is a two-story restaurant and bar at Park Avenue South and Sixteenth Street, the big hangout of the sixties. Mickey Ruskin, the owner, has operated previous establishments—Deux Magots on East Seventh Street, the Paradox, the Ninth Circle, the Annex—that attracted poets, poetry readings, painters, sculptors. At Max's, the heavyweights of the art world hang around the long bar, and in the back room, kids, groupies, dropouts, beautiful little girls of fourteen who've already had abortions, get noisy or stoned.

Going to Max's is like going to a gallery opening. You dress up or down. The last time I was at Max's I wore an old lace nightgown dyed violet. Tonight my ultra mini will stop traffic.

In the back room, lit by talented light artist Dan Flavin, red and yellow neon tubes produce an air of mystery and modernism. Taped rock music bounces off the walls. Mickey has a flair for recognizing who is somebody in art and who will be somebody. For booze and food he exchanges paintings and collages that years later will make their way into museums. The barter system keeps the place noisily animated, for even the least solvent artists can drink with abandon. We eat the biggest steaks I've ever seen. Andy had nothing earlier and I only had time to sample the lavish buffet at Jasper's . . . when? Just a few hours ago, but it seems like days.

Andrea Wips, that sweet little Jewish lamb, so tiny she looks like a child, comes in at 2 A.M., stoned out of her tiny skull. She jumps on a table and screams, "Show time, everything's coming up roses! Marilyn's gone, so love me while you can, I've got a heart of gold." She dances to the rock beat pouring out of the speakers. She lifts her blouse to show her beautiful, adolescent, pinkish breasts. She grabs her tits and challenges the men, then freaks out if one touches her. "Look at my melons, they're juicy, I'm going to be on top tonight, I'm a real woman! Show time!"

She lives on Park Avenue in a rich uncle's apartment. She is in love with Andy. She has a fantasy that they will marry and share their whole life. She makes an entry about Andy in her diary every single day. She sidles over to him. He says, "See you tomorrow." That seems to make her happy, even though it's Andy's generic greeting.

A kid walks up to our table and asks Andy, "Do you have a lendable dollar?"

Andy looks him over. He's a good-looking youngster, probably an art student. Andy says, "Come by the Factory tomorrow. We'll put you in a movie." The kid takes the remaining slice of rye bread out of the basket in front of me, spreads it with mustard from the jar on the table, and walks away. Andy is ready to move on. It takes us a while to hail a cab. (Damn that wild Indian giver John Chamberlain. If not for him, I'd still have my beautiful car.)

We taxi down to St. Mark's Place and look in at the Dom. The place is packed. The Velvet Underground assaults our ears. Two films are playing through red filters. Clouds of smoke swirl in the red beams of the projectors. I expect fire engines to arrive any minute. Ondine dances over and holds a whispered conference with Andy in the corner farthest from the music. I hear a whip crack backstage. "Let's go," I say.

"Come by tomorrow," Andy tells two girls in green bras and black tights. "We're making a movie."

Stanley Amos lives nearby. He runs an open house for art-

ists, street people, druggies. We drop in. Half a dozen people sit around in a psychedelic room, painted in Day-Glo whirlpools of color on walls and ceiling. We hang out there for an hour. I am glad to sit quietly.

Then we taxi uptown, to Park Avenue and Fifty-third Street, for breakfast at the Brasserie, in the Seagram Building. On the way we stop at a newsstand to pick up the morning papers and a stack of new magazines. The early morning sun is just hitting the windows on the eastern walls of Park Avenue's towers. They glow in pale orange rectangles. We order big breakfasts—bacon, eggs, French fries. We spread out our reading material, turn to the gossip columns first. I say, "Let's see if we're alive today." I flip through the pages. My name is mentioned once, Andy's twice, but there are no pictures of us. That makes it only a fair day. A day with no mention of ourselves is a lost day.

We check the list of art and movie openings, figure out how to crash those we're not invited to. Invitations and announcements arrive by the stackful every day. We feel we must go everywhere, do everything. If we're not invited, we walk in anyway. The whole game is people: meeting them, getting them involved, asking them for money, pulling them into our orbit, being invited to their parties and events. Every new person is a new possibility, a link in an ever-lengthening chain, an ever-climbing ladder.

What we're doing now is scheming the scene for the day. We do it every day, sometimes alone, sometimes together, sometimes on the telephone. Finally we go to our separate homes to shower, change, pick up our messages, scheme some more.

When I step into a taxi at the Park Avenue corner, the driver says, "Hi, Ultra." I feel as if I own the earth. That instant of recognition makes my day. I have Andy to thank for this degree of fame, for putting me in his movies. I feel a part of American culture. Maybe I'll be in the history books. I'm ready for the next twenty-four hours.

144

I am dying to meet Andy's mother. We all know she lives with him in his brownstone at Eighty-ninth Street and Lexington Avenue, but she never comes to the Factory, and we are never invited to his home. She has been instructed not to answer Andy's phone at the house. She has her own phone, for calls to the family and local merchants. It's clear that Andy doesn't want to reveal his dissolute life to Mama. But that doesn't diminish my curiosity. Finally I say, "Why are you hiding your mother? Are you ashamed of her?"

He evades answering, but when I keep at him, he says, "She doesn't have the right clothes."

"That's easy—let's buy her some."

I definitely have the right clothes and not necessarily expensive designer outfits. I've learned to achieve a distinctive contemporary look by putting together tops, bottoms, shawls, scarves, surprise accessories from odd and offbeat sources. I patrol the thrift shops, uptown and down, for marvelous, outrageous, eye-

stopping clothes. My best recycling effort is a wraparound white skirt that once camouflaged the ugly legs of a dressing table in an old house on Staten Island. The *New York Times* photographed me in that skirt and *Women's Wear* and various fashion magazines have frequently pictured me as a pacesetter.

"Come on, let's buy her some nice things."

"She never wears anything I get her."

"Did she wear that two-dollar paper dress from Abraham and Straus?"

"No."

"Thank God. Your mother needs some good clothes and a woman's touch in choosing them."

"You can't shop with her—you wouldn't understand each other." He thinks that closes the discussion.

I persist. "So come along," he says, "but don't tell the other girls." He grimaces, but he is trapped. We make a date for the next day at noon. On a sunny Thursday in the fall of 1967, I take a taxi to their house, ring the doorbell, and get back into the cab to wait. I know I'm not going to be invited in, so there is no point in standing at the door and putting Andy on the spot. Andy comes out first, then a strong-looking older woman dressed in black. She has pale skin, ghostly gray hair, a large nose. She wears beige low-heeled shoes with comfortably rounded toes. She carries a shopping bag for a purse.

Andy sits in the middle and asks, "Where are we going?"

"Let's try Macy's," I say. "It has the best choice." And, I think to myself, moderate prices. I can't imagine thrifty Andy is interested in a big-ticket wardrobe. We take off. I give Mrs. Warhola a small bottle of perfume and say, "A lady without a scent has no future." Her smile is fresh, earthy.

"Thank you, thank you," she says, nodding her head.

"Mom needs clothes for our next film. She's going to star as an aging peroxide movie star with a lot of husbands."

I hold back a laugh.

"I'm trying to bring back old people," Andy says, and to his

mother, "Ma, you can put on the perfume in the movie." She nods her head, and again her smile illuminates her face as she says, "And drink champagne."

At Macy's, we head for the women's department. Julia holds tightly to the side of Andy's black jacket, her wrinkled fingers tightly pinching the heavy leather. We browse through the dresses. Julia looks at the price tags and shakes her head. I select three dresses, one black with a pleated skirt, one with little flowery red roses on a black background, and a draped dress in pale mauve. Andy sits in an armchair and buries his head in a magazine. He flips the pages automatically.

When Julia goes into the dressing room, I stand by outside. She emerges wearing the mauve dress backward. Andy says, "Fabulous, Ma."

She looks at the price tag and says, "Too much."

"Don't worry, Ma."

She returns to the dressing room and this time invites me in. "Andy's my baby," she says confidingly. "My other baby, a daughter, she die when my husband left, 1912."

I feel my heart turn over for her. I had not known that when Andy's father departed for America he left behind a young wife grieving over the loss of her firstborn. Very tenderly I help her take off the dress. For underwear she is wearing a home-made camisole of white sateen. On the left shoulder strap, pinned over her heart, are three gold medals, two of the Virgin Mary and one of Christ.

"I marry in 1909," she says. "Beautiful wedding, like a picture. Gone, all gone—the war, the soldiers. Ondrej run to Poland, in the night, one mile, go to America. My baby girl die, six weeks. I go crazy. Baby dead, no doctor, I scream. Andy my baby now."

She puts on the black pleated dress and shows it to Andy. He says, "Fabulous; take it."

Julia examines the price tag and shakes her head. "Too much."

"Don't worry, Ma."

Back in the dressing room, Julia continues to unburden herself. "I live with old people. Work like horse, carry bags of potatoes on my back. Nine years I don't see my husband."

We show Andy the printed dress. "Fabulous." We buy all three.

"Mom needs a fur coat, a mink," Andy says.

I am astonished. Now that he's in a shopping mood, there's no stopping him. We take the escalator to the fur department. Julia holds on to the black leather sleeve of her baby. This time Andy looks at the merchandise. He quickly pushes apart the coats on their hangers. As he glances at each coat, Julia grabs the price tag and says, "No, no, no."

Andy pulls out a pale mink and shows it to his mom. She shakes her head emphatically. "No, I like *barani-kožuch, baranica*."

"What's that?" I ask.

"It's a sheepskin coat they used to wear in her village."

"Embroideries," she adds.

Julia finds a rabbit coat. "*Zajac*," she says, looking pleased. It has brown spots.

This time it's Andy who shakes his head. "A peroxide movie star has to wear a mink coat."

I can see we're not going to get anywhere with the mink today. "What about a hat?" I ask.

"*Šiatok*," Julia says.

Andy explains. "That's the flowered scarf they wrap around their heads."

Mama Warhola never plays the peroxide movie star, but she does appear in a filmed portrait, one of a series of quickie films of individuals, which represent a barely moving version of a photomatic sequence. Some time later, he gives Maminko a mink coat. By then I've learned that a number of canny fur dealers are swapping pelts for paintings. I'll bet anything that Maminko's mink cost Andy nothing but a small silk-screened flower. And I'll also bet the furrier today is still happily licking his whiskers.

CHELSEA GIRLS

The movie *Chelsea Girls,* made in 1966, is the high-water mark of underground films. At a cost of less than $1,500, it grosses $500,000. Breaking away from the linear narrative that prevailed in filmmaking from the earliest days of silents, it batters the spectator's perceptions with random continuity, split screens, disjointed drama, and spiced-up sadomasochism. The camera, nailed to a tripod, every so often unexpectedly zooms or swivels.

In a cinematic stroll from room to room in the raunchy Chelsea Hotel on West Twenty-third Street, the film, in twelve reels, visits twelve rooms, in which twelve different comedies, extravaganzas, operas, and outrages are enacted, among them: room 116, "The Trip"; room 202, "Afternoon"; room 422, "The Gerard Malanga Story"; room 516, "Hanoi Hannah"; room 632, "The John"; room 732, "The Pope Ondine Story"; room 822, "The Closet"; room 946, "George's Room." Precisely on target, the film captures the disarray of the unraveling sixties, when transgres-

sion became law and unorthodox routes were traveled for instant enlightenment or ever-denser confusion.

When we showcase the film on campuses, students go wild. It is manna from heaven. It is their lives, or their fantasies—or both—played back to them in garrulous, chattering, mind-boggling disorder. The first four reels are shot in color. We run out of money, so the next eight reels are black and white. When the management of the Chelsea Hotel finally throws us out, we have to finish shooting at the Factory. The change of locale causes considerable anguish, for it violates the strict rules of cinema verité, but we have no choice.

Cinerama is the rage that year. We can't afford the technology, but we knock it off by splitting the screen. We put two screens side by side, run two projectors, and daze the viewers with two separate sets of moving images that assail their vision and force their heads to pivot, right, left, right—migraine!

Chelsea Girls opens with a blank screen on the left, and on the right pretty boy Eric Emerson is seen, first through a red filter and then through a blue, obviously tripping. Now on the left screen, Ondine, in black parody of a priest's garments, pulls a syringe out of a greasy paper bag and in a familiar ritual, sticks himself in a vein. The microphone must be just under the bag, for the crackling sound of the paper is as nerve-racking as the rustling noises of a compulsive candy-eater in the next seat in a movie house.

With new blood in his Methedrine, or rather new Methedrine in his blood, Ondine, as the pope, serves as confessor to Ingrid Superstar, while on the right Eric starts a striptease. Ingrid calls Ondine a disgusting phony; he smacks her on the jaw. The right side of the screen goes blank as the smacking accelerates. Ondine orders Ingrid off the "set," acknowledging that this is a film, not a glimpse into real life. Ondine strikes again. As Ingrid runs off, Ondine screams, "Who the fuck does she think she is, coming on the *set* and pulling such a trick . . ."

In one episode, Nico, the singer with the Velvet Under-

150

ground, endlessly trims her bangs but never talks. Brigid, playing the Duchess, deals dope. There is toilet sitting, restless eroticism, muffled frenzy, narcissistic egoism, hustling homosexuality—something to offend everyone. Each minidrama plays until its reel ends. The viewer knows the film, all three hours and fifteen minutes of it, is over when the houselights go on.

I am around for most of the filming, and at the first showing I position myself at the theater exit to gather comments from viewers. These run the full gamut, from "a grand epic of the underground" to "a paroxysm of disintegration," with such in-between opinions as "fat, disgusting lesbianism," "*quel ennui,*" "elegant," "nasty mockery," "only a fool will sit through it," "degrading," "very hip," and "Warhol should be locked up."

After he sees it with a real audience in a real movie house, I ask Andy his impression. He says, "People are so fantastic—you just can't make a bad movie." At the time I'm rather impressed with it. I see it as an epic of sorts, with Joycean overtones. (But when I see it years later at the Whitney Museum as part of a retrospective of all Andy's films, I can barely sit through its deliberate meaninglessness and self-indulgence.)

The *New York Times* says: "Andy Warhol has produced a film that is half Bosch and half bosh . . . at its best a travelogue of hell, a grotesque menagerie of lost souls whimpering in a psychedelic moonscape of neon red and fluorescent blue. . . . If it was Mr. Warhol's aim to show that the really appalling thing about sin is the boredom it springs from and ends in, he has succeeded all too well."

With a send-off like that, which Andy's fans interpret as a rave, *Chelsea Girls* becomes the first underground film to enjoy a long run in a commercial movie house in midtown Manhattan. We are all elated. We feel we are real moviemakers. One of these days we may even become real stars.

In the spring of 1967 I meet Andy at the Cannes Film Festival, where he has already arrived with Paul, Gerard, Lester Persky, and International Velvet, our real, real beauty. We are not

part of the main festival, but our purpose is to screen *Chelsea Girls* in one of the smaller viewing rooms, to bring it to the attention of international film distributors. We all dress in menacing black leather, we wear sinister hip boots and dark glasses with enormous lenses. We carry whips, make scenes wherever we go, pretend to bully waiters and ushers. We do *anything* to get noticed by the distributors and covered by the press.

On the publicity front, we succeed. We take home bagfuls of clippings in a dozen languages from papers all over the world. On the distribution front, we strike out. *Chelsea Girls* does not get shown at the festival, even in a phone booth. But we judge the trip a success. We upstage Brigitte Bardot. And by sheer brashness, we put Andy on the map as an underground filmmaker, now blinking his unmatched eyes behind their heavy shades in the aboveground glare as we fly our act to Paris and London.

I go along when Andy takes *Chelsea Girls* on a tour of college campuses in the fall of 1967. In San Francisco, we're a smash. The students, who are already in an uproar over Vietnam and civil rights, clasp us to their bosom. They can't get enough of *Chelsea Girls* and us. The press, on cue, heats up the furor. When they've written all they can, praising and damning the film, the papers turn to feature stories about the Warhol entourage.

Rod La Rod, Andy's lover at the time, is described as "an Alabaman with shoulder-length brown hair. He claims to have two gods, Governor Wallace and Warhol, whom he calls 'The Great White Father.' "

I am described as "a vibrant girl with frizzy black hair and heavily pencilled green eyes. Her credits include the recent notorious stage production in St. Tropez of Picasso's 'Desire Caught by the Tail,' in which she plays a dual role of a nude prostitute and a piece of drapery."

The truth about that is more charming than shocking. Picasso's fable, written for his children, was dramatized outdoors in a tent in St. Tropez, where it ran for the month of July 1967. In it,

wearing a body stocking, I play the drapery. Someone else plays the prostitute. Various actors play a table, a big foot, a chair, a rug. John Chamberlain, wearing copious violet eye shadow, wanted to play the rod of my drapery. One night he came onstage but was so drunk he crashed my drapery to the floor. That ended his stage career. The biggest hit was Taylor Mead, with his sad, hound expression, who, more nude than not, wearing two long, drooping ears and a long, dragging tail, played a dog.

Warhol tells a reporter, "It's hard to say what is real and what is fake in my films. It's true that I never edit anything. But I'm learning about editing while running the camera." He goes on to reveal that he has just finished his first sexploitation film, *I a Man, Tom Baker*, which he made to raise money, and he adds slyly, "It's really dirty."

The reporter takes the bait: "Dirtier than *Chelsea Girls*?"

Andy nods and reminds him that *Chelsea Girls* was banned in Boston and Chicago. "The new one has more close-ups," Andy says, guaranteeing a headline in the next day's paper.

SEX?

When Andy was a sickly
eight-year-old, he was con-
fined to bed all summer long. He listened to
the radio in the company of his Charlie McCarthy doll.

I ask, "Did you play with dolls?"

"Gosh, no."

"Who were your heroes?"

"Dick Tracy. I Scotch-taped his photograph on the bedroom
wall."

"Why Dick Tracy?"

"Sex appeal."

"You just stared at him?"

"I fantasized about Dick's dick."

"What?"

"I fantasized it was lollipop."

I think to myself: A lollipop goes in and out of a mouth, usu-
ally a child's mouth.

Andy laughs. "Yes, Dick's lollipop." He adds, "I had two sex

idols—Dick Tracy and Popeye." (Warhol paints portraits of Dick Tracy and Popeye.)

"Did you also fantasize about Popeye?"

"My mother caught me one day playing with myself and looking at a Popeye cartoon."

"Why Popeye and Tracy?"

"They were stars. So was Charlie McCarthy. I wanted to make it with stars. I fantasized I was in bed with Dick and Popeye. Charlie would rub against me and seduce me."

I ask, "Were they father images to you?"

"Don't know. I barely knew my father. He died when I was fourteen."

"Why do you prefer men to women?"

No answer. Even though Andy is open in his own circle about his homosexuality, he tries to keep it secret from the public. "I did a cock book," he says.

"A cook book?"

Laughing: "You're naive."

A gallery director, Mario Amaya, editor of the London publication *Art and Artists* and a friend of Andy's, explains that in 1957 Andy went around town painting dancers' feet. Later, he moved on to cocks, drawing everybody's cock. Hence the cock book. Andy is attracted to boys who are delinquent and perverse. He is a voyeur and wants people to expose themselves. All painters are, by definition, voyeurs; I have met hundreds of painter-voyeurs in my life. But Andy extends the boundaries of voyeurism.

When kids drop in from the street, Andy asks, "Can you take off your clothes? I'd like to take a picture of you."

Either the kids are on drugs—in which case they do not know whether they are dressed or not—or they take off their clothes to be hip and liberated. Nude theatrical performances are going on all over town, so in the Factory it is taken for granted that you strip, or you don't belong on the scene.

Especially to the boys, Andy says, "Bend down. I'd like to

Polaroid your ass." The kids are either embarrassed or amused. They have never had such an open proposition. If they are embarrassed, they are shown Polaroids of other kids. Close-ups of genitalia are very abstract. You cannot recognize anyone by those close-ups. So who cares? You cannot be blackmailed. You may recognize someone's nose, because you've seen it. How can you recognize genitals you've never seen before?

One day in 1965, when I step out of the elevator into the silvery Factory on East Forty-seventh Street, Maria Callas's voice is blasting on the stereo. Ondine, the great fan of classical music in the Warhol crowd, is pulling his clothes together. Rod La Rod, another member of the circle, is handcuffed. The handcuff is the current gadget. If kids get too wild, we handcuff them.

Ondine says, "We threw Andy out of our orgy."

"Why?"

"All he did was watch."

I ask Ondine, "How often do you have an orgy?"

"It's an everyday orgy."

"How many people?"

"Twelve, four, one—who knows?"

"Male or female?"

"Both."

Andy is the passive voyeur, the receiver. He is feminine.

Another time I'm talking to Andy about Truman Capote. "When you were with Capote, who was the female?"

"With Truman we had a hard time."

"In what way?"

"Getting it on and/or up."

"But who was the female?"

"Both."

"Your mother, does she suspect anything?"

"My mother says, 'Don't worry about love, Andy. Just get married.'"

I laugh. "How did it start with Capote?"

"I was in love with him before I met him in 1951. I wrote him every single day for a year."

Sex?

"Did he reply?"

"Hmmm. I was engaged to Truman for ten years. A secret engagement."

"Did you exchange rings? Or earrings?"

Andy laughs. "We exchanged photographs. I made fifteen drawings to illustrate *The Stories of Truman Capote*. That was my first solo exhibit."

"What kinds of photographs did you exchange?"

"Photos of us kissing and making it naked with each other."

Andy is fascinated by the naked body. He has an extensive collection of photographs of naked people. He delights in the fact that every organ of the body varies immensely in shape, form, and color from one individual to the next. Just as one torso or one face tells a different story from another, so, to Andy, one penis or one ass tells a different story from another.

In 1964 Andy films *Taylor Mead's Ass*. The seventy-minute silent film in black and white is not famous for its action. The camera focuses for seventy minutes on the actor's ass, which requires unmatched patience from the unpaid Taylor. While it is shooting, Andy walks around the studio, talks on the telephone, goes to the bathroom. The film is insolent. With a thumb of his nose, Andy says "Bottoms up" to society.

Many artists have that impulse. I remember Marcel Duchamp showing me a naked photo of himself standing as a statue perched on a pedestal. His body was superbly proportioned. It had a rhythm that reminded me of his *Nude Descending a Staircase*.

Then there was the time Salvador Dali did a plaster imprint of my breasts. A specialist in statuary replicas for the Metropolitan Museum of Art came to the St. Regis at teatime. Dali and I were having tea with the Marquesa de Cuevas, who was born Marguerite Rockefeller. After our first cup of tea, Dali and I excused ourselves and went up to the mezzanine floor, to the office of the jeweler Carlos Alemany. I undressed. The castmaker fiddled with my breasts, his hands trembling as he applied plaster. It would take a while for the plaster to set, so I threw a violet

cape, trimmed with gold, around me, and Dali and I rushed back to the King Cole Room to rejoin the marquesa.

Listening to the violins playing "O Sole Mio" as the plaster dried, tightening and tingling on my breasts, Dali and I exchanged mischievous glances. I delighted in the moment.

I want to know more about Andy and Capote. I ask, "Are you still involved with him?"

"Only on the telephone."

"On the telephone?"

"I don't like my hair messed up."

I always wondered how Andy's wig withstood really rough treatment in the sack, even with its secret snap to his skull. I could not imagine Andy taking off his wig. I suspect even the stoned kids would have been scared out of their wits at the sight of that whitish cranium.

"Yes, sex-phone," Andy continues.

"You make love on the telephone?"

"You know I only want to be a machine."

(Before you read any further, please answer the following question: How would a man who is a machine make love? Close your eyes and come up with an answer, no matter how wild it might be. Only after you've answered the question should you read on, because Warhol's sex life will then make some sense.)

"Why sex-phone?"

"You don't get dirtied."

"If you blush, they can't see you, is that it?"

"You don't get wet by urine."

"You don't like to be touched?"

"No."

I recall the day we had lunch in a health food store on East Fifty-seventh Street. As I was returning Andy's change, my hand accidentally touched his. Andy flinched and drew back.

"What's the matter?" I asked.

"You touched me."

"So?"

"I don't like to be touched."

"Why?"

"Except by my mother."

"You don't want to be involved emotionally?"

"No, I don't."

Now, still pressing him about Capote: "You went from physical lovemaking to long-distance lovemaking with Capote?"

"He became a problem. Hangovers, amphetamines, AA meetings."

"Bad morning breath?"

He shrugs. "That's when I got married to my tape recorder." This is one of Andy's famous quotes.

Later, on a rainy day: "Do you record all your sex-phone conversations?"

"Gee, sure."

"What are you planning to do with the tapes?"

"Sell them or make them into a play."

"Explain to me how you get off on sex-phone."

"Sex is so nothing. The last time Truman put his cock in my mouth, I felt nothing."

One night Andy takes me, along with Gerard, Paul, and Rod La Rod, to see a Forty-second Street movie. Andy buys big ice cream cones and popcorn for everyone. I have never seen a commercial porno film, one that exploits sex, aberrational or otherwise, with the sole aim of arousing the viewer. In Andy's movies, which years later are shown in the world's most prestigious museums, the intention is to film the realities of our lives as they unfold. We film eating, sleeping, making love, going to the bathroom, taking drugs, beating each other up, whatever the entourage is up to at a given moment. We seek vérité rather than ejaculation under a folded newspaper.

Now I am horrified at the utter cruelty and brutality onscreen, the blatant rawness of the sex, the bloody reds and pinks, the nasty and animalistic approach. At one revoltingly vile scene

of torture, I vomit all over Andy. I have to leave the movie house. Exposure to that film turns me back into a virgin for a whole season.

Andy is always cool. Only once do I see him lose his temper. Little Andrea Wips wants to be in a particular movie, and he does not include her. She is on drugs and she is furious. She screeches, "You fag, you asshole, you Warhole, asshole, Warhole . . ."

"Get her out of here, out, out—and never come back!" Andy screams.

On another rainy day when we are sitting around, I ask Andy, "How old were you when you first had sex?"

"About twenty-three or so."

"Did you know about it before?"

"When I was six I saw kids in school suck off a boy."

"What did you think of that?"

"Gee, I don't know."

"Does it bother you that two men together can't conceive?"

"With scientific progress, someday men will."

"The male-female attraction is so powerful," I say. "It's as inevitable as day and night."

"How can a man know what a woman feels?" he asks. "It's too different."

Is it so different? Or is this an area in which Andy's imagination fails him totally?

Another time when we're talking, I ask, "How do you feel about prostitutes?"

"It should be the other way around. She should pay the guy. She's hot."

"What makes you think she's hot? Maybe she needs the money. Maybe it's just a job."

"The way they look is very hot."

"Andy, you're too much of an artist."

"What do you mean?"

"You're too visual."

Andy's answer makes me realize what an unbridgeable gulf

exists between the sexes. What woman today believes hookers choose their work because they really like it? But many men cling to this fantasy.

At the Factory, the boys go in and out of the darkroom in the back, where Billy Name prints his photographs. I know that it's quick sex in, quick sex out. I am never admitted to the darkroom.

It is all so casual. Go into the back room, suck some dick, have a drink, go back to work. It's completely ordinary in this group, in this time of demystification of sex. It's hip to believe that sex is nothing special, hardly worth mentioning.

One day I tell Andy, "You know what *capote* means in French?"

"No."

"It means condom."

"Hmmm."

"We should design a condom for gays that pops when you come."

"Why?"

"For entertainment." I know I'm talking nonsense.

In the same spirit, he says, "I'll autograph 'Andy' across each head."

Andy is interested in unexplored, highly theatrical territory for his movies. Arthur, a very young, devastatingly beautiful man, is a specialist in sadomasochism. In his small Upper East Side apartment, lit by candles, Andy and I sit on the edge of a torture rack. We are investigating the scene as a possible movie set.

Arthur says, "I'd like to put both of you on the rack."

I look for the door.

"It's a gentle treatment," he tells us reassuringly.

I keep my eye on the exit.

Before Andy knows it, he is on the rack and his fly is opened. I try to look out the window, but the glass has been darkened.

"I'll rub you with wood alcohol to make you feel good," Arthur offers. Andy moans. "I'll get a match," Arthur continues.

I rush through the door and run for my life.

Later that night, I call Andy. There is no answer. I call again. At 3 A.M., he finally answers. His voice has more delay than ever before. "I'm through with sex," he moans.

"What happened?"

"Those kids, they're crazy. I'll stay married to my TV."

"What's on TV?" I ask.

"A Joan Crawford movie."

We both watch TV all the time and call each other to describe the movie that's on. Sometimes we're watching different movies, describing the action to each other, frame by frame.

Andy's real obsession is money, not sex. It is as a device to make money that he toys with the elaborate concept of sex-phone.

The idea is: (1) a credit card agency verifies the caller's account and (2) telephone operators, girls or boys, on different extensions, carry on sex fantasies with the caller. Three-way, even seven-way, conversations are possible on different extensions. He says, "You can believe you're making it with anyone or having an orgy with Elsa Maxwell, Cleopatra, James Dean, Queen Elizabeth, anyone."

"Tiny Tim," I suggest.

"The living or the dead—makes no difference."

"The dead should cost more, because the operators have to do research to know about them."

"Gosh, it's easy to make people believe that Groucho Marx is on the other end of the phone."

"Or a centerfold bunny," I suggest. "And you can pretend to be anywhere, like in your mother's bed."

"Or the White House or a factory."

"A canning factory like Campbell's."

He laughs.

I say, "Inside a shopping bag, if you're a bag lady."

"That's what gay couples do when they go into a men's room together," Andy explains. "They take a shopping bag along. One stands in the bag, and all you see below the partition is a man with a shopping bag."

"What do they do?"

"A blow job."

"One of them has to be an acrobat," I say.

"I wish I were a robot."

"Why?"

"Then the robot does it."

Another time I ask him to name his favorite movie. I tell him
that mine is *Gone With the Wind*.

"Mine's *Barbarella*."

I remember the Roger Vadim film. Jane Fonda in leather is
strapped onto a lovemaking machine, and gadgets and metal ten-
tacles caress the erogenous zones of her body. She finally has
the orgasm of her life. Yes, that's Andy's style: Let the machine
do it.

"A robot-computer to answer the phone," he says. "That would
be great." He is back to his sex-phone idea, pushing it along
another notch. "It would do the job without emotion."

There's no point in telling him that emotions are what make
people what they are.

"The computer could be programmed with a male or female
voice," he continues.

All right, I'll play too. "You could use the voice of the caller.
You know, record the incoming call. Then the computer imitates
that voice when it answers."

"That's for people who love themselves."

"You'll need a toll-free number," I say.

"No, no, we charge fifty cents a call."

"Just to call in?"

"Sure. That's to get a recorded sex message. We change the
message every fifteen minutes so perverts keep calling. When
you get a talking robot on the line, that costs thirty-five dollars."

"How long does the call last?"

"Gosh, however long it takes a man—two minutes, twenty
minutes."

"What about a woman?"

"Same price. And sixty dollars for two robots on two extensions."

"They're all in bed together?"

"Yes."

The phone rings. We are at the Factory. Andy walks over to the silvery phone, hung by the silvery door, on the silvery wall, near the silvery elevator. "Hello. Do you want Rotten Rod or Baby Boy or Italian Salami? Oh, all three? That's an add-on, twenty dollars more. Tell me what you want and I'll set it up. Yes, sir, I'll get down and lick your boots. Come on over." Andy hangs up. His new concept makes him eloquent.

"Who was that?" I asked.

"Some kid."

"It works; it's all in the imagination," I say.

"Sex is an illusion. The most exciting thing is not making it."

I've heard Dali say the same thing. Is Warhol copying Dali? Or does Warhol think like Dali?

"If it's a fetish call, like incest," he goes on, "it's easy on the phone. In person, it gets out of hand."

"I like the warmth of human skin, the touch of a hand. . . ."

Andy ignores me. "A mutilation call, gee, that's easy on the phone. You can cut off anything you want."

All the while, Andy has his tape recorder on. That night when we drive home from the Factory, I somehow manage to slip the tape out of his bag. It is so unbelievable I want to play it for the other girls.

One day, we're being driven downtown to a party. "What's the most bizarre sex you've ever heard of?" I ask.

"A faggot who likes to dress up in lacy nightgowns and have smoke blowing on his face and that's how he comes."

Andy starts to talk about a place called Hell Fire Club, on Fourteenth Street. It is reported to be a private club where the most unimaginable and indescribable things happen. I've heard that the odor of urine and feces is everywhere. Biting, hitting, slapping go on until blood spurts.

"Have you been there?" I ask.

"Sure, yes."

"Is it true they have dildos, clamps, chains, handcuffs?"

"For starters, and golden showers."

"What's that?"

"A man drinking piss."

"Don't tell me any more."

"And brown showers."

"No, don't—"

"A shit shower."

"No."

He won't stop. "You know about fist fucking and head fucking?"

"No, please."

He explains with an obscenely graphic gesture.

"They must end up in the hospital."

Now, years later, looking back with an altogether different consciousness on the ugliness and brutality, I wonder what the satisfaction is meant to be. Everything is so destructive. I let my mind dwell on the depravity, searching for meaning, to understand how people can do such revolting things to each other. And why: Surely not for any kind of pleasure I can comprehend.

Then gradually I begin to grasp what Andy was trying to say with all his babble about machines and sex. Where sex has turned repulsive and inhuman, machine sex beckons alluringly. Only in telephone sex, robot sex, computer sex, is there escape from ugliness and cruelty. Machine sex is the only kind left that is uncontaminated, antiseptic, clean, even a little mysterious. Let's not think about affection and tenderness—they are entirely beyond expectation.

I think back to one of Andy's earliest paintings, compelling in its simplicity—a starkly black-and-white six-foot-high Coca-Cola bottle, painted in oil on canvas in 1960. It is his first serious Pop work. I think of the paintings of clean, shiny Campbell soup cans, the young, unlined, fresh-scrubbed faces of Marilyn Monroe, Jackie Onassis, Ingrid Bergman, so many others.

Yes, here is still another of the endless paradoxes Andy strews along our paths. In sex, as in art, tongue in cheek, thumb to nose, finger on the collective pulse, he reinvents shining, pristine, early morning purity. His kind, of course: on the surface, no deeper.

THE SHOOTING

On Monday, June 3, 1968, I look out the bedroom window of the seven-room duplex just off Fifth Avenue in which I have been living since 1967. The sun is so hot on my terrace that I prefer to stay indoors. I am sitting naked in the full sun on my bed—which is covered with an American flag—and I am talking to Andy on the telephone. "You know, Andy, that Valerie Solanas is a dangerous cookie. She's a real bitch. Have you read her SCUM Manifesto?"

SCUM, the Society for Cutting Up Men, is one of the more bizarre manifestations of the radical fringe of the feminist movement that is just coming into full flower. The excesses, of course, command the press, so almost daily there are headlines about editors and business executives besieged in their offices by throngs of enraged women, about bra burnings, and about threats of mass castrations. The SCUM Manifesto pushes the feminist rhetoric to a new fury. I read Andy some choice bits:

" 'To be male's to be deficient; emotionally limited; maleness is a deficiency disease and males are emotional cripples.'

" 'The male has a negative Midas Touch—everything he touches turns to shit.'

"Listen, this is what she says about prejudice: '. . . the various discriminations have the practical advantage of substantially increasing the pussy pool available to the men on top.' "

"Uh-huh," is all Andy manages to say about this.

I go on: "And about communes [then very much in vogue]: 'The most important activity . . . is gangbanging.'

"On the hippie: 'He's . . . all the way out to the cow pasture, where he can fuck and breed undisturbed and mess around with his beads and flute.'

"Now hear this on culture: '. . . a sop to the egos of the incompetent.' "

Another "Uh-huh" from Andy. He must think I'm his mother, reading him the funny papers.

"How about this on money: 'After the elimination of money, there'll be no further need to kill men.' "

This time he groans.

"Here's something else about men: 'The male's by his very nature a leech, an emotional parasite, and, therefore, isn't ethically entitled to both live and prosper.'

" 'If SCUM ever marches,' " I go on reading, " 'it'll be over the President's face; if SCUM ever strikes, it'll be in the dark with a six-inch blade.' "

Nothing's too outrageous for Andy. He says, "She's a hot-water bottle with tits. You know, she's writing a script for us. She has a lot of ideas."

I warn him, "But you have to know what she's writing about. You might be a target for her." He laughs again.

After we hang up, I stretch out full length on my flag to sunbathe. All year round I sunbathe nude. I hate white marks on my body and I love to soak up the vitamin D. Later, I dress, lunch with a friend, check the thrift shops in my neighborhood for recent donations of violet castoffs.

The Shooting

Valerie is on my mind all that day. I first met her in 1967, when we appeared together in the film *I a Man*. We were seven principal girls along with Tom Baker, a serious actor. I recall the way Valerie fixed her narrow, piercing brown eyes on me. She had brown hair cut in bangs, a sagging mouth. She was about twenty-eight, of average height. She wore flat shoes, khaki trousers, a sweater, and a dark blue work cap. We called her Valerie Barge Cap. In the film she was to play herself, improvising along the lines of the SCUM doctrine.

She opened her conversation with me: "Those disgusting pigs, men! They're all leeches." She moved closer to me. "Love can only exist between two secure, freewheeling, groovy female females. Love is for chicks. Why do you let him exploit you? Why don't you sink a shiv into his chest or ram an ice pick up his ass?"

Before I could figure out an answer, Andy herded her toward the staircase outside the Factory, where her scene was to be shot. Valerie was excellent in her role. She spouted from her manifesto. Andy was moaning behind the camera, a kind of approving moan. He liked her switch-blade pronouncements.

Now it is a year later. At about a quarter to five in the afternoon, my phone rings. The voice on the other end is frantic, hysterical. I think it is Viva. Much later I find out it is not, and to this day I have no idea who made that call. The Viva-like voice is gasping, "I was just talking to Andy on the phone. Then something happened. I heard him say, 'Oh, no!' Then there were three revolver shots and screams. He dropped the phone. I yelled into my phone, but no reply. There's trouble."

"Right, right," I say soothingly. I think the caller is tripping. I've had calls of this type before.

"You don't understand," she screams at me. "Andy has been shot."

Viva has a stormy temperament. I don't want to antagonize her, but I want to get her hallucinations off my phone line. "OK, OK, I believe you," I say coolly, trying to bring down her intensity.

Her intensity stays up. "We might be next. I bet the Communists did it." (They have their office in the same building as the Factory.)

She hangs up. That's a good script, I think to myself. Andy should stage it. But it would have to be real to work. No phony gun. No catsup for blood. No dummy props. We never pretend anything. It must be a real assassination. . . .

Suddenly a flash goes off in my head. I have a crystal-clear vision of Valerie Solanas aiming a thirty-two-caliber gun at Andy. I dial the Factory. A voice I don't know answers the phone and says, "There's been a shooting here."

I throw on a Chanel suit and take a cab to the Factory at Union Square. There I find police cars, policemen, and crowds in the street.

"He is dead," someone says.

I want to rush up to the fifth floor, but the police bar my way. I join the crowd in front of the building and spilling over into the square. I look up toward the windows of the Factory, but they tell me nothing. No one seems to know exactly what has happened, beyond the fact that there has been a shooting. Most people believe Andy is dead. I finally find out that he has been taken to Columbus Hospital on Eighteenth Street. I hurry there.

A mob mills around the lobby—police, press, some of the Factory regulars. Out of the babble and confusion, I piece together the story.

Valerie's spinning mind is under the impression that Andy and Maurice Girodias, publisher of Olympia Press, have conspired against her, that they are trying to control her and have taken over the rights to her writing. She has to straighten them out. She can't find Girodias, who is in Canada. She goes to Andy's loft at two-thirty that afternoon and is told he is out. At four-thirty, she reappears and takes the self-service elevator upstairs. She is wearing khaki jeans, torn blue sneakers, a yellow sweatshirt, a blue turtleneck sweater, a trenchcoat, on that hot, sunny day, and, most peculiarly for someone of her ultra-feminist per-

170

The Shooting

suasion, she has on mascara and lipstick. In one pocket of the trenchcoat is a thirty-two-caliber automatic and in the other a twenty-two revolver.

Andy has recently acquired a new assistant, Fred Hughes, a dark-haired, handsome man who formerly worked for the oil-rich, art-collecting de Menil family in Houston. Fred has been making sense of Andy's chaos. He small-talks Valerie. "You still writing dirty books?"

She steps around him, pulls out her thirty-two, targets Andy, and fires a barrage of bullets. Andy lies on the floor, bleeding real blood, not red paint. He tries to crawl under the desk. She moves in closer and fires again. He is having trouble breathing. Fred leans down over Andy and starts giving him artificial respiration.

Valerie turns toward Mario Amaya, whose magazine has recently run an article on Andy. She fires at him. He ducks and catches the bullet in his hip, flees toward the back room, crashes through the door, slams it shut. She hurls herself against the door to push it in; Mario holds it closed from inside. Paul Morrissey, hearing the shots, watches Valerie through the projectionist's window, helpless to stop her. She about-faces and, legs apart, parodying a gunman in a Western movie, walks toward Hughes, who begs her not to shoot.

"I must shoot you," she yells.

Fred falls to his knees and cries, "You can't. I'm innocent."

As she aims at Fred, the elevator doors open. She darts in and disappears. Fred calls an ambulance and the police. Billy Name, crying, leans over Andy to help him. By the time the stretcher arrives, Andy is unconscious. He is carried out, flat on his back, wearing a leather jacket, trousers, and boots, his silvery wig brushing against the cop's holster.

Dead on arrival is the consensus minutes later, when he is carried into the hospital. But Andy, as usual, dissents. He is still alive enough to be rushed into emergency surgery, where a team of four doctors fights for six hours to save his life.

While Andy hovers between life and death, the rest of us, in

the tiny hospital lobby, are a living hurly-burly. Andy's mother is there, crying, *"Moje dieťa je mrtvé, zabili moje dieťa, oh my God, blázni, my baby je mrtvé,"* mixing English with Slovak, I am told by someone who knows the latter. *"Moja laska je mrtvá, moj milovaný syn odišiel, on bol najlepší, moj Andy, moj drahý,"* or so it sounds to me. She is wearing a babushka. She seems about to fall to the ground. Gerard Malanga holds her up until an attendant brings her a wheelchair and she is sedated. I walk over to her and I take her hand in mine. I remain silent.

I hear someone say, "How can they bring him back from the already dead?" Billy Name, a bathtub plug hanging on a metal chain from his neck, his eyes as red as a rabbit's, is nervously pacing the corridor. The only two seemingly normal people are dealers Leo Castelli and Ivan Karp, in a corner, giving an interview. The press is voracious. Reporters crowd around us, hurling questions. "Is it drug related?" "Was she his girlfriend?"

Photographers fight for front positions and in the process almost trample Julia's wheelchair. She bends her head low to escape the photographers. She does not want her picture taken. For many in the entourage, this is their first view of Andy's mother. They crane to get a look at the Old World peasant, transplanted to New York, who has been concealed inside his brownstone all these years, shielded from the unorthodox life of the Factory.

Now Viva is comforting her. Andy's mother is muttering to herself in English: "My boy good boy. He go one o'clock mass St. Paul every Sunday. Good religious boy. They kill him, my Andy. . . ."

"Your baby will be fine," I say, patting her hand.

She is the only one not interested in publicity. Shamelessly, the rest of us vie for position in front of the cameras. Viva and I make the paper the next day. The caption says we are waiting anxiously during Andy's operation. I have a strange hairdo with two ringlets on each side, like a Hasidic Jew. Viva is wearing a fringed suede cowboy jacket and lots of mascara. In one article I am quoted: "A girl calling herself Ultra Violet, another Warhol

film femme, said, 'This underground movie world is a mad world with a lot of mad people in it. Maybe this girl, Valerie, was mad herself.' " I am sorry to see one of my less brilliant statements preserved in print.

In the hospital lobby, an impatient line snakes toward the pay phones. The hospital phones ring constantly. Ivy Nicolson, a tall, beautiful model, sometime actress, and mother of four children, is threatening to kill herself if Andy dies. She is delusional and thinks Andy will marry her. She is eventually taken home by Louis Waldon, a most kindhearted underground actor, who keeps a close eye on her as she calls the hospital every ten minutes, ready to jump at the fatal word.

Dr. Massimo Bazzani, medical director of Columbus Hospital, gives Andy a fifty-fifty chance to live. Is that good news or bad news? At least he's alive.

Later, the doctor reports: "The bullet that hit Warhol twisted crazily through his abdomen and chest, wreaking much damage. It entered through the left lung, his spleen, stomach, liver and esophagus before penetrating the right lung and emerging from his right side. X-rays established that only one slug had caused the damage."

The police put out an alarm for the attempted murderess, whose last known address is a dark single room in the back recesses of the Chelsea Hotel on West Twenty-third Street, where we filmed *Chelsea Girls*.

Word arrives that Valerie has surrendered at 7:30 P.M. to a rookie patrolman on traffic duty at Seventh Avenue and Forty-seventh Street. She handed him her guns and said, "The police are looking for me."

The press abandons us and flies, like a flock of crows, to the Thirteenth Precinct station on East Twenty-first Street, where Valerie is to be booked. Thirty newsmen are made to wait outside for an hour while she is questioned. When she finally comes through the door, smiling triumphantly, her hands cuffed behind her, it is bedlam. She poses and smiles for the photographers.

The clicking and whirring of the cameras drown out her voice. When it is quiet enough for her to speak, she says, "I'm a writer. [Smile.] Read my manifesto. [Smile.] It will tell you what I stand for. [Smile.] It's not often I shoot somebody. Warhol's a culture vulture. I gave him my manuscript. He claims he lost it. He's using it."

She is the Superstar of the day. About to become famous, she is already infamous.

After the press is satisfied, she is booked on charges of felonious assault and possession of a dangerous weapon with intent to kill. She is fingerprinted and locked up.

I go home, exhausted and yet exhilarated. For all these years now, I've been trained to experience events of every kind in terms of headlines and photographs in the paper. Real emotions? Real feelings? They have been smothered by our obeisance to the media, warped by our need to strike a pose, smile, smile some more, whip out a witty retort.

Of course, I don't want Andy to die. I don't want him to be in pain. I want desperately for him to recover. But I am not able to cry for Andy, not yet. I am not choked with grief. My heart is not breaking with sorrow or loss. Rather, I am excited, turned on, by the drama launched by that crazy woman's bullets and now being played out in Andy's hushed hospital room.

Andy stays in intensive care and on the critical list for a week. He is allowed no visitors except his mother and his two brothers. Soon Jed Johnson is permitted to see him. Distraught at the time of the shooting, he is calmer now and brings us daily reports of Andy's progress.

Since I can't see Andy, I decide to call on his mother. It's the kind of civilized thing you'd normally do to comfort the mother of a friend who's been injured. I tell myself my motives are pure, but more than anything, I want to see the inside of his house. As far as I know, he has never allowed any of us through the front door—certainly not any of the women. What is he hiding? I am dying to know.

The Shooting

With a bouquet of pink roses in my hand and a bottle of champagne and dressed à la Czechoslovak, meaning in a mixture of flower prints, I ring the bell. The wrinkled woman receives me. She remembers me from the shopping excursion. I am so dazzled by what I see that I can hardly squeeze out a polite greeting. So this is why Andy never lets any of us in, I say to myself. He plays poor, but look at this treasure trove.

My eyes can find nowhere to rest amid the carousel horses, boxes of all kinds, a giant wooden Coke bottle, a carnival punching bag machine, a John Chamberlain sculpture, Victorian furniture mixed with dozens of shopping bags, Tiffany lamps, stuffed peacocks, rugs piled as in a cluttered shop—Indian, American Indian, Oriental, rugs of all sizes—silver everywhere, china, porcelain, paneling, all of Ali Baba's treasure. What a collectomaniac! We've shopped together in antique stores, but I never knew he bought everything in sight.

Julia seems happy to see me. The poor woman hasn't had her Andy to talk to, even though he's never won any prizes as a conversationalist. In her thick accent, she cries, "They kill my Andy. They kill my Andy."

I scrutinize her face, searching for any resemblance to her son. She continues: "I love him, my Andy, the good, the bad, it's all in my Andy, the smart, the dumb, the genius, the drugs, it's all inside of him. The Slovak red blood, very red, inside him. He photographs everything, my Andy, does everything. He is the everything man, it's all in him. He dies for it."

"No, he is not dead," I say. "He will be fine. You'll see."

She is cheered and looks at me. "Oh, you nice girl. You're still not married." She is staring at my left hand.

"No."

"My Andy nice boy. He should marry." I nearly choke on the piece of braided cake she has offered me. "Eat, eat, it's *houska, hoska.*"

"It's delicious—it has nutmeg. What else?"

"Almonds, raisin, butter, eggs, milk, sugar, flour, lemon skin.

I cook for *moje sladké srdce.*" That's the way it sounds to me. I write it down later, phonetically. She goes on: "My Andy wears his red cheek inside, his white cheek outside. That's the American white cheek. Great artist, my Andy."

"Yes, he sure is."

"Would you like to marry my Andy?" I start to choke again. She taps me on the back while I cough and swallow the remaining crumbs.

What can I say to her? I decide to speak her language. "Your baby sweet baby, but too white for marriage."

She looks at me, opening her eyes wide, waiting for a better explanation. "Anemic," I say. "Red blood count low."

She nods.

"Not ready for marriage yet, your baby," I go on.

"My baby forty years old," and she lapses into incomprehensible syllables: *"Srdce moje, môj genius, ja milujem svoje dieťa, ja nemôžen, bez neho."*

I can visualize her back in the 1950s, much younger, perhaps thinner, bending over Andy's commercial art assignments as she deftly adds color or extends a line and then signs his name in her pointed, wide handwriting. I visualize her as a young woman, pretty, with high color, sitting at the bedside of her little lamb. She made herself indispensable when he was a baby. He made her indispensable when his career was beginning. She loves him for it. Their knotted umbilical cord is still tied.

As I leave, chewing on the piece of braided cake that she's pressed on me in the doorway, I think of something that has not crossed my mind in decades: my mother's baba au rhum, an old family tradition. It's strange; I almost never think of my mother.

RECOVERY

After the shooting, Andy remains in the hospital for fifty-four days. By June 19, he is listed in satisfactory condition. The papers print his medical bulletins daily. When he is finally allowed to receive phone calls, I dial his number. The phone rings six times before it is picked up. "Hello, Andy."

Protracted silence, then, "Yes."

"This is Ultra. You must feel like the lucky sole survivor of a plane crash."

"Yes."

"Are you thinking about taking off again?"

"Ummm."

"We all love you, you know. We miss you. I think you should settle down, get married."

"Ghr, ghr, grrhh." It's his turn to do a little choking.

"I truly love you for all you've done."

"Ummm." He does not like to get sentimental.

I wonder if he can talk, or is he strapped to a life-support system, with tubes in his nose and mouth? I ask, "How do you explain it all?" Silence. "Why were you the one to get shot?"

In the voice of a blanched octopus, he says, "I was in the wrong place at the right time."

I tell him about the reactions of various members of his entourage. I tell him that Jackie Curtis is considering tattooing his name over her heart. International Velvet and her boyfriend and Nico locked themselves in her apartment, drew the blinds, lit all the candles they could find, turned the place into a votive chapel, sat on the floor, and stared into the candles, swinging back and forth like Moslem weepers, until they heard his surgery was successful. I don't tell him at this point that International and her boyfriend have split, and she has left for Paris.

Another thing I don't tell him about is the story by Peter Coutros in the *Daily News* the day after the shooting. It is a slashing, pitiless obituary, not just for Warhol but for his era. In the years to come, I am to read it and reread it many times. It goes, in part:

> Long before Valerie Solanas got around to pouring her venom at Andy Warhol through the muzzle of a gun, the waspish, silvery-haired Maharishi of Modness was in trouble, deep trouble. His world . . . suddenly stopped caring, stopped knowing, stopped even realizing that Andy Warhol was alive and reasonably well. The pop artist who had savored success out of a can of Campbell's soup was now the pooped artist. The underground film maker who once focussed his camera for eight hours on the navel of a sleeping man had dissolved, faded out. . . . Andy Warhol was in trouble. The morality of the middle class bugged Warhol. He grew up in it and now he was running away from it. He was running hard but getting nowhere because he was running in the New Morality of the Four-Letter Word, and there's no traction there. . . . Creativity doesn't imply rendering classics into "The Adventures of Huckleberry Fag" or "Puke's Bad Boy." . . . It's been said that Warhol movies and stag movies were the same. Not true. No one ever needed a score card to tell the players at a stag.

Dustin Hoffman, Ultra, and Viva in *Midnight Cowboy,* **1968** (Photo © 1969 by Jerome Hellman Productions. All rights reserved.)

RIGHT: **Factory #2: 33 Union Square West, 1969** (*St. Louis Post-Dispatch/* Paul Berg)

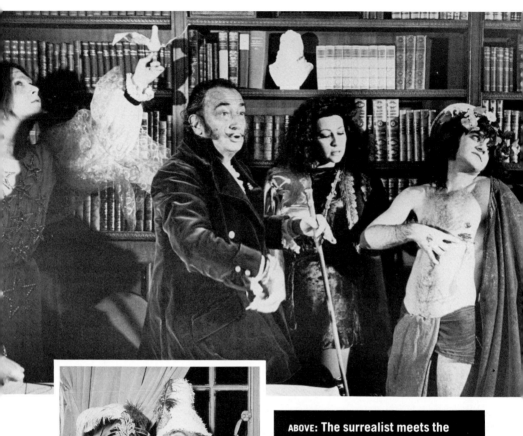

ABOVE: The surrealist meets the absurd, 1969 (*St. Louis Post-Dispatch*/Paul Berg)

LEFT: Party time with Salvador Dali: the St. Regis, 1969 (Ron Galella)

FACING PAGE: With Dali at the opening of his exhibit, Huntington Hartford Museum, 1969 (Vladimir Sladon)

Factory #2: through a glass darkly (Billy Name)

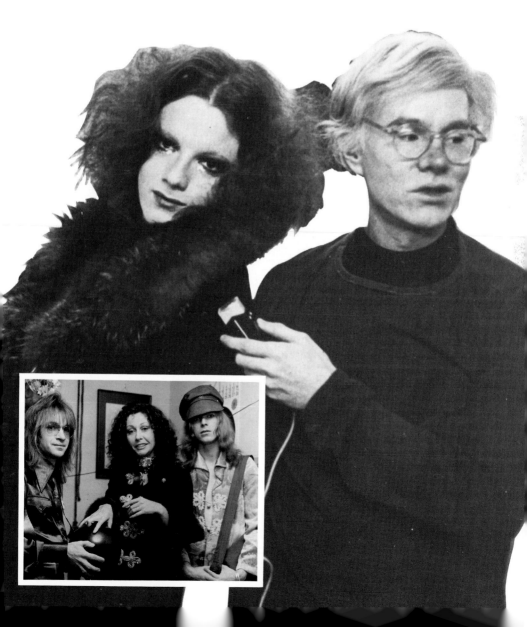

Jackie Curtis talks just like a woman (Leee Childers/
Neal Peters Collection)

INSET: **Rock impresario Rodney Bingenheimer and
Ultra with David Bowie during Bowie's first visit to
U.S., 1970** (Courtesy Rodney Bingenheimer)

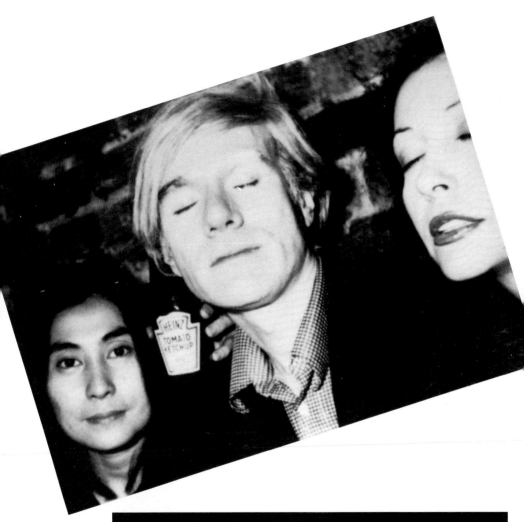

Yoko Ono, Andy, and Ultra at Max's Kansas City, 1971 (David Bourdon)

FACING PAGE, TOP: "Girl Talk" with Candy Darling (Frank Teti/Neal Peters Collection)

FACING PAGE: The artist Edward Ruscha, 1971 (Edward Ruscha Archives)

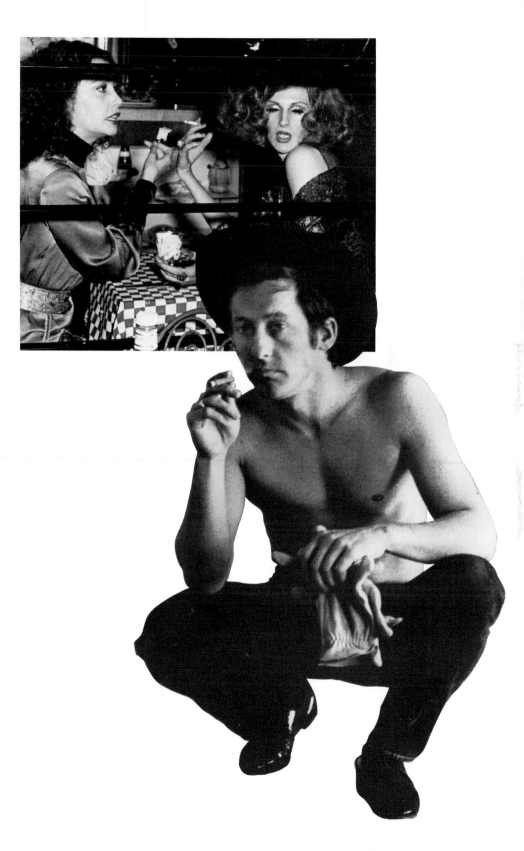

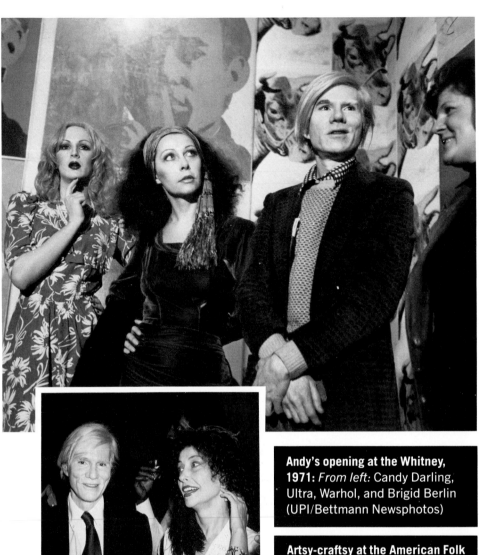

Andy's opening at the Whitney, 1971: *From left:* Candy Darling, Ultra, Warhol, and Brigid Berlin (UPI/Bettmann Newsphotos)

Artsy-craftsy at the American Folk Art Museum, 1977 (Ron Galella)

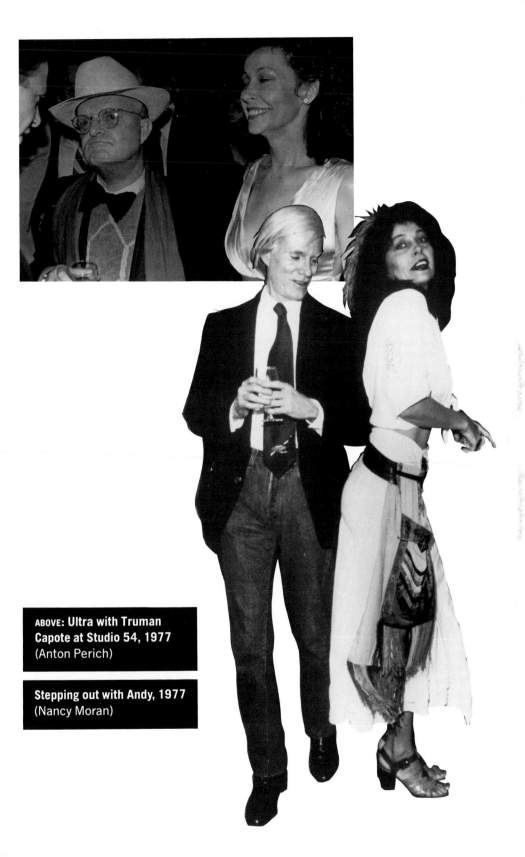

ABOVE: Ultra with Truman Capote at Studio 54, 1977 (Anton Perich)

Stepping out with Andy, 1977 (Nancy Moran)

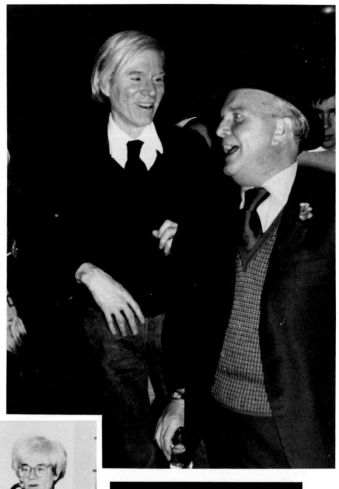

• Who was underground movie superstar Ultra Violet referring to when she said: "Andy got hurt in the big game of reality"?

Baby Boomer

Andy Warhol

Famous for 15 minutes
(Courtesy Trivial Pursuit™, Horn Abbot Ltd.)

BELOW: Andy's final resting place, next to his mother
(Courtesy Madalen Warhola)

Trivial Pursuit is a registered trademark in Canada and U.S. of Horn Abbot Ltd. and throughout the

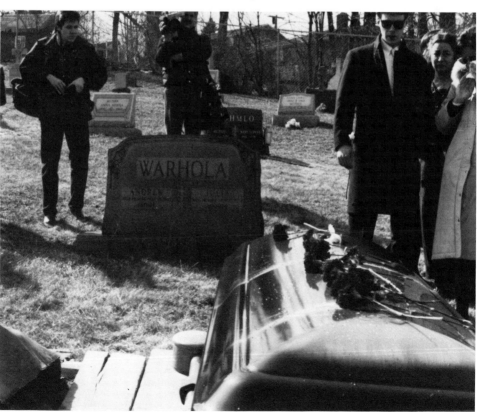

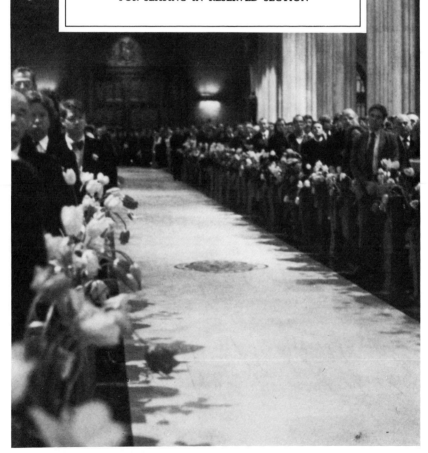

THE FAMILY AND COLLEAGUES OF
ANDY WARHOL
ANNOUNCE A MEMORIAL MASS
ON WEDNESDAY THE FIRST OF APRIL
TEN FIFTEEN O'CLOCK
ST. PATRICK'S CATHEDRAL

PRESENT THIS CARD BEFORE TEN
FOR SEATING IN RESERVED SECTION

Invitation to a Happening

The mourners at St. Patrick's (Courtesy Madalen Warhola)

A ceremonious goodbye

ANDY WARHOL

A Memorial Mass

Wednesday, April 1, 1987 – St. Patrick's Cathedral

Prelude	*March of the Priest – The Magic Flute* – Mozart Piano – Christopher O'Riley
	Louange a l'Immortalite de Jesu – Oliver Messiaen Cello – Carter Brey Piano – Christopher O'Riley
Scriptures	The Book of Wisdom 3: 1 – 9 Brigid Berlin
Speakers	John Richardson • Yoko Ono • Nicholas Love
Communion	
	Amazing Grace Soloist – Latasha Spencer
Postlude	*Recessional* – Ravel Piano – Christopher O'Riley • Barbara Weintraub
Celebrant	Father Anthony Dalla Villa, St. Patrick's Cathedral
	John Grady, Director of Music, St. Patrick's Cathedral

A LESSER-KNOWN ELEMENT IN THE PORTRAIT OF ANDY WARHOL

Five hundred homeless and hungry New Yorkers will assemble on Easter Day at the Church of the Heavenly Rest, on Fifth Avenue at 90th Street. They will be served a delicious meal, and they will be treated as honored guests by some eighty volunteers. They will also be saddened by the absence of one who, with dedicated regularity, greeted them on Thanksgiving, Christmas and Easter. Andy poured coffee, served food and helped clean up. More than that he was a true friend to these friendless. He loved these nameless New Yorkers and they loved him back. We will pause to remember Andy this Easter, confident that he will be feasting with us at a Heavenly Banquet, because he had heard another Homeless Person who said: "I was hungry and you gave me food...Truly, I say to you, as you did it to one of the least of these, my brothers and sisters, you did it to me."
The Reverend C. Hugh Hildesley, *Church of the Heavenly Rest*

Raphael I – $6.99 Andy Warhol 1985

Flowers to be donated to Mother Teresa – Missionaries of Charity, The Department of Parks – Forestry, and children's wards at various hospitals.

RIGHT: The other side of the program from the memorial mass

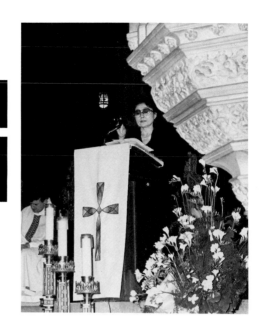

Yoko speaks well of the dead (Ron Galella)

BELOW: **Sharing condolences with Claus von Bulow and John Richardson** (Rose Hartman)

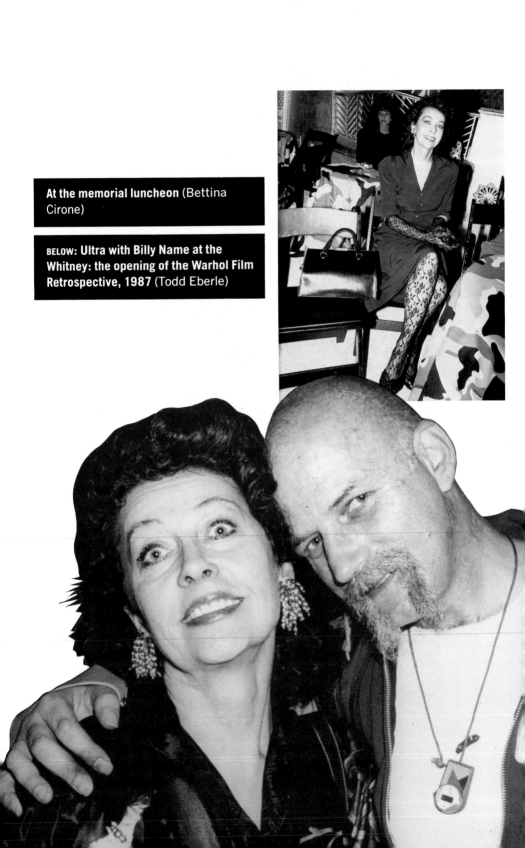

At the memorial luncheon (Bettina Cirone)

BELOW: Ultra with Billy Name at the Whitney: the opening of the Warhol Film Retrospective, 1987 (Todd Eberle)

Recovery

As he struggles to stay alive in a world he has so little use for
. . . Andy Warhol must smile at having reaped one large satisfac-
tion. His "achievements" earned him space on the art and film
pages of the press. His precarious condition has gotten page one
headlines.

When Andy is able to talk, he gives me the victim's-eye view
of the event. "Forget it, no chance," are the last words he hears
before losing total consciousness. Someone has pronounced him
dead. He makes no claim of crossing into heaven or elsewhere,
of viewing the awesome mysteries and then returning to earth.
But undoubtedly there is a perilous moment when his vital or-
gans fail and he hovers on or just over the brink of death. Heroic
medical measures restore him.

"How did it feel?" I ask.

"For days I'm not sure if I'm back or not. I feel dead, I keep
thinking I'm dead. Then I think I'm alive, but I feel I'm dead.
It's strange." A brush with an eternity of silence has rendered
Andy eloquent.

As he gradually regains consciousness after the operation, he
hears on a distant radio the words "assassin" . . . "shot" . . .
"horror" . . . "disaster" . . . "terror."

"I think it's related to my death," he recalls. "I hear nurses
crying. I think: You shouldn't cry for me. Later, I vaguely see
images of a burial on the TV. Is it my burial? I figure that's the
way it is—after you die, they rerun your death and life on TV.

"Then I hear the name Kennedy and a shot. Why are they
rerunning the JFK assassination? Through a cloud, I see a pic-
ture of St. Patrick's and I think: Why do so many people come
to my funeral? It's so strange to be dead. It's just like watching
TV."

Not for several days does Andy discover that two days after
his own shooting, Robert Kennedy was fatally gunned down in a
California hotel. It is this second Kennedy assassination and fu-
neral that he sees through a fog of sedation on television. The
nurse confirms it to him.

179

Once Andy is on the mend, he enjoys talking on the phone to the Factory crowd, to celebrities, to people from the art world, to reporters and well-wishers. When he starts complaining, we know he's recovering. "If only Kennedy were shot a different time, I would have gotten all the publicity," he laments. "Death is just another headline."

He gets plenty of publicity anyway. The press covers every step of his recovery. He leaves the hospital in August. The first trip out of his house takes him down to Forty-second Street, where he sees a porno movie and buys the dirtiest magazines he can find. He loves pornography and, deprived in the hospital, is in need of a quick fix. His second trip takes him to the studio of Richard Avedon to have his lacerated torso, crisscross scars, and stapled stitches immortalized by the foremost photographer of beautiful women. The striking photo, which turns him into a St. Sebastian, except for the black leather jacket framing his shoulders, appears in hundreds of newspapers and magazines worldwide.

In early September Andy and I attend a party to celebrate the completion of *Midnight Cowboy*. Our picture, taken at the party, makes the front page of the *New York Post* on September 6, 1968, my birthday. The caption reads: "Artist Andy Warhol, accompanied by his underground film star, Ultra Violet, made his first public appearance last night since he was shot in June by another of his stars, Valerie Solanas. Miss Solanas was sent to a mental institution."

I say to Andy, "You've had publicity, fame, headlines. Now what?"

"More fame."

"Fame is a moving target."

In a voice that sounds like a distant echo, he taunts me: "How do you always manage to get in front of the camera?"

Several weeks later, we are alone in the Factory. Andy turns to me and with a beyond-the-tomb look in his eyes says, "I'm afraid."

I am startled. This is not our Andy. He normally knows no fear. Now he says, "I wasn't afraid before. I shouldn't be now, since I've just been dead and come back. But I'm afraid." He looks at me, almost pleadingly. "Why?"

"It's just that you haven't gotten your strength back. You'll feel differently soon," I tell him in a gentle, soothing voice. It is painful to look at him. He is bent forward, with one hand placed protectively on his stomach. I want to reach out and stroke his arm, reassure him with the pressure of my fingers, with human contact, but I dare not.

Then, in a flash of insight, I see that from now on Andy will always be afraid. Fear will not leave him. When the ambulance attendants pick up his still-pulsating body from the floor of the Factory, Warhol the artist remains there, sprawled forever next to a stack of his paintings. Even as the surgeons stitch together the flesh torn by Valerie's bullet, their surgical thread cannot stem the artistic fluids that continue to ooze from every pore. Only one shot penetrates Andy's body, but all four bullets penetrate the creative spirit inside him, killing the artist.

That night I toss on my bed. I cannot sleep. My mind is on Andy and his bleak cry of fear and my certainty that the artist is now dead. Why should this be? I think back over all the times I've used death words in connection with Andy. I've talked about his necrophilia, his condemned-to-die face, his predilection for disasters, his paintings of a plane crash, an electric chair, a race riot, an ambulance accident, Vietnam, a suicide, a pistol. Death hovers around him. He plays footsy with death. He holds death at bay with his art.

Yes, that's it. In his continuing flirtation with death lies the source of his creativity. His death wish fuels a fire that blazes into paintings, films, originality, energy, art.

But now that the acrid taste of death fills his own mouth, the game is up. The reality of near death kills the death wish. The life/death tug of war is played out. His body wins. But his inspiration loses.

FAMOUS FOR 15 MINUTES

In this crystalline vision of Andy's future, I see that from now on his art will be repetitive, automatic, empty, a rerun of what went before. His life will veer off in a different, safer, more conforming direction. The artist, the sorcerer, the conjuror, the diabolist of the 1960s is gone. The man—the businessman, the moneyman—will live on, accumulating more and more money and mountains of possessions to allay his terror.

VALERIE SOLANAS

Valerie Solanas, the failed assassin, fascinates me. I am struck by her activism in the face of Andy's passivity. I contrast her passion for a cause, no matter how weird, to his indifferent voyeurism. Her inflamed but misguided courage astonishes me. I must find out more about her. Nearly all of us at the Factory have had our moments of anger at Andy. He's promised us fame, money, Superstardom, and only given us walk-on parts in his home-made movies. When a film has succeeded, he's kept the profits and seized the headlines. When we've protested, he's said, "Next time, you'll see." We try again, and next time is exactly like last time. But we're hooked. We're having the time of our lives riding the Pop wave, and if we quit, what other game is there? We are all captives of Andy's magnetism and his outlaw culture.

And now Valerie, no more wronged than any of us, probably less so, pumps real bullets into his already frail body. Who is she, this would-be murderess, *ma semblable, ma soeur*?

Her birth certificate indicates that Valerie Jean Solanas was born on April 9, 1936, in Ventnor, New Jersey, just south of Atlantic City. Her father, Louis Solanas, twenty-one, born in Canada, is a waiter in an Atlantic City hotel. Her mother, Dorothy Bondo Solanas, eighteen, was born in Philadelphia. She is a salesgirl in a five-and-dime. After Louis and Dorothy divorce, sometime in the 1940s, Valerie moves with her mother to Washington, where, in 1949, Dorothy marries Edward Frank (Red) Moran, a piano tuner. Valerie has two sisters.

From the start, Red Moran is irked by the willful Valerie. She is disobedient, runs away from Holy Cross Academy, stages tantrums in the public school she is sent to, chops off her shoulder-length hair, then, dissatisfied with the result, ransacks her sister's bedroom, upends the garbage pail, laughs defiantly when her maternal grandfather whips her with his belt.

She never forgets her sense of female helplessness in the face of overpowering male authority.

On her own at fifteen, she goes out with a sailor. It's not clear whether or not she gets pregnant, but ever since, she's angry at men. She graduates from high school in 1954, in her senior year collects A's in everything except a B in physics. She enters the University of Maryland at College Park, does well, supports herself by working in the animal laboratory of the psychology department, where she vivisects animals, and especially enjoys cutting their organs, including their sex glands, into slender slices.

She puts in a little under a year at the Graduate School of Psychology at the University of Minnesota. After a brief time at Berkeley, she wanders the country and lands in Greenwich Village, where she writes her scalding manifesto and copyrights it in October 1967. She also writes a play, *Up Your Ass,* about a man-hating hustler and a panhandler. In one version, the woman kills the man. In another, a mother strangles her son.

At the Chelsea Hotel she meets Maurice Girodias, publisher of Olympia Press, who left France after he got into trouble for violating pornography laws. He gives her a six-hundred-dollar

advance on a novel she wants to write along the lines of her manifesto, but he can't do anything with her play. Grove Press turns it down. Nobody takes her manifesto seriously.

Her anger builds. Maybe she can use Warhol's films to promote SCUM. Andy is intrigued by her campy, offbeat notoriety. She hardly seems any more of a Bellevue basket case than the rest of his outré sorority. In this instance, the murderee leads on the murderess. He underestimates her pathology. His confidence is not unreasonable, for he has already escaped death a few times at the Forty-seventh Street Factory.

Some years back, a stranger wandered in about midnight, asking for money. Then, with no provocation, he fired at Paul Morrissey's head. The gun chamber was empty. He fired a second time, into the air, and a bullet went off. The cold war was going on outside; inside, Russian roulette was just another adult game.

Then there was the legendary time when Dorothy shot Marilyn. Billy Name had a subentourage straight out of the absinthe depths of Le Moulin Rouge. Among Billy's picturesques were Stanley the Turtle, Silver George, Rotten Rita, someone called the Mayor, Binghamton Birdie, and Dorothy Podber, a veteran of the avant-garde of the mid-1950s.

One day, Dorothy arrived, dressed in leather, with several friends in leather, and a Great Dane in his natural leather pelt. She peeled off her long leather gloves, pulled out her pistol, aimed at Warhol. Then at the last split second she shifted her aim to the stack of Marilyn Monroe portraits against the wall and fired. She put her pistol back, pulled on her gloves, gathered her followers, and left. This stylish event was regarded as an art happening.

"Was Andy afraid for his life?" I asked Billy when he recited this outlandish tale.

"No. He was angry that she did it on her own instead of as part of a movie. But he secretly thought she'd done something great."

The bullet penetrated six paintings, which are now called

"shot-through Marilyns." They are more valuable than ordinary Marilyns because they are indisputably authentic.

When it is time for Valerie's trial, Girodias retains two distinguished lawyers to defend her. Telling them they can take their talents to hell, she says, "I need nobody's help. I can beat this thing myself." She brushes aside Judge David Getzoff's suggestion to arrange Legal Aid counsel. At her arraignment in Criminal Court, she declares, "I was right in what I did. I have nothing to regret. He was going to do something to me which would have ruined me." Then she shouts, contrary to everyone's understanding of the facts, such as they are, "He wanted to produce my play and I did not want it staged. Warhol had me tied up, lock, stock and barrel."

The judge reminds her, "You must realize this is a serious charge."

Valerie replies, "That's why it's going to remain in my competent hands." She is sent to Bellevue Hospital for psychiatric examination, then to Elmhurst General in Queens. She is being held without bail.

Nearly a dozen detectives inspect the Factory to reconstruct the crime and retrieve the slugs from the walls. They search through files, photographs, stills, receipts, transparencies, nude shots of Joe Dallesandro, looking for motives, clues, and, no doubt, thrills.

Valerie is released on $10,000 bail. While out on bail at Christmas 1968, she calls the Factory. Andy picks up the phone. I see his face go whiter than white. He slumps but does not fall. Valerie wishes him a Merry Christmas and threatens to repeat the shooting if he does not meet her demands: her appearance on the Johnny Carson show, publication of the SCUM Manifesto in the *Daily News*, $25,000 to repay her for what he's stolen. She also wants him to make her a star, and on and on. After that, security at the Factory is reinforced with a double door and a buzzer, and Andy is never again alone or unprotected. Valerie's bail is raised to $50,000 and then to $100,000.

A revolutionary all the way, Valerie defends herself, shouting defiantly, "Warhol deserves what he got. He is a goddamned liar and cheat, a thief. All that comes out of his mouth is lies."

She is declared incompetent to stand trial but later pleads guilty to first-degree assault and is sentenced to three years, one year of which she has already served while awaiting trial. She is sent to New York State Prison for Women at Bedford Hills and later to Mattewan Prison. She is released in September 1971, arrested again that November because of threatening letters and telephone calls to Girodias, publisher Barney Rosset, Howard Hughes, and Robert Sarnoff of NBC. In the letters she claims: "I have a license to kill." In and out of mental institutions in 1973, she continues to write obscene and incendiary letters. In 1975 she spends eight months in South Florida State Hospital. In 1977 she mails a rambling letter to a *Playboy* editor, on the theory that he is a contact man for an entity she calls The Mob.

After that, she disappears from sight. But when Andy dies in 1987, her name is revived and her short-lived fame rekindled. I begin to wonder: Is she by any chance the woman who danced on the steps of St. Patrick's on the day of his memorial service? Is hers the voice that called me right after the assassination attempt, the voice I took for Viva's? By what perverse error is my picture in the *Star* captioned with her name shortly before the memorial service?

I decide to track down Valerie, to see if she is still alive and what she's doing. I call all the crazies of the sixties. Few remain, most have blown away. Even the crazies tell me to keep away, she's too dangerous. I write letters to missing persons bureaus all over the country. I check all the shelters and soup kitchens in New York. I don't find her, but I learn that she has used variations of her name—Solanis, Solaris—and along the way I obtain her Social Security number. It finally occurs to me that she may be collecting SSI. By pretending to be her sister, needing to send her an urgent message, in November 1987 I get a number to call in northern California. A woman answers. I ask

for Valerie Solanas. There is a long silence. Then the voice says, "Oh, oh, I see who you mean. Let me see if she's in her room."

Then a voice, which I recognize from our movie *I a Man*, says, "Yeah?"

"Is this Valerie Solanas?"

"Yeah."

"You mean the famous Valerie Solanas?"

"Yeah."

"Have you written any other things besides the manifesto?"

"No."

"How come?"

"Oh, nothing to say."

"What are you doing now."

"Nothing." Then she adds, "I'm not in this place under that name."

"What name do you use?"

"Onz Loh."

I make her repeat it. Then she asks, "Do you have the newspaper edition of the manifesto? I don't have a copy anymore."

I figure she means the photo-offset edition she put out herself in October 1967. I have one copy, but I don't intend to give it to her.

"What about the book edition?" I ask. Sensing a commercial opportunity in the wake of all the publicity about Andy's near demise, Girodias finally published the manifesto in book form in August 1968, two months after the shooting.

"No, it's full of mistakes. It's not the same." She tells me that the book was not a big seller.

"Do you know that Andy Warhol died?" I ask.

Her voice perks up. "No, I don't."

"He died last February."

"Oh, really."

"He went to the hospital for an operation and died two days later."

"Oh."

"How do you feel about that?"

"I don't feel anything. Say, can you write to the copyright office for a copy of the manifesto?"

"I'll see. What happened to all the people in the sixties movement?"

"They died."

"Do you remember Ultra Violet?"

"Yes."

"What happened to her?"

"She died too."

So much for death and resurrection. But I'm glad I tracked down Valerie. After I speak to her, I find it hard to get her out of my mind. I keep thinking what a shame it is that she's mad, utterly mad. For in the beginning, beyond her overheated rhetoric, she had a truly revolutionary vision of a better world run by and for the benefit of women. I have sympathy and a sneaking admiration for anyone bold enough to propose solutions, even off-the-wall ones. But assassination, no. Never.

PARTIES OF THE NIGHT

n the late spring of 1968 I meet Norman Mailer at a birthday party for Senator Jacob Javits in the large Javits apartment on Park Avenue. The Javitses know *everybody* in New York and Washington. Senators, bankers, businessmen, actors, artists, novelists, journalists, society matrons, debutantes, and second cousins are kissing, crying out with pleasure at seeing each other (some haven't met since the last party, twenty minutes ago), balancing drinks, hors d'oeuvres, purses, handshakes, and backslaps. It's the kind of party Andy wouldn't miss for the world, but once he's here, he sidles off to the periphery to look at the paintings—Marion Javits is an enthusiastic aficionado of the arts—and observe the social habits of the natives.

The minute I see Mailer, I recognize him as a force of nature. He radiates energy and belligerence. His crinkled black-and-white hair stands up; his blue eyes crackle. He is his own man, macho, cunning, provocative. I want to tell him how much

I admire him for marching on the Pentagon in the huge protest against the Vietnam War and then celebrating that crusade in his book *Armies of the Night,* but I am a little afraid that if I choose the wrong words he may punch me. I've heard that he'll punch anyone who antagonizes him, if he's sufficiently booze-soaked, and I can see that tonight the booze is going down him fast.

At that moment, Leo Garen, a producer of art films and a friend and defender of poets, tells me he is involved in making a movie with Mailer; would I like to be in it? Would I? I want to start this very minute! Leo brings Norman over and introduces us. Mailer says, "You're very beautiful. What do you do?"

"I'm an actress."

Mailer the terrible says, "Your hair is hideous." I am wearing it wild and snaky. He goes on, "Show me your behind."

"Right here, now?" I gesture at the roomful of uptown people.

His eyes shoot annoyance at me, as if I'm being childish. "Just turn around." I turn and pull my slip tight around me. I am wearing nothing underneath. He says, "Gorgeous but too big." Andy says nothing, but Leo gallantly protests that my buttocks are just fine.

Norman says, "Your accent is hopeless."

"I can camouflage it." I have only the trace of a French accent, and I know how to speak unaccented English when I want.

"Have you acted before?" Norman asks.

"She acts all the time," Andy says. "We do a film a day."

Norman does not seem to be highly impressed with that credential, but he says, "All right, you can play a *belle de jour* who goes to a male house of prostitution." He walks away.

"Do you think he really means it?" I ask Andy.

"Gee, yes, no."

"Do you mind if I do a movie with him?"

"Why not? It's good publicity."

A week or so after that, Valerie Solanas's bullets nearly end

Andy's life. He is still in the hospital when I get a call from Leo Garen. Shooting of *Maidstone*, the Mailer film, starts in a week in East Hampton. Yes, I'm expected to be there. I'm terribly excited, but I feel awful that I can't even tell Andy the good news. He is recovering but not yet allowed to receive phone calls.

A cast and crew of hundreds invade the sylvan property of Barney Rosset, publisher of Grove Press, who bravely and rashly has provided a locale for the shooting. The press is out in full chase—reporters, gossip columnists, photographers from the newspapers, TV, *Life*, *New York* magazine, and various foreign periodicals. There's also a sprinkling of prizefighters and novelists. It's just as well Andy isn't here—he'd die of envy.

A voice at the level of my knee says to me in French, "I am the madame of a male house of prostitution." I look down and Hervé, a dwarf, introduces himself. He tells me I'm to be one of his patrons.

Norman, barefoot, in cutoff jeans, lived-in black shirt, and brown leather cap, addresses his army of the day: "Right now the film does not have a plot, only a presence. It will be about the subtle nature of reality. It will be about a famous movie director, Norman T. Kingsley, played by me, who has come to East Hampton ostensibly to look at sites for his new film, but he is also deciding whether or not to run for president of the United States.

"He knows that if he joins the race, he faces the chance of being knocked off. As we all know, this is the time of assassinations. That's why a group named Protection Against Assassination Experiments, Control, known as PAX, C—a mixture of the CIA, FBI, Secret Service, M-1, and M-6—will cover the candidate."

A prowling photographer snaps my picture with Marion Javits and Mailer's wife number two, or is it three?

Norman goes on: "The film Kingsley is making, the film within the film, will be a spoof of *Belle de Jour,* but with a male house that women visit. The male studs will be called the Cash Box."

"They'll be managed by me," Hervé confides to my hip.

(*Belle de Jour* is a popular French film, directed by Luis Bu-
ñuel and starring Catherine Deneuve, which takes place in a
high-class Parisian house of prostitution.)

After a vast amount of shouting and milling around and much
trampling of the lawn and shrubbery, the spectators, the press,
and the actors are separated, the five different camera crews haul
out tons of equipment, and I say to Hervé, "This is a military
operation. Andy's films are child's play next to what's going on
here."

I am sitting on the terrace with the three other actresses who
are to play belles. We are applying blusher and tightening our
stockings under our miniskirts. Mailer comes charging at us. "All
right, who's the first victim?" He points to the three others and
says, "You're Joy-Belle, Penny-Belle, Sally-Belle," and to me,
"You're Belle-Belle." I wonder who is Telephone-Belle. No, that's
a name for a Warhol Superstar.

But first there's a scene in which a delegation of blacks chal-
lenges presidential candidate Norman T. Kingsley, or NTK, an
intentional echo of JFK, about his position on welfare, housing,
drugs, social problems in the ghetto. The camera rolls as the
actors playing the militant blacks hurl their ad-libbed questions
at candidate Kingsley/Mailer, who zaps back his answers in a
parody of confrontational politics.

At the bar under the trees, a crowd gathers around the am-
munition cases of vodka, gin, and Scotch. John de Menil, the
oilfield magnate and art collector, elegantly dressed as always,
says, "Hi, Ultra. Are you plotting to assassinate NTK?" I just
shake my head. I'm rather sensitive to assassination jokes.

A little later, Mailer approaches with a young black man he
introduces as Lee Cook. He is a writer and will play one of the
studs, named Lazarus. It begins to dawn on me what I am ex-
pected to do. Then Mailer claps his hands for attention: "Time
for the belles' love scene." And to me, flashing his blue eyes:
"Get undressed for your love scene in the stud farm. Lazarus will
make you happy."

My God, I think, it's like the film Andy made in my apart-

ment, when I had to take off my clothes, only this is worse. These people are serious about their vérité—they want me to do the whole thing. Excitement vies with apprehension within me. If new experience is what my life is all about, this is a high point.

I've never made love to a man on camera before an audience. Do I dare? Mailer is glaring at me. I feel he wants me to chicken out, so he can either punch me or start a fight and signal the camera to roll. He won't get the scene he intended, but he'll get another, just as good or better—Ultra Violet refuses to go to bed with a black man onscreen. Headlines, scandal, *publicity!*

I can feel the adrenaline pour into my bloodstream. All right, here we go. I begin with a flip comment to Norman: "This is black in white, I presume."

"No, baby, pink in pink."

While I'm getting ready, Norman films a segment in which he is interviewed by a women reporter, who asks, "How do you feel about sexual freedom in America?"

NTK/Mailer: "It's good until it injures your sense of smell. By the time sex ceases to smell good, you've had enough of it."

Then Jeanne Cardigan, a British TV commentator, who is playing herself, says to a TV camera in front of the movie camera, "A late bulletin from NTK's sexual front: Ultra Violet, star of many Andy Warhol movies, will film a scene of all-out lovemaking with a young black man, another cinematic first for Norman T. Kingsley. Ultra now embraces Lazarus."

On cue, I do just that, on one of several beds that have been set up in a kind of playhouse that has been turned into a bordello. The other belles and their studs are getting ready for their scenes. I blot out everything from my mind. I push away all thought of the leering onlookers. I stop worrying about getting pregnant—whose baby would it be? Lazarus's? Mine? NTK's? I'm an actress. I'm playing a part. I'm going to play it to the hilt. What's more, I've caught the machismo virus. Damn them all; if

they think they can humiliate me, they're wrong. I'll show them I'm as bold as they are, maybe bolder.

Lazarus lowers himself over me. I hear a mass intake of breath. Then a man's voice cries out, "Shit!" There's a commotion in the direction of the camera. Someone shouts, "What the fuck's happening?"

"The fucking film ran out," someone answers.

The camera stops. Lazarus keeps on doing what he is doing, but I stop. In a rage, he grabs at me. "No film, no scene," I say with finality. I am playing by authentic cinema vérité rules. I reach for my robe, wrap it around me, get up and leave. They never do get back to that scene.

Some days later, we arrive by motorboat on Gardiners Island, America's only fiefdom, the virtually uninhabited seven-by-three-mile island deeded to the ancestors of Robert David Lion Gardiner three centuries ago by the British crown. In this beautiful, unspoiled setting, with ducks, gulls, and ospreys circling above and the sky meeting the water all around us, we are to enact a scene of brutal violence.

Norman T. Kingsley and his brother Rey—"king" in Spanish—are engaged in fratricidal strife. Rey is played by actor Rip Torn, who looks like a killer with his Doberman pinscher face—pinched lips, villainous eyes, chiseled cheeks, pointed ears. The camera rolls. Torn strikes NTK on the head with a hammer. He raises the hammer, strikes again, then again. Norman ducks, raises his hand to shield his head: "You crazy fool cocksucker."

Rey raises the hammer and says, "You're supposed to die, Mr. Kingsley."

Mailer is bleeding. "Stop it—let go of the hammer."

Rey/Torn: "I'm killing Kingsley, not you, Mailer."

Mailer seizes Torn and bites his ear. They grapple. Now Rey/Torn is bleeding. Norman is strangling him with both hands. The camera is going. The crowd is shrieking.

Beverly, Norman's wife, screams in horror. "What've you done, you motherfucker!"

Norman's children wail. Men arrive and separate the two mad dogs. Mailer lunges at Torn and starts strangling him again. Beverly screams again. "Norman, your head is bleeding."

Norman: "Because he hit me with a hammer, the asshole," then, to Rip Torn: "I'm pulling that scene from the movie."

Beverly: "Let me see your head, Norman."

Norman to his crying children: "It's all right. It's all right."

Torn moves toward Norman. Norman raises his fist. "Get away. I'm going to cold cock you."

Torn: "It's what I had to do."

Beverly, advancing on Torn: "The kids are here—that's enough."

Torn, now playing Rey: "Brother—"

Norman: "You're not my brother anymore."

Torn: "The picture doesn't make sense without this."

Norman: "Fuck you. It's my picture, and I know what makes sense. You did it in front of my kids—that's what I can't forgive. You wanted to assassinate me."

"That's in the picture."

"I saw it in your eyes."

The camera is still going.

Torn: "I pulled that punch."

"Not hard enough."

"I never hurt an actor before."

They keep trading insults: cocksucker, champ of shit, up yours, kiss off.

Then Norman to the sound man: "Turn off the tape; he's a very dull talker."

The cinema vérité now stops.

I head back to New York, still shaken by what I have seen. The battle between Mailer and Torn was so real, so convincing, so full of genuine fury, I was sure one of them was going to die right before my eyes. If they weren't forcibly dragged apart, the world that afternoon would have lost an important actor or a major novelist, in a tragic, real-life theater of the absurd.

196

Andy is still in the hospital. I give him a breathless blow-by-blow account of the filming, with emphasis on the Mailer-Torn main event. But I have to stop, because I can see how much it hurts him when he laughs. It's too bad—Andy laughs so seldom, and I know laughter is good medicine. But not to the extent of pulling out his stitches.

In 1969 Mailer's *The Armies of the Night* wins the National Book Award and the Pulitzer Prize. Not quite up to his dream of running for president—I think the filmed assassination attempt really scared him—Mailer campaigns unsuccessfully for mayor of New York City. As for *Maidstone,* it is widely shown in art theaters and on campuses, and Mailer later writes a book, also called *Maidstone,* that documents the making of the film.

In 1975 Anthony Portago, great-great-great-grandson of King Alfonso XIII of Spain (or very close to it), invites me to a party at Mailer's apartment in Brooklyn Heights. From his bay window he has a majestic view of New York Harbor, giant oceangoing vessels, tiny tugboats, and the Statue of Liberty. I find his blue-jean eyes immensely attractive. But I remember that he once stabbed a wife. It might be risky to get too close.

I limit myself to a mildly provocative thank-you note: "The everlasting, flaming light of the eternal bearer of truth, the Lady of Liberty, floods its rays into Norman Mailer's living quarters on Wednesday night, the 10th of December 1975, and I, Lady Violet, bear witness."

A noncommittal Mailer replies, "Dear Lady Violet, Send me more poems. Happy New Year."

I let it go at that.

MOONSTRUCK

"The moon is no cheap date," I tell Andy as we drive on January 10, 1969, to a party given by *Life* magazine for the three astronauts, Walter M. Schirra, Jr., Donn F. Eisele, and R. Walter Cunningham, who on October 11, 1968, in Apollo 7, began an eleven-day flight that included 163 earth orbits of 4.5 million miles in just over 260 hours. When I say no cheap date, I am referring to the $23 billion and the three human lives already spent on our moon venture.

"Andy, how do you feel about the conquest of space?"

"Gosh, I don't know." It is a treat to go out with Andy, for he has been hibernating since his recovery from the shooting.

I can't understand his indifference to space exploration. I am really fired up about the program and the impending landing on the moon. From years of reading science fiction, I am on intimate terms with the galaxies. As a reader of romantic poetry, I am a confirmed moon lover. The mystery of the full moon and its relation to madness has always fascinated me. And then, as a woman, I feel akin to the moon, for the twenty-eight-day lunar

tides control my ovarian cycle. The moon's longtime association with femininity convinces me that the Mount of Venus must be located among its deserts and valleys.

Now the moon is moving within our reach. One of us, an ordinary, down-to-earth fellow citizen from this planet (too bad it has to be a man—surely a woman would feel more at home on that ghostly landscape), is about to set foot on the lunar surface.

The imagination of the nation has been triggered by the fiery vessels lifting off in columns of smoke. The challenge of putting an American on the moon, proposed by President Kennedy at the start of the decade, confirms our world supremacy. Those clean, crew-cut young Americans, risking the unknown dangers, become national heroes. How can anyone not be intoxicated with excitement? Yet here is Andy, cool and indifferent.

I say, "I'm interested in knowing if there's life on other planets."

"It's hard enough to be famous here."

"Sometimes I think it's wonderful we're going to the moon. Other times, I feel the moon will be raped and despoiled and its romance demystified."

Andy's only answer: "Gee, Ultra, what imagination."

I persist. "Tell me now, what's your reaction to man walking on the moon?"

"One of my works will be up there."

As part of an art project, six artists—Rauschenberg, Oldenburg, Warhol, Chamberlain, Novoros, and Myers—are each making a drawing on a grid of six ceramic and tantalum squares. These tributes from our culture are to be printed on a tiny rectangular computer chip, which will be clandestinely attached (Andy tells me the project is not sanctioned by NASA) to the hatch of the Apollo 12 lunar module, which is scheduled for launching in November 1969. As usual, Andy has been asking everyone, "What shall I do for the moon project?" He eventually settles for a calligraphic squiggle of his initials. "Just in case there are people up there," he says, "might as well start the PR now."

We are attending the *Life* party as guests of our friend David

Bourdon, *Life*'s art editor. David has both an openness and a shy reserve that remind me of Andy, as if they might be far distant cousins. But his good, rich laugh sets him apart from Andy, and I particularly like him because a lot of the things I say he finds very funny, responding with great merriment. David greets us and introduces us to some of his colleagues on the magazine.

I can see that they are having a hard time with me. Because I view this as a very festive occasion, I am dressed to the nines and beyond. I am wearing a semi-see-through black synthetic dress I bought at Klein's on Union Square for three dollars. When I tried it on earlier in the day at home, I found it too loose. So I turned it around back to front. That way it has a much tighter fit. Much. I wear the belt tied around my neck rather than at my waist. I have on gold-coin gypsy earrings so huge they could easily be mistaken for left-over earphones. Andy is wearing his usual black turtleneck, black slacks, and black jacket.

Life is putting on a greatest-show-on-earth party. Among the many celebrities and entertainers I spot Mike Wallace, Henny Youngman, James Earl Jones, and girls from the cast of *Hair*. When I see Schirra, I tell Andy, "I think he still has some moon dust on his shoulders."

"No," Andy said, "it's dandruff." When we get closer, I see he's right. Schirra wears one of the ugliest ties I've ever seen. His hair is parted on the right. Walter Cunningham has a triple crew cut, exposing his powerful neck muscles. He, too, wears a really awful tie, with two big squares of color. He has a five-o'clock-shadow beard, a look not then fashionable, and very bushy eyebrows. I never get to see Donn Eisele in the crush of people.

Andy asks, "Can you get their autographs for me?" He is too shy to ask for himself. I take Andy's autograph book over to Cunningham and ask him to draw a picture of the moon.

"Where are you from?" he asks. He looks meaningfully at my out-of-space outfit, trying not to focus his eyes on my breasts. "There's nothing like you out in space."

He looks like a very average man. In my romantic imagina-

tion I expected a more dramatic look and really dashing style. I
ask him, "How are you different now compared to before your
one hundred sixty-three earth orbits?"

"Just the same."

I am disappointed. I say, "Andy and I and the people at the
Factory expected you would return with permanent changes."

"Like what?"

"Like a rewired brain or extraterrestrial perception. I hoped
you could read my fortune." I extend my hand. He takes an hors
d'oeuvre from the tray of a passing waiter and deposits a hard-
boiled egg in my hand. In my palm it feels like an ovarian egg
of the future.

"What factory do you work in?" he asks.

"A people factory."

"What's its name?"

"Factory."

He gives me a puzzled look and goes off to find someone
more sensible to talk to.

On the way home, Andy and I are raking over the guests and
the party. "Did you see Cunningham's tie?" I ask.

"Do you expect taste in an astronaut?"

That summer, on July 20, 1969, 600 million human breaths
are suspended on this earth as Command Pilot Neil Armstrong
radios to earth the historic words: "The Eagle has landed." The
breathing resumes. But not for long. Our breathing stops again
as the landing craft hatch opens and the camera aboard the lu-
nar module aims at the steps leading down to the surface of the
Sea of Tranquillity.

And then Armstrong's words that will echo through time:
"That's one small step for a man, one giant leap for mankind."

In Central Park, 100,000 New Yorkers are gathered on the
Sheep Meadow to watch the Sunday night moon walk in a live
telecast on three screens, each nine by twelve feet, supplied by
the three networks and bordered with the legend LIVE FROM THE
SURFACE OF THE MOON. Most of the crowd are dressed in white

and silver lamé. Children are selling moon food, yellowish waf-
ers, for a quarter. There is parachute art, a taped lecture by
Buckminster Fuller, a synthetic aurora borealis. Moon music plays
on the synthesizer.

The next day in the *New York Post,* Alfred G. Aronowitz de-
scribes the lunar rites which began early that hot, historic Sun-
day and continued far into the night: "Who has never wanted to
reach up and touch the moon? One day we'll see lights flashing
on it without giving them a second thought. Will the tides still
ride the same way? The greatest show is the sun. Beneath it,
Doris Freedman, director of the Cultural Affairs Department, is
wilting bravely in white vinyl pants and a slick white jacket belted
with wide star-spangled leather. They should have gotten Ultra
Violet."

Where is Andy? He no longer ventures out into huge crowds
of strangers in public places. He is at home, glued to his
television.

And where is Ultra Violet? I am at New York's ground zero,
on the Sheep Meadow that Sunday night, far beneath the silvery
moon, actively engaged, amid some shrubbery, with a male rock
star in our own private lunar rites. As he enters me, up there on
the three screens Armstrong steps out of the module, arousing a
worldwide climax, including my own.

So impressed am I with my lunar orgasm that I write a song
entitled "Moon Rock." It is a rock-and-roll tune about the rocks
found on the moon. Several weeks later, I perform the song in a
punk rock gospel style of my own invention in a garage on the
Lower East Side. It is there I meet Olivier Grief, a young French
composer, a musical genius, first-prize winner in piano and com-
position at the Paris Conservatory, who has studied privately with
Olivier Messiaen and Luciano Berio, giants of modern classical
music. Messiaen converses with the birds and with all of crea-
tion. I thought of him when, years later in California, I told a
group of young spiritual groupies who were dabbling in aware-
ness, "Reincarnation is for the birds." A cute little groupie asked,
"Do you mean that only the birds are being reincarnated?"

Moonstruck

Grief invites me to be the only soloist for a modern opera he has composed. The performance takes place at the Juilliard School of Music. I go wild that night. I flip a live cat in the air. I show my breasts. I sing arias, scales. I improvise. The audience is transported—in two directions. Half applaud madly. Half hiss loudly. Olivier has to apologize for my lamentable behavior. It takes me three days to recover from that extravaganza. My only excuse is that I was moonstruck.

EDIE

Edie Sedgwick touched my life and will forever haunt my memory. Born in 1943, she hastens to get back to heaven in 1971. A society darling, a debutante listed in the Social Register, with her youth, wealth, beauty, jaunty intelligence, and American neon-blue blood from Massachusetts, she perfectly embodies the beautiful people. A John Singer Sargent portrait of Edith Minturn Stokes, an ancestor for whom Edie is named, bears witness that perfection of form runs in the family.

In the summer of 1964, Edie packs her hatboxes, makeup basket, stuffed animals, and artist's materials, leaving behind her unfinished horse sculpture, covered with damp towels to keep it moist in her absence, and races to New York in her gray Mercedes-Benz in the company of Gordon Baldwin. She unpacks at Park Avenue and Seventy-first Street, in the fourteen-room apartment of her bedridden grandmother. She models for a teen magazine. An exquisite dancer, she rocks-and-rolls all night. She says, "I've got to dance things out." She performs for hours, creating her own choreography, borrowing from the fox-trot and the twist. As

she spins, sparks of glamour fly off to an admiring crowd of young men with floppy neckties and flipped-up handkerchiefs in their breast pockets, who hang around her.

Edie becomes the new girl in town.

Since sixties people worship the rock singer more than the song and the dancer more than the dance, everyone stares at the beaming energy of Edie, trotting with youth on her thorough-bred legs. After dinner at L'Avventura (the restaurant of the min-ute, where she always orders salmon), she ends her night at one of the *in* spots—Harlow, Shepheard's, Ondine, Arthur, or Steve Paul's The Scene.

In the fall of '64 she moves to her own apartment, on East Sixty-third Street between Fifth and Madison. Tom Goodwin, a friend from Cambridge, who is her hired chauffeur for one hundred dollars a week, zaps her gray Mercedes to rubble in front of the Seagram Building. Edie leases a limousine from the Bermuda Service. The driver loves her forty-dollar tips, but she never pays her bills. Whenever her credit runs out, she switches companies.

Early in 1965, Andy takes me to a party at the East Fifty-ninth Street penthouse of Lester Persky, a successful producer of commercials, who is a compulsive party-giver. He is a charm-ing host and has a Japanese cook. Around his marble table in the formal dining room, lit exclusively by candles, the Grecian faces of the young boys glisten with lust as in a Platonic retreat. The penthouse is a place of rendezvous over the years for Ten-nessee Williams, Judy Garland (already crumbling under the ef-fect of booze and drugs), Montgomery Clift, Gore Vidal, William Inge, and Truman Capote.

That night we meet Edie Sedgwick. I am struck by her daz-zling beauty. "Glamour she inhales, glamour she exhales. The word 'glamour' is coined for her," I say to Andy.

Before the evening is over, Andy asks her to come by the Factory the next day. He speaks the routine phrase: "We'll put you in a movie."

I see her again when she arrives at the Factory, in her above-

the-knee leotard and her black desert boots. A few weeks later, her Black-Capped Chickadee's voice is on the other end of my telephone. "I want you to help me with my new hairdo. Can you come over?" Her apartment is a gallery of clothes, fur coats— red fox, leopard—fur scatter rugs, embroidered pillows. I see huge peacock-feather earrings, tens of dozens of tights, a complete line of cosmetics. She has drawn on the wall right above her bed the life-size galloping Arabian stallion she left behind in Cambridge.

Sitting on a huge leather rhinoceros amid her canvases and easels, I admire her drawings of marmosets, harvest mice, rats, muskrats, squirrels, all absolutely adorable. She perfectly captures the tenderness of those sweet creatures. She offers me an opossum gently carrying with her incisors her newborn across the drawing page. The little one looks so helpless and innocent, yet human, that it has the same delicate vulnerability Edie herself generates. I cannot help but fall in love with both the small animals and Edie.

One of the mice in a drawing is wearing a top hat. "Why not?" she says. It reminds me of the cats Andy's mother published in the early fifties. One of them wore a plumed hat, above the caption, "Some wore chapeaux."

She calls Reuben's restaurant and says, "Please, caviar and blinis, immediately." She turns to me and says, "To be eaten with vodka or champagne."

Dancing to the sound of Ornette Coleman, she says, "I am dyeing my hair silver." She cuts it shorter and applies a mauve glittery lotion with one of her paintbrushes. "To match Andy's."

As I watch, I ask idly, "Do you have a boyfriend?"

"When I was a child, my father tried to sleep with me, and one of my brothers tried too. I wouldn't go for that. I just didn't want to."

Poor white ermine, I think.

"One day I found my father making love to another lady in the sitting room. That sight sent me spinning."

"Poor lamb," I say.

Edie

"I tried to tell my mother. My father screamed, 'You're insane.' My father called the doctor. They gave me so many tranquilizers I lost all my feelings. Mummy wouldn't believe me either."

"Poor sweet," I say. I want to pat her hair, but it is all sticky because of the silver dye.

"I like that song," she says, and turns up "Those Lazy-Hazy-Crazy Days of Summer," with its lyrics by Charles Tobias.

"You're not eating," I say, pointing to the caviar and blinis.

"No, I started being anorexic in school. I ate less than my rat, Hunca Munca. I used to pig out—eating and stuffing. I filled up, crammed up, then threw up."

I tell her, "I went on a hunger strike at a French boarding school, hoping they would send me home. I tried to vomit, but I couldn't do it."

"Oh, it's the easiest," she says, picking up a scarlet ibis-feather earring and tickling her uvula with it. Hoagy Carmichael's music covers the spewing and puking. Then her two dimples smile her satisfaction.

"You didn't answer me. Do you have a boyfriend?"

"After my father had me locked up, I got pregnant and had an abortion. It was easy. So my first romance was a real bummer. It really screwed up my head."

Poor child, I think. How could such an infant give birth to a baby?

She changes her tights from pink to black. Her eloquent, athletic legs are absolute beauty. I tell her so. "I fly with my legs. Like I pick up the wings of a bird and play on a flute. I converse with animals, just like my brother."

She mounts her bed, draws in charcoal additional hairs on the forelock of the pedigreed stallion on her wall. She keeps singing, "Blowing in the wind, blowing in the wind," as she strokes flying hair to his mane. "I love Bob Dylan. I also love nitroglycerin queens and aging pederasts—they're no threat to my body."

In 1965 she becomes the girl of the year. She is featured in

Life, Time, Esquire, Vogue. Her style—her black dancer's tights, right out of *Hamlet*, her five-and-ten T-shirts, and her white mink coat—becomes her trademark. She sets the trend for that year.

Edie and Andy, the androgynous media couple, become the toast of the town. They look alike, dress alike; both wear banana-shaped high-heel boots. At parties and openings, people ask, "Which one is Andy? Which one is Edie?" Of course we maliciously point to coltish Edie for Andy, while Andy whispers to Edie, "Will you answer for me?" Edie writes "Andy Warhol" in their fans' autograph books.

Edie is Andy's counterpart, more boyish than he—his gestures girlish, her motion muscular. Edie is all Andy ever wanted to be. Now that Marilyn is dead, here is Edie.

In March 1965, in a clipped coif, Edie debuts in *Vinyl* with an otherwise all-male cast, including Gerard and John McDermott and headed by amphetamine queen Ondine. It is a seventy-minute sixteen-millimeter black-and-white film, its general concept provided by playwright Ronald Tavel.

Edie's huge, *fusain* black eyes remain Popped as she watches Gerard do his juvenile-delinquent torture number on a runaway kid, Ramsey Hellman. Under the supervision of a real sadomasochist expert, Malanga uses the razor blade, candles, chains, and nails. Edie, in a black leotard, propped up on a silver-sprayed trunk, flicks the incandescent burning ashes of a cigarette on the tortured boy lying at her feet.

Like Marilyn Monroe in *The Asphalt Jungle*, she steals the show with her five-minute sit-on.

"How was your first filming?" I ask.

She says, "Near the end, the entire room was stoned. Amyl nitrites and everything else. It ended up with everyone doing it with everyone right on the couch, in the bathroom, the hallway, the roof. I couldn't believe my eyes. I walked over to Andy, but he was mechanically chewing on his hamburger."

"Did Andy give you any direction?"

Edie

"He just said, 'Work for no meaning.' "

She becomes the Super-Superstar, dethroning Princess Baby Jane. She is so celestial, we feel no jealousy.

Effervescent Edie stars in *Poor Little Rich Girl, Bitch, Kitchen, Prison, Face, Afternoon, Beauty, Space, Outer and Inner Space, Lupe,* and *Vacuum.*

The enchantress becomes a piece of Pop Art. At shows, everyone looks at her, not the art. Art incarnated, she is so very beautiful to look at. "So effectively created, she exposes all the dishonesty in the room," says Robert Rauschenberg.

Rock singer Patti Smith says, "I am not into girls, but I have a real crush on her."

Fashion magazines pick up on the female Superstar. Edie makes things Pop for Andy. She opens doors for him. Patronesses of the arts Ethel Scull, Dominique de Menil, Lita Hornick adore her—and him. Now Andy covers the new ground of fashion, in addition to films and art. She lifts Andy up to new heights of social and fashionable strata.

Straight line, anthracite eyebrows, silvery moist lips, white hair, Edie dances the Sedgwick—that's what we call it—wearing a million bangle bracelets, perched on the highest of heels with her God-created perfect legs arabesquing in her rock-and-roll ballet with fluid grace. Out every night, Edie picks up the tab for her entourage of thirty leeches, including Andy, Edie's friend Sandy Marsh, and myself.

René Ricard, stylist, art connoisseur, underground actor, is on the scene the night Mick Jagger, most famous rock singer, meets Edie, most famous girl in New York. "Everyone watching, boy or girl, wanted to fuck both of them," he says. An explosion of flashbulbs momentarily blinds the mob of kids screaming at The Scene. Police use their sticks to keep the crowds back. People outside chant, "Mick! Edie! Mick! Edie! Mick! Edie!"

Edie is at her height, too high to last. Born innocent, not knowing right from wrong, Edie tightropes on the edge of the vortex that whirls her into the underground sewer, the darker

depths of the underworld. As vertical as is her rise, so vertiginous is her fall.

Edie is troubled by the stories told and retold around the Factory about Freddy Herko, star of *The 13 Most Beautiful Boys*, a flamboyant actor and a gifted dancer. On October 27, 1964, lean, naked, a Mozart freak, with the music of the Coronation Mass on full blast, he swirls with stunning velocity, advancing in great rushes toward an open fifth-floor window. In one extreme bound, in a grand jeté à la Nijinsky, he takes off with flying élan, free at last, a magnificent frigate bird, scissor-tailing across the sky above building roofs on his own momentum. In his ultimate leap, he lands on the asphalt, dead on Cornelia Street in Greenwich Village, a martyr of druggery.

Andy's reaction is, "What a shame we didn't run out there with our camera to film it." I see Edie's terrified expression at that remark.

Edie is troubled, too, by the movie *Horse*, which we see together. It was filmed in the Factory just before *Vinyl*. Andy rented a huge stallion for the day. The plot involved four guys who were to sexually assault the horse and make love to it; the theme centered on Western cowboy homosexuality, bestiality, brutality, animality. The boys, all stoned and boozed to the teeth, are coached by Tosh Carillo, who plays an S & M cowboy.

With his obscenely prehensile toes, Tosh unzips the jeans of all the boys in sight. In full erection, they charge at the horse from all sides and from behind. The stallion becomes nervous. They give it amyl nitrite, passing the drug under the horse's flaring nostrils for a quick fix. But the horse knows better and kicks Tosh full in the face. They're all so excited with the stallion that Tosh keeps on charging the horse and gets kicked again.

Edie screams in horror. As the excitement mounts, Tosh and the boys strip, while kissing and licking the stallion, then beat at each other, slam each other's heads against the concrete floor of the Factory until some bleed, others howl in pain. We are told that at the shooting Andy keeps filming while Ronald Tavel

screams, "Cut it out, cut it out." But the beatings go on until Tavel separates the demented combatants.

At the viewing, Edie cries, "How perverse. I'm thinking about the clay horse I left behind. How sweet animals are, sweeter than men."

As money runs out, fun runs out too. Edie goes through eighty thousand dollars in six months. Like nearly everyone else around, she uses drugs, especially with all her Cambridge friends, the Timothy Leary crowd. In her icebox she stores little brown vials of LSD to drop on sugar cubes.

By 1966 she is hooked. She is crushed when she is excluded from Andy's next movie, *My Hustler*. For her, the music stops altogether. By 1967 she is falling apart. Her free will is eaten away by the chemical agents that take control of her. Ondine becomes her French maid. His primary task is to awaken her from her barbiturates. To get through to her, he has to ring the bell for a full hour, in his own amphetamine frenzy. For break-fast he serves her drug paraphernalia and a saucer filled with speed. Desperate for money, Edie steals English antiques and pieces of art from her grandmother's elegant apartment and sells them to buy drugs.

Edie calls me one day, screaming, "All my jewelry has dis-appeared, my diamond ring. They tell me it's in my cold cream jar, but it's not." She calls an hour later: "My fur coats have disappeared too, and I can't find my long white satin evening gown and my black ostrich cape."

Her designer clothes vanish, one after the other. She is stripped down to nothing. I call her to find out how she's doing. She is out of control, her words are not connected. One day she alarms me when she tells me that during the night she passed out on the tiled floor of her bathroom and knocked her head on the toilet.

"Can't you go to your family?" I ask her. Surely there is someone who can take care of her.

"No; they're worse than the Warhol crowd."

211

The next time on the phone, she says, "I got white light all over, in my head." I realize she is singing the words of "White Light/White Heat," the song written by Lou Reed that goes on, ". . . ooh white heat watch that speed freak, gonna shoot it up ev'ry night of the week . . . ev'rybody want to kill their mother."

"Would you like me to call your mother?" I ask. There *must* be someone.

"Oh, no; my family's worse than Warhol," she repeats. "My head is spinning. I have to shoot up every half hour. I cracked my skull when I fell. . . . I bleed through the nose, but a friend came over . . . gave me some coke to fix it. I felt low, so I popped more speed. . . . Then I start to hallucinate. . . . I scream. . . . I call Dave."

"Dave who?"

"Don't know. He plunged a big needle in my butt. No, my stomach; my butt is all bone. I went out for an hour. When I came back I felt worse. Dave gave me some acid. . . . It sent me insane."

"Edie, is that all you're feeding on—speed?"

"Haven't had any food in four days except seventeen cups of coffee. I'm down to seventy pounds."

She goes into a coma and is taken to Manhattan State Hospital. I try to call her there but can't reach her. I want to help her, but by this time I've been around enough drug people to know that even the most loving friend is powerless against the compulsion toward self-destruction. Edie is beyond lectures and appeals to stop. And if I try to take her drugs away, she will feel so threatened she will turn around and take a double dose.

Dealing drugs, she gets busted, goes to jail briefly, and is put on probation for five years. I hear that in 1968 Edie Sedgwick and Valerie Solanas meet in the hospital on New York's Ward Island, where Valerie is under examination to find out if she is rational enough to stand trial for shooting Andy Warhol, and Edie is struggling to recover the sanity she lost in the Warhol years. Do they discuss Andy? Do they compare grievances? I wish I could tell you, but I don't know.

Edie

A few years later, I see Edie in California. She has become a monster, with a wide skull and a limited range of emotions and thoughts. The mind-expanding drugs have enlarged her head. Her skeleton looks enlarged as well. She is a prisoner of the earth, and only death will deliver her.

When she dies, in 1971, Andy is not at her deathbed to film her. Her death is only of passing interest to him now that she is cast out from stardom. At her funeral, her casket is covered with magnolias.

On my next trip to California, I visit her grave in Oak Hill Cemetery in Ballard. The heroine of "Blonde on Blonde," a Bob Dylan song, rests at last under a slab of red granite, inscribed simply and almost anonymously:

EDITH SEDGWICK POST

WIFE OF MICHAEL BRETT POST

1943 – 1971

I know the fallen angel tiptoed all the way back to heaven.

When the people at the Factory hear the news of Edie's death, they say, "Oh, I thought she died two years ago."

I have an overwhelming feeling of waste for the little rich girl who did not inherit from her family even the most basic emotional securities. With her glorious smile like a Broadway curtain opening, self-lit with her spotlight, she became bait in the Warhol trap of fame, sex, and money, used as an irresistible decoy to lure live young boys, screaming headlines, and above all box-office payoffs.

I cannot shake off my sadness and sense of loss. I start to question Edie's life and my own. Would she have been better off if she had stayed home with her family? Would I? This is a thought that has not occurred to me before. Maybe it's time for me to put some distance between myself and the Factory.

S uddenly and unexpectedly I am in love, madly, wonderfully in love, positively more in love than ever before in my life. My love is Edward Ruscha, an original talent, a promising West Coast painter. We first meet at a party in his house in 1970. He opens the door, I find him immensely seductive. I am attracted to him beyond reason. He has a wife and a child, a little boy called Frenchy. That does not deter me. I am too crazy about Edward to think rationally. I meet him in his studio. When he touches me, kisses me, I feel ecstasy. We make love divinely.

I fly from New York to Los Angeles as often as I can to see Edward—King Edward I call him. I give him bags of gold English sovereigns with King Edward's face. I give his son presents. From New York I make arrangements with a stable in California to rent the best stallion I can secure for one day, and on his birthday I have it delivered to his studio door in Los Angeles. He loves the horse. To thank me, he makes a painting

using chocolate and violet petals instead of paint. He is famous for applying natural materials, such as mashed strawberries, black beans, carrots, to his canvases. He also likes to use words in his paintings. This one is titled *Well Roughly*, an expression I use all the time.

For my birthday he does another painting for me. He uses his own blood to write on it the words "Oro Puro"—pure gold. I am stunned by the beauty of the painting and deeply moved by the gift of his life fluid. I lean it against the wall in my apartment and go into the bathroom. I hear my dog, Hello, make an unfamiliar sound. I come out to find her licking the letters of the painting. The blood! I move her away from the painting, but I do not have the heart to punish her.

On Edward's next visit, I show him the painting, with great embarrassment. He finds it much improved. "It's gone from hard edge to expressionist," he says.

On one of my trips to California, Edward arrives carrying a huge box. "It's a wedding ring," he says. I unwrap the box. In it is a Black Beauty bowling ball. I insert three fingers, and an electric current charges through me. It is as if my fingers, my whole hand, then my arm and all my body become possessed by Edward's love. I feel engaged to him. I wish I could marry him.

I adore my Black Beauty bowling ball ring so much that I wear it almost all the time, or rather carry it, with three fingers of my right hand in the ball and my left hand bearing its weight. I am "wearing" the ball ring at a press party for rock star David Bowie on his first trip to the United States. He is astounded at my outsize "ring" and at my outrageous behavior when I give a press interview in a bathtub filled with milk.

My love for Edward is intense, fierce. It dominates my entire life.

I am so thrilled to be in love with an artist, for even though I've been a socialite and a superstar and have had recognition, money, lovers, it is art that has been the most rewarding element in my life. It gives me a sense of meaning and fulfillment, a

reason for living. I have had unique relationships with artists, from Dali to Chamberlain, from Graham to Warhol. They have painted me. I have been their confidante as well as critic. I encouraged unknown artists by acquiring their works, and at times we both benefited financially when I resold their paintings or sculptures.

I vividly remember, while shopping with Andy in a thrift shop, discovering an inlaid wooden box fitted with cut-crystal carafes filled with liquors of various colors. It was so magical I bought it, knowing it belonged in the collection of Joseph Cornell, whose artistry lay in creating boxes that contained a universe of their own. Through Ray Johnson, another artist, I had the box delivered to Joseph's house. Two weeks later, I received a poem and two violet-flower earrings, encased in a charming violet-color box, all of it made by Joseph for me. I subsequently gave it to the Smithsonian Institution in Washington.

Now that I am so happily in love and have edged out of the frantic Warholian whirl and no longer need to catch every opening and stalk every photographer and greet every dawn, I have time to read and think. I search for a sense of reason and fulfillment. After all, "Ultra" means "beyond." I want to experience life more deeply. I seek out more profound meanings. I begin reading about spiritualism, astrology, numerology. I look into fortunetelling, magic, psychic phenomena. Luckily I never get into voodoo—my friend Hugh de Montalembert does and is blinded for life. I read and reread the writings of Alice Bailey, Gurdjieff, P. D. Ouspensky. I try on disciplines the way I once tried on clothes.

My search leads me to meditation, transcendental and otherwise. I follow the footsteps of Yogi Paramhansa Yogananda and then Sathya Sai Baba. I endorse the "I am," a very pure and absolute religion founded in 1920. I flirt with Christian Science. I sit in the lotus position for days. I study the Scriptures, I read the Koran, the Bhagavad Gita, the Urantia, a monumental book about the superuniverses including our own. I create, produce,

direct, and star in my own cable-TV talk show on consciousness expansion.

As my own consciousness expands, as I grope my way through discourses and holy texts, I become a little uneasy over my relationship with my beloved Edward. We are committing adultery. A detail like that never troubled me in the past. I have always taken love as it pleased me, reached out for it without regard to consequences. I've thought of a betrayed wife as her husband's problem, not mine. But now I begin to think about my own role in this wrongful relationship. I become aware that adultery is forbidden by all the systems and philosophies I have been studying. Shaken by that awareness and in the light of ancient truths, newly revealed to me, I see that our love affair is immoral, forbidden. At least a thousand things in my past life were immoral, forbidden. It is too late to undo them now. But my passion for Edward is present, immediate, and immense.

I am hurting Edward, his complaisant wife, his child, myself. I do not want to break up a home. I have to practice what I now believe in, to take responsibility. I must observe the Ten Commandments. I have to stop. I cannot explain this to anyone. I cannot even explain the intensity of my feelings to myself. In my circle of friends, there is no one to whom I can talk about guilt and retribution. All I know is that I must do something very difficult, nearly impossible, and I must do it right away. I am a person who believes in absolutes. I feel I have no choice.

In New York I pick up the phone, dial Edward's number, and say, "I never want to see you again."

Today I wonder why I wasn't gentler, kinder. But at the time, it has to be all or nothing. I have no strength for debate or argument. I cannot find the words to tell him that what he has been doing is wrong and what I am now doing is right. It sounds too self-righteous, especially on the phone. If I try to do it face to face, it will be worse and I won't be able to resist his charm. So I break off without explanation and let him believe what he will—another man, a change of heart, whatever.

My heart breaks. I cry openly in public places and fail to hide my tears. I adore this man more than anything in the world. I come close to killing myself over this lost love. Yes, I wish to die, for a part of me believes that I must perish as a final punishment. But another part recognizes that I must endure the expiation process to the end. I must submit myself to the burning of my love flame until it finally consumes and purifies me.

Feverish and full of fear from my reading of the Bible, I am not sure whether it is hallucination or a true visitation when the prophet Isaiah appears and says to me, "Come now, and let us reason together, saith the Lord: though your sins be as scarlet, they shall be as white as snow; though they be red like crimson, they shall be as wool."

I am totally possessed by this vision. I repeat Isaiah's promise as a mantra for days on end. I check the words in the Bible, Chapter I, verse 18, and know they have been written for me.

Then a recurring, surreal dream haunts my nights: I am standing near the edge of a cliff, where I pick a magnificent violet. I bottle the scent. With a pair of metal tweezers I tear apart the stamen. I examine the seed. One by one, I weigh the petals. I measure their length and width with a centimeter ruler. With a calculator I evaluate their density. I proceed to cut up the flower and fit the tiny pieces under a microscope. Violet color bleeds off on my fingers. The shreds of petals rot swiftly, but before they disintegrate I accumulate a long list of data. I copy the information into a notebook. Then I try to put the violet back together again.

When I can't, I am frustrated. I feel powerless. I grieve over the flower. I brood over my inability to make it whole again. The dream wrecks my sleep seven nights in a row. On the eighth night I awaken. I know I must be bleeding internally, for blood is running down my leg. I feel so desperately ill I know I must be dying.

REFORM OR PERISH

call Joseph Koster, a man who has given up his successful Wall Street interests to write and read widely in Eastern philosophy. We have become good friends. Joseph is in love with me, but I am not in love with him; I am still and forever under the spell of Ruscha. I am grateful for Joe's devotion but unable to return his ardor. I ask him to take me to the emergency room at Lenox Hill Hospital. I am on the table in the emergency room, among accident victims and someone who's just been shot. The doctor leans over me. I am frightfully ill, so ill I actually feel my spirit leave my body. I'm sure I'm dying. I prepare my soul for God. "Please receive me as I am," I pray. "I know I'm not too clean. I regret the things I've done. Please forgive me. If I had to live my life again, I would live it differently."

The emergency room dismisses me, and Joe and I ride home in a taxi. I start to bleed again. Joe wants to take me back to the hospital. I say no; I know there will be no instant forgiveness by

God. I must live through this trial on my own. "Please take me to your place," I ask Joe.

Joe lets me stay with him for a year. He treats me gently, sweetly. I spend most of my time in bed. It seems I bleed through the day, I bleed through the night, I refuse the treatment of a doctor; I don't trust doctors. Joe, like a saint, cooks for me, brings me food, feeds me with a spoon. I am nailed to the bed. Only a short while ago, I was on the go twenty-four hours a day. Now each sunset impresses me as the last of my life. Each sunrise seems to bring my last day.

When I am awake, I review my life, screening it like a motion picture. I envision the homes I have broken up, my lies, my robberies, my abortions, my adulteries, my cruelties, my recklessnesses, my sins. I read the Bible. I realize with horror that I've broken just about every one of the Ten Commandments.

I think of the psychological and sociological devastation that we who proudly labeled ourselves the avant-garde have caused. I am overcome with guilt, with remorse.

I dwell time and time again on the youngsters I've seen OD. I am especially troubled by Edie. I am obsessed by her memory, a bright morning star, and I let her waste away. I saw her turn to dust. Could I have prevented her death? Am I my sister's keeper? The Scripture teaches us so. Is redemption of self possible without redemption of others? A feeling of unworthiness, selfishness, callousness, ugliness weighs on me.

Alone and in torment, I think of Edie. In my sane mind, I know I was powerless against the forces pulling her to destruction. Neither logic nor love can save a person possessed by drugs. But still the doomed Edie haunts my weird, flickering dreams, dreams of hellfire, racks, and torture devices that punish me day and night. In one of my dreams I see Edie hanging head down, feet up, tied to a rope. She has a bag of puke in her mouth; she is gasping. I learn much later that when Edie received shock treatment, a bag was placed at her mouth to receive regurgitated matter.

Reform or Perish

In a recurring dream I see a headline: "Ultra Violet X-Rays Andy Warhol." At Joe's insistence, I have been x-rayed repeatedly in recent months as the doctors search my body, instead of my soul, for the malady that is consuming me. In my dream, I become the technician who orders Andy onto a table cold as a morgue slab, which tilts him head down, almost to the floor. Then I focus the probing eye of the machine on his vital organs, dart to safety outside the door, and return to say, "Now turn, please, just a little to your right. . . ."

Later, when I hold the x-ray film up to the light of truth, what do I see?

I find a human-inhuman hologram of a man with a yellow flickering light on his forehead, like a third eye. On close examination, it proves to be a Polaroid camera embedded in his brow. There is dense printed circuitry from his eyes to his ears to his hands. In his inner ear is a library of microcassettes. His tongue is missing, but there is a coin slot in his mouth.

Surprisingly, a heart-shaped valentine is pinned to his right chest. Handwritten across it in blood-red letters: "I love you, Mother."

A fiery track—starting at his abdomen, continuing to his chest, on to the left lung, then the esophagus, liver, stomach, spleen, on to his right lung and out his side—puzzles me. Then I recognize the path of the bullet that nearly killed him.

The gallbladder blinks off and on. I'm not sure, but I think I detect the word "Help."

The genitals don't show.

The limbs are normal except for the nuts and bolts that rivet them to his skeleton.

An infinite inventory of numbers is imprinted on his skin. The digits go on and on: birth certificate number, telephone numbers, charge accounts, bank accounts, insurance policies, zip codes, social security and internal revenue numbers, real estate registry numbers, passports, license plates, club memberships, many more.

221

In the morning, awake and feverish, I ponder the meaning of this dream. Is Andy a Lucifer, tempting us into a cybernetic nightmare from which there is no escape? Is he the apocalyptic beast of materialism, identified by 666? Or is he a prophet come to warn us, save us, from mechanized, computerized destruction?

After a year of struggle with devils that want to keep me on their side, I conclude that I must choose: Death or change. It is that simple: Reform or perish. The doctor tells me I have an ulcerated colon. He recommends its removal. That means carrying a sack for body wastes all the rest of my life. My bowels are burning with excruciating pain, but I refuse the surgery. The pain becomes more intense.

A few nights later, in my delirium, I visualize myself in a store in California with a friend. We're shopping—well, actually shoplifting. We look around to make sure we're not observed, then blithely slide various items into our oversized purses or shopping bags.

My friend and I are caught. We are arrested, handcuffed, hauled off to the station house, fingerprinted like common criminals, stripped, and subjected to a totally humiliating body search by a lady cop. Do they think we've stuffed pearls up our vaginas? I awaken in a cold sweat, remembering with horror that this is not a dream but something that happened to me a few years earlier, something I've tried to banish from my mind. I recall now that my friend's attorney got us off without a jail sentence. I thought the ugly episode was finished. But now it explodes in my mind, spewing poison through my arteries and veins.

One day, alone in the apartment, in agony and in tears, I know I can't go on any longer. I've seen the four seasons go by outside the window. Maybe it's time to leave. I welcome death. Death will end my persistent memories of Edward. I try to get out of bed. My knees give way. I fall to the floor. I get hold of one of the bedposts and try to pull myself up, but I remain on my knees. I don't have the strength to rise.

With a loud cry, I growl up to God. I beg for his mercy. I scream out loud, "I pray to you, God of Isaac, Abraham, and Jacob. I pray that your son Jesus Christ save me. I accept Him as my savior."

Those are the magic words. I cry for a long time. Then a calm comes upon me. I sigh and sigh and sigh and sigh. Peace envelops me. I am released of all the demons bottled up in me. Finally I crawl into bed and sleep quietly. That night my cheeks have some color, and I'm able to sit in my nightgown at the dinner table with Joe and his son Chris.

I suppose some would say I experienced a nervous breakdown. Certainly I suffered a psychic collapse, brought on by my agonizing break with Ruscha. Maybe my body rebelled against the life I was leading; maybe I was punishing myself for my sins. Once I broke through to acceptance of God, my immune system rallied and healing began.

I undertake to heal myself. I conciously choose to investigate alternative medicine. I dive deeply into the literature of healing, nutrition, positive thinking, acupuncture, color therapy. I study books on rebuilding physical and emotional health. I discover Chinese medicine and its principle of regeneration. I change my whole style of living, thinking, eating.

I am warmed and comforted immeasurably by Joe's concern for me. We finally become lovers, in a gentle, wistful way: I out of gratitude, he out of hope I will someday return his passion. But that is not to be.

At first when I go out of the apartment, I feel like one of those fragile ninety-year-old ladies who live in dread of being knocked down by some young punk, for they know they will not be able to pick themselves up. I have to hold on to railings and building facades as I walk. But our bodies are more resourceful than we know. Eventually energy returns. Life prevails.

While I am still struggling, Edward, my greatest love, calls me and says, "I have my walking papers." I've never heard that expression before, but I know instantly what it means. Even though I still love him, my condition does not permit a warm

reaction to his news. I can't tell him I'm dying, dying partly because of him. He tells me he's coming to New York.

"I'm sorry, I can't see you," I say. How can I let him see me like this? I've lost fifty pounds. He used to love my curves; now I resemble a Buchenwald skeleton. I don't have the strength for a rendezvous. And even though he is free, I don't believe he has repented. But most of all, I can't let him see me like this.

When he gets to New York, he is still so much on my mind that I gather enough courage to call him at the Stanhope Hotel to offer some kind of explanation and to hear his voice one more time. A woman answers the phone. I leave a message. He calls me back. "You didn't want to be with me, so I brought someone else," he says. "I can't get rid of her now."

A few years later, I run into Edward in New York. My heart skips several beats. I feel myself swooning with my old passion. But he is with someone new. It is too late for me. In 1982 the Whitney Museum gives Edward a retrospective show of 140 of his works. Now fully recovered, healthier than ever, I make myself as beautiful as possible and attend the opening. When I see Edward, again my heart misses beats and the old flame seems to rekindle. I greet Edward, I tell him the show is a beauty. He tells me that he has built a house in the California desert. That must be a beauty too. Alone late that night, I weep that the home is not for me.

HOME, SWEETEST HOME

As a teenager, I left my home in France, a black sheep. In 1975 I return, a sick sheep. I half expect to die and need to mend a huge hole in my life before it is too late. My sister Edwige is waiting for me at the Nice airport. She has the intense blue eyes, fair skin, and blond hair of my father and grandfather. She is ten years my junior. She has a very rich husband, three lovely children, and an apartment decorated with signed antiques. She has not lived through tidal waves and tempests, as I have. I wonder why she smokes one cigarette after another.

We drive along the Mediterranean, where bathers are bouncing in the waves. The fragrance of the mimosa and the cactus-like agave trees awakens sensory memories of my childhood that seem buried as deeply as Akkadian ruins. The car stops in the paved driveway, bordered by laurels in bloom. Dogs bark my first welcome. Then comes a Portuguese maid dressed in white. The monumental glass-and-cast-iron front door opens slowly, and my

father is framed by the sea, visible behind him through the marble hallway and the glassed wall of the dining room.

Of course, I recognize him. He is my father, my long-lost father. Now his hair is white. When I last saw him, twenty years ago, it was black. His eyes peer at me through glasses with transparent frames. His nose seems a little longer, his forehead wider. The scar is still on his left cheek from his long-ago childhood. His dignity is striking. He extends his arm to shake hands. I am not to get a kiss, not to be enfolded in his arms and pressed warmly against his chest. That is not his way, and I must accept it. If I am not ready to accept him as he is, then all my years of struggle, all the recent agony, have been for nothing.

I extend my hand to him. We shake hands. He says, "*Sois la bienvenue.*" You are welcome. I take a deep breath. It is good to be welcome, good to be home. An array of Dalmatians and Irish setters, my brother's dogs, and miniature pinschers, my older sister's and mother's dogs, swarm around my feet.

My mother is in the hallway. She offers her cheek to me. I am struck by the ravages of time on her face, but her features are still beautiful. It will take me a while to get used to the ruin of her classical loveliness; I have lived too long with the youth culture.

I am overwhelmed by the beauty of the house, by the security I breathe in the air. I walk through the gallery of portraits of my ancestors. They look down at me, reminding me of where I have come from, of the proud descent. They speak to me of well-ordered hearths, cries of children, laughter of adolescents, conversations of grownups, the fullness of life. The onrush of life fills the huge emptiness within me. Why, in my youth, did I view these people as jailers? Now I see them as my lifeblood. It took all of them, through centuries of history, to beget me. I shiver, with a deep but healing contraction of my whole being.

Dinner is served by another young woman from Portugal. The food, very fresh, but richer than I am used to, soothes my ailing soul. I can see my family looking sorrowfully at my pale,

thin face, my lifeless hair, my emaciated body. But they say nothing. We speak casually of the children, of plans for the next day. Would I like to go fishing with the fishermen? "No, I think I'd rather rest, take it easy."

As we climb the monumental white stone stairs of the large, three-story house, I want to kiss my mother again. Since there is no one else in sight, I say, "Mother."

"Yes, daughter."

Then, daringly, "I'd just like to kiss you good night."

She presents her cheek. I kiss it. I wish I could bury my whole body in her lap. I wish I could crawl back into her womb, remain there another nine months, and start all over again. I wish that, at the very least, I could hug her, lean my shoulder against her. But in our family, feelings are shown in other ways— in wills, in inheritances. Flesh to flesh is alien, untried. I wish desperately it were otherwise.

I walk along another corridor of ancestor portraits. I scrutinize each serene or frowning face—there are no smiles for serious exposure to posterity—searching for clues, for meaning of the mystery, the alchemy of family. In my bedroom, a photograph of my paternal grandfather awaits me. Even in black and white, I can see his limpid blue eyes, the white of his hair and mustache, the pink of his large, aquiline nose. I remember now how fond he was of me.

I close my eyes and see again my grandmother, his wife, thin, kind, devoted, a perfect lady. Where are they now? I wonder. Are they hovering over this house that once was theirs? Are they looking over the headboard of my bed, my childhood bed, unused for twenty years, made of Louis XVI mahogany, made when Louis XVI sat on the throne of France? Almost reverently, I finger the gilded garland on the headboard, the yellow Naples silk bedspread encrusted with the symbols of a later monarch, the bees of Napoleon.

In bed, I think about our dinner. I see the huge table covered with a white cloth, elaborately embroidered with the family ini-

tials. I see the porcelain designed by my grandfather, his mono-gram engraved in gold and in silver on the heavy flatware. My sisters have received substantial dowries and my brother lives magnificently on my maternal grandfather's estate. Perhaps someday some of the wealth will be mine.

I consider the lives of my siblings—their homes, their family treasures, their gardens, their trees. Why have I torn up my roots? I think of my mother's kiss. I left home without looking back. Now I want to tell her I've changed, I want to tell her how much I love her.

My tears flow. Where are these oceans of tears coming from? Healing tears pour down my face, balm for my wounds. I look around my room, *à la recherche du temps perdu*. On a small Louis XVI library table I see a book, beautifully hand-bound. It is a book of records in my mother's handwriting. I sit on the edge of my bed and turn the pages of our past. The first page records my brother Yves's birth, the date, the hour, his weight. He was breast fed. Each precise time of feeding is noted. On the second day his weight has decreased slightly. The record continues for each day of his babyhood. His height is noted, his first words, his first cold, the day he first ate apple purée. How remarkable! How moving that this is all here in her writing, lovingly pre-served.

I turn more pages, and there is the same careful record for my sister Catherine. Her history covers ten pages. Turning more pages, I see with amazement my own name, my weight, the hour of my birth, the time of my first breast feeding. I, too, weighed a little less on the second day of my life than on the first. I, too, gained, ate apple purée, spoke my first words—*papa, toutou, maman*. Again it takes ten pages to tell my story. There are an-other ten pages for my younger sister, Edwige.

The tears start again. I have been loved. I have been loved exactly as the others were loved. But I never knew it. I always thought I was discarded, cast out of my parents' love. Now, after I have spent nearly forty years in the prison house of darkness, the light of truth opens my blind eyes.

228

I pick up another bound volume, a record of our ancestors, the line of the Terrays. Heading the genealogy is Antoine Terray, *bourgeois de Boen-en-Forez; cité en 1569.* What is he, sixteen or seventeen generations my senior, alive in another time of turmoil—renaissance, reformation, endless wars of religion and territory, Medicis and short-lived monarchs? Did he know about the then new New World across the broad, restless sea, to which I have fled? That night I dream of kings in ermine and velvet, their heads lopped off by flashing golden swords.

When I awaken the next morning, my brother and sisters and the children are at sea on a fishing boat. We meet at lunch to admire their catch, which will become a bouillabaisse for dinner. We talk about family. I ask, "What happened to Jean Duron?" He is the wild young cousin who led all our mischief in childhood.

"After a collection of wives," Yves says, "he voluntarily left for Africa, without a forwarding address."

"He is the shame of the family," my mother says.

My brother-in-law asks politely, "How is your life in New York?"

"Have you heard of Andy Warhol?"

Heads shake all around the table.

"He is hard to explain," I say. "He is an artist, the shyest, the simplest, the most commercial, the most conceptual artist the world has known."

"He is your . . . friend?" my mother asks tactfully.

"He was my very good friend," I say, knowing that she will misunderstand, for friend, in that sense, means lover in France, but there is no way to explain what Andy was, or is, to me. I go on: "Life in New York is different, not as traditional." To stay on safe ground, I tell them about a neighbor who was threatened with eviction from his apartment because of his barking dog. To keep both apartment and dog, he had the veterinarian remove the animal's vocal cords.

"How perfectly awful," my mother says.

"Now the dog can't speak," a small nephew says.

Rip, my brother's Dalmatian, growls as if he's been following the conversation disapprovingly. We all laugh.

My older sister says, "We saw you on TV in *Taking Off*. We recognized you right away."

"That was one of Miloš Forman's first movies," I say, and to the children, "I played the parent of a runaway child."

"Weren't you in *Midnight Cowboy* too?"

"Wow, you've met Dustin Hoffman!" a nephew exclaims.

"Yes."

"Wow, how is he?"

"Just like you and me."

"You must be famous."

"For fifteen minutes," I say.

My statement is not in any context for them, but they all laugh anyway.

We take our coffee on the veranda, in the shade of century-old parasol pines. "We go to church at eleven tomorrow," my mother says, ". . . if you wish to come with us." I note her hesitation. The last time she saw me in church, I was crying piteously at Christmas mass after I was released from reform school.

I say quietly, "Yes, I wish to. I've been reading and studying the Bible lately. I find it most fascinating."

My mother looks up, startled. I have forgotten. French Catholics of my mother's generation do not study the Scriptures. It's probably no longer forbidden, as once it was, but my conservative family still follows the old ways. The word "Bible" to my mother signifies the Old Testament. She says, "You know we don't read the Bible. We are not Jewish."

An old memory stirs. "You were very kind to the Jews during the war. Didn't you hide Mademoiselle Lévy-Durass?"

My father says, "Yes, and your aunt Françoise hid a whole family."

"Just like Anne Frank," my brother says.

I had not known about the hidden family. My father tells us that Françoise trembled each time her father, my grandfather,

230

came for lunch, because he was the chief clerk of the court of justice. All of them could have been deported or killed if the Nazis had found out.

After lunch we form a procession back to the portrait gallery. I have noticed how much little Lionel, Catherine's son, looks like Aribert, one of the remote ancestors. His father holds up Lionel in front of Aribert, and the boy takes the same pose. "How amazing," says my brother-in-law.

"Is that me?" Lionel asks.

On that good note we part, I for a three-hour siesta in my room to gain more strength, the others for the beach or tennis. As I lie on my bed, many thoughts and emotions crisscross within me. I do not want for myself the life of my sisters and brother, yet now I wish to be married, married for all time and eternity. I have to laugh at myself—I am so absolute. That's my nature: black or white, violet or orange, *tout ou rien.* I have thrown away hundreds of proposals. I was not ready for them. Now I am ripe for marriage, but who will have me, whom would I accept? I would not want either of my sisters' husbands. Why am I so difficult to please?

I'm a stranger to my family. When I first came to New York, never for an instant did I feel like a stranger. But here, now, at home among my own people, I am a stranger. The same blood flows in our veins but mine pulsates to a different beat. I want the conversation to be more intimate, more about feelings, but it never is. I must accept them and admire them as they are, accept them on their terms, not mine. Is there love among us? There is politeness, sociability. Then I scold myself. How can I abandon my family in complete rebellion, then come back two decades later and expect them to believe I am overflowing with love for them? I would have to explain the purgatory I've gone through, the full circle of hell that has brought me back to honor my father and mother.

When I awaken from my nap, I gaze at a wooden lion, rampant, on the mantel, a cherished heirloom from my father's side

of the family. Another Leo. I think of Andy, that pale Leo with his plastic mane. Why did I ever invite him into my life? Why did I invest so much of my life in his? It seems incomprehensible to me now. Fame? Frenzy? To be at the most innermost *in* spot in the universe? But why? I will never really know.

At dinner, I find that the excellent home cooking and my family's good humor have restored my appetite. I eat ravenously. The conversation returns to my life in New York.

"Are you earning a decent living with your art sales?" my father asks.

"Just about."

One of my brothers-in-law talks about a Broadway show he saw on a recent trip to America. I tell the children, "Tomorrow we'll have an English lesson before dinner."

"Oh, that has merit," says my father.

We talk at length about the next day's menu—food is always a favorite topic. We move on to whether Edwige spends too much money on clothes. She is wearing a new suit from Chanel. I compliment her on it and tell her that I once had tea with Chanel in her salon. Everyone is enormously impressed. "Did you buy anything?" my sister asks.

"No, I was there with Dali." They know who Dali is, but they are not curious to hear more.

After dinner, the women move into the card room, the men to the smoking room. My sisters speak candidly of inheritance and the eventual disposition of the family business. At first I am shocked. I have forgotten that the orderly distribution of assets across the generations is as ordinary a subject of conversation to them as casual talk of succession to the British throne is to us.

Then it dawns on me that they are eyeing me with more than a little suspicion, thinking that I have returned home to solidify my inheritance rights. Oh, little do they know the truth. I came here really to say goodbye before I die. But now I know I am not going to die. I am going to live.

A month of their healing, their love, even if at arm's length,

a month of their fine food, sunshine, my mother's smile, and my father's immutability, and I am well again. I take my leave, promising to return soon, much sooner than before.

The first thing I do when I get back to New York is to call Andy. My first question to him is: "How is your mother?"

"Why do you ask?"

"I just came back from France. I am bathed in the unconditional love of my family. I am a new person. I am concerned about your mother."

There is silence.

"How is she? Is she still wearing the dresses we bought?"

"No."

"Why not?"

No answer.

"How is she?" I insist.

"She died."

"When?"

"Several years ago."

I am aghast. "Several years ago, and you never told me?"

"I never told anyone."

"Why?"

More silence.

"Where did she die?"

"In Pittsburgh. She went there when she became ill."

"Did you cry at her funeral?"

"I didn't go."

"You didn't go?"

"No."

"When did she die?"

"In 1972."

Now I am silent.

He says, "I switch to another channel in my mind, like on TV. I say, 'She's gone to Bloomingdale's.'"

I have a little trouble breathing as I hang up. I can't grasp the idea that Andy, who lived with his mother for over forty years,

who was closer to her, more faithful to her, than to anyone else—friend, family, or lover—can speak of her death in such an off-hand manner. And not to go to her funeral, not to accompany her on her last earthly journey. Well, at this late date I should no longer be surprised by the paradoxes Andy presents and lives.

Maybe I should listen to him more carefully. When he says he is, or would like to be, a machine, he speaks the truth. It is not a put-on. A machine does not have to deal with grief.

M oving into the seventies is like falling off the edge of a suddenly flattened earth—not just for me; for almost everyone in the Warhol circle. Reputations reverse, connections break off, people vanish—into death, into obscurity, into altered states.

After the shooting in 1968, Andy gradually shuts his door on the old entourage, the bohemians, the stoned strangers who take off their clothes. Ondine, Taylor, Jackie, all feel betrayed by Andy and unwelcome in the by-appointment-only, high-tech Factory at 33 Union Square West, where doors are now locked and bolted. A receptionist keeps a security watch, and an air of efficiency replaces the kinetic freakiness. By 1973 Andy moves his operation to plush offices at 860 Broadway, exquisitely decorated by Fred Hughes with an Art Deco desk from the S.S. *Normandie*, a Courbet painting, and a formal, paneled dining room. Andy buys Art Deco treasures, many of them by silversmith Jean Puiforcat, for a song on one of his trips to France. Art Deco has not been

revived yet, but once again Andy is ahead of the trend. His collecting mania is well under way.

Andy's goal from the beginning has been fame and money. He has the fame—although never enough of it. Now he is after the money. That requires a different, more serious coterie of attendants and helpers, to prepare his screens, apply his paint mops, take his Polaroids, develop his photographs, drive for him, run his enterprises, shuttle his photographs and paintings around the international gallery and museum circuit, keep his complex affairs going from day to day.

I drop in at the new headquarters from time to time, but without the old silvered ambience and the welcoming crazies, I no longer feel part of a close family. I greet Andy at openings and social events. We talk on the phone. But it is different. The affection I once felt for him—to the extent that affection for a person so deliberately plastic, robotic, and unreachable is possible—is draining away.

Besides, he no longer needs me for introductions to socialites who once left him tongue-tied. Now, on his own, he finds moneyed buyers for his paintings and, in his new, upscale social life, entertains them at formal lunches in his paneled dining room, courts them with spreads in *Interview*, his gossip magazine about movies, art, and life-styles. *Interview* had its beginnings in 1969, when I was around enough to be as annoyed as the others when we were refused free passes to a film festival. The solution was to start a publication of our own. I was there when Andy, John Wilcock, Gerard Malanga, and Paul Morrissey launched *Interview* on a shoestring. I peddled the magazine on the street on my way to parties. It quickly blossomed into a powerful publicity vehicle for Andy and a recruiting device for his celebrity and socialite portrait sitters.

For anyone with $25,000 to spend, Andy happily takes a Polaroid (which he automatically snaps anyway), blows it up, has silk screens made, passes rollers over the screens. Voilà! A genuine Warhol, untouched by human hands. The whole world sits for him: Liza Minnelli, John Lennon, Muhammad Ali, Diana Ross,

Ingrid Bergman, Golda Meir, Jane Fonda, Yves Saint Laurent, Eric de Rothschild, Halston, Diane von Furstenberg.

He flirts with powerful and wealthy ladies: Lady Lambton, Diana Vreeland, Mercedes Kellogg, Lily Auchincloss. In one of his rare political statements, he does a portrait of Nixon and captions it: "Vote McGovern." From that day on, he claims, he gets audited by the IRS.

The prestigious museum shows that eluded him for so long now occur almost routinely—the Tate in London, the Whitney in New York, the Musée Galleria in Paris, important shows in Stuttgart, Düsseldorf, Bremen, Berlin, Munich, Vienna, Zurich. His photographs go on view in Cologne, Amsterdam, London.

"The greatest art is making money," he tells an interviewer.

In New York in 1972, Andy sends Bob Colacello, a young writer for *Interview*, to do a two-page spread on the New Ultra. It is titled "At Home with Ultra" and includes an old photo of me as a man. Bob describes my electric-blue foyer, my American-flag curtain, the astronaut-on-the-moon pillows that cover the twin beds placed in the center of my living room. Commenting on the spectacular view of Central Park, the Hudson River, the mid-town skyline, he writes, "No wonder Ultra has delusions of divinity." I tell him that I am working on a script, "The Last Supper," which combines spiritual drama and camp comedy. Jackie Curtis, Holly Woodlawn, and Viva are to appear in it.

Bob asks, "Why are you using girls to play the apostles?"

I tell him, "Well, Holly is not quite a girl. Jackie, she's not quite a girl. But I think women are finally coming out of oppression."

By this time I have many new friends and new interests. In New York and in Hollywood I appear in ten films. I compose popular songs and record an album for Capitol Records and write on the cover:

in the beginning
there was nothing
but ROCK

237

> then somebody invented the wheel
> and things began
> to ROLL

It is a rainy Sunday in 1972.

"One, two, three, I am under," says Jane Fonda.

"Under where?" I am tempted to look under the table in the Russian Tea Room on Manhattan's West Fifty-seventh Street. But there's no need to, for Jane is sitting right in front of me, ignoring the restaurant's fabled chicken salad. She is ignoring everything. For five long minutes she is completely silent. Then suddenly she snaps her fingers and says, "I'm out from under."

"Under what?"

"Under hypnosis."

I've never had any experience with hypnosis. I've always thought of it as something on the circus side. But Jane seems perfectly normal. "I just think of going into myself," she explains. "I concentrate on the tip of my cranium, and at the count of three I am under. When I am under, I program myself for whatever I want. I imagine myself thin, not smoking, memorizing a script. I only wish I could resolve the Vietnam War by hypnosis."

Thank God she is out from under in time to help me extinguish a cigarette butt that has kindled a fire on our table. She gives me the address of Dr. Jules Bernard, her hypnotist in Hollywood. I take his course on self-hypnosis and learn about the power I always knew I had, the power we all have. I will always be grateful to Jane for teaching me this skill. I use it to memorize scripts and songs, to calm myself when the tension builds. It gives me a sense of self-control that I never had before.

I realize how sharply the world has shifted when I am invited in 1977 to a private party at Studio 54 on West Fifty-fourth Street, at that moment New York's most in sanctum. I reach into my

closet for a suitable outfit and pull out a pink satin nightgown of the 1940s and its matching long jacket with exaggerated shoulders. It will do.

The place is garish, frantic, ear-pounding, in the usual disco manner. It's four in the morning. The game is to see who's there. Everyone's playing it. I spot Andy and Truman Capote standing off to one side. I'm not sure I can make myself heard over the music except through body language. I have seen little of Andy since the night he told me on the telephone about his mother's death—that's how far our paths have diverged.

The two move toward me. Andy is all in black leather. He looks older, his face is leaner, his eyes deader. Truman wears a gray felt cowboy hat, a long red scarf, a black satin bow tie, a jacquard sweater, and a dark brown tuxedo jacket. His waddling body reminds me of Donald Duck.

They greet me as if we've seen each other the day before. It is business as usual. I ask Truman, "Are you a fan of Walt Disney?"

"Ooh, yees, I loove tooo haave breeeaakfaast whiile waatching hiis mooviees." Truman's speech is now slurred and quite indistinct.

Now, as the photographers descend on us, Andy says, "I love openings. I'd go to the opening of a new toilet." He must go every night—still. He adds, "When I'm out, I play hard." He points to the tape recorder and the camera draped around his neck. He's also carrying AA batteries, an extra black-and-white camera, and ninety-minute tapes. He goes out only with friends who supply a limousine to transport his equipment.

Capote says, "Aandy, yoooou missed myyy best paaartyyy ever."

"How many celebrities were there?" Andy asks. That's how he judges a party.

"Hoooow suuperfiiicial caaan yoooou get?" Truman demands, hypocritically.

The crowd is packed in so tight it is almost impossible to move. A waiter, naked as far as I can see, offers champagne.

Then I see he is wearing a G-string. I accidentally step on Truman's webbed foot. He goes, "Yaacks, yaacks, yaacks."

Andy does business here. He promotes *Interview* magazine. He says, "Last week I promised the cover to Bianca Jagger, Lee Radziwill, and Margaret Trudeau."

"III'm duuue for your cooover," Truman reminds him.

"When it's really fun here," Andy says, "you expect someone to be murdered." There have recently been several mob-related killings around the club.

I stare at him and wonder how he can speak so lightly of death after the attempt on his own life, and after his mother's passing away and Edie's tragic ending. Has he no memory? I feel as if I'm going to scream.

Since my breakdown I have viewed life with a survivor's eyes. I want an end to the violence and cruelty. I look around at all the barren glitter. I wonder: Do I really have higher values now? Or have I just lost my sense of fun? Am I jealous of the eighteen-year-olds I can no longer compete with? Has my immunity to cynicism run out? Yes, I think it has. I know it has. I feel a chill under the hot lights. The writhing bodies around me conjure up images of Sodom and Gomorrah. I pull my nightgown jacket closer around me.

Why am I squeezed into this sordid place in this drunken, drugged, uncaring crowd, in an out-of-date nightgown? It is ludicrous. I have to leave. I don't even stop to say goodbye. I doubt that either Andy or Truman notices that I am gone.

A few days later, I walk down a New York street with the seven-year-old daughter of a friend. We pass a newsstand. She notices a magazine cover showing a bright, bloody red crotch. The child does not quite know what to make of it. She stops and asks, "Is it dog food?"

"No, it's hamburger, center cut," and I mutter to myself, "New York cunt."

"What's that? Does it hurt?"

I drag her past the lewd display, and as we walk I reflect on pornography, the scourge of the seventies. I think of Gutenberg and his invention of movable type five and a half centuries earlier. What if he'd anticipated such a newsstand display of hairy cunts, spread crotches, parted cheeks, licking tongues, darkened assholes? I begin to wonder: Did we contribute to the pornographic invasion in the heedless Warhol years?

Not long after, I am sitting in the back seat of a beige Mercedes, straight off the showroom floor. Ellen Harrison, widow of Wallace Harrison, the architect, is driving. Next to her is a Mercedes salesman. Kay Leperck, a motherly friend, is next to me. We are talking about Ellen's husband. She says, "It took him only thirty-eight minutes to conceive the whole architectural ensemble of Rockefeller Center."

I say, "I think Lincoln Center is his greatest legacy."

"Hold it," Ellen says. "Lincoln Center was his baby, but the United Nations was his masterpiece."

Kay cuts in: "The most kitsch was at Flushing Meadow, the Trylon and Perisphere at the 1939 World's Fair."

The car makes a right turn downtown from Eighty-sixth Street. Ellen sees Andy Warhol crossing the street. "That corrupter of youth!" she yells. "Think what he did to Edie." Her foot accidentally pushes down the accelerator. The car almost mounts the sidewalk. Andy gives a leap backward to avoid the front right wheel. His hair brushes against the building and gets trapped between two unmortared bricks. His wig remains hanging on the brick wall. The Mercedes salesman puts a hand on the wheel to help steer us safely into our lane.

"Thank you," Ellen says calmly, "and yes, I'll buy this car. It has good control of the road."

"Who was that?" the salesman asks. Nobody bothers to tell him. I am amused that Ellen feels such anger toward Warhol. She must see a number of his most famous paintings on the wall whenever she visits her relatives. Her uncle David Milton married Abby Rockefeller, the sister of Nelson Rockefeller, who was

almost as compulsive an art collector as Andy. Ellen's mother, I've heard, did not want her brother to marry a Rockefeller, but in this case, true love prevailed.

I recall that at a dinner at the vast Rockefeller estate at Pocantico Hills in Westchester, Andy once said to me, "Why don't you have an affair with Nelson?" That's one party I'm happy to say I sat out.

It becomes open season on Andy.

I hear that after Edie's death, Bob Dylan uses one of Andy's paintings as a target in a dart game.

Andy's book *Popism*, written and compiled by Pat Hackett, partially from tapes, comes out in 1980. He says of me in it: "All the girl Superstars complained that Ultra would somehow find out about every interview or photo session they had scheduled and turn up there before they did—it was uncanny the way she always managed to be right on the spot the second the flash went off. She was popular with the press."

The week after I finish reading *Popism*, I see Andy on a Sunday morning at the flea market at Twenty-fourth Street and Sixth Avenue. He is buying cookie jars. I tell him I've enjoyed reading his book but I've noticed many inaccuracies in it. He replies, "Not my fault. I never wrote it, never read it."

A s the 1960s recede into a past that seems as remote as ancient Nineveh and Tyre, I start to collect the stories of the survivors and the obituaries of the victims. It becomes an undertaking that keeps me busy until this day.

To my amazement, Ondine, real name Bob Olivio, one of the freakiest of the drug people, turns out to be a survivor. He tells me, "If it were not for my mother's love, I would be dead. I owe her everything. I collapsed. I OD'd. My liver went, my teeth went, my kidneys went, my mind went. My mother is a saint."

The roof caved in on Ondine after Andy was shot in 1968. At that point, he turned away from drugs and booze and got the support of AA. When he and Andy went together to the funeral of Judy Garland, another victim of the pharmacopoeia, Andy said of the straight, sober Ondine, "Oh, I can't stand Ondine now. Now that he's clean, he's lost all his wild eloquence."

Ondine now lives in Queens with his mother. It's hard to visualize him in a humdrum, middle-class life.

Viva is one of the few who have stayed completely in character. In an article in *New York Woman* in 1987, she complained that she is still penniless, still celibate, still a Communist, and still living at the Chelsea Hotel. But she is luckier than the rest of us—she has two beautiful daughters: Alexandra, fathered by her onetime husband, Michel Auder, a French filmmaker, and Gabrielle, whose father, a soap opera actor, refuses to acknowledge paternity. Gaby was baptized on the roof of the Chelsea by a feminist radical rabbi and an Episcopal priest. Alexandra and Gaby are breaking into show business. Returning to her first real interest, Viva recently had a show of her paintings in the south Bronx.

Gorgeous Susan Bottomley, known to us as International Velvet, abandoned modeling, moved to Paris, then Wales, then Hollywood, then San Francisco. Each time she moved, she married. Her prominent lawyer father retired to Utah and died there.

Brigid Polk, born Berlin, a permanent fixture at all four Factories (the original one, on East Forty-seventh, the two later ones on Union Square, and a fourth, the headquarters of Andy Warhol Enterprises, opened in 1984 in a former power plant on East Thirty-third Street, totally restructured and decorated by Fred Hughes), endured with Andy until the end and beyond. If you call Warhol Enterprises today, she answers the phone. A loyal defender, she says, "From the beginning, I adored Andy." She weaned herself off drugs in the early seventies and today has well-groomed hair, subdued makeup, the poise of a Park Avenue lady. "I could kill the doctor who first started me on tranquilizers," she said recently. Helped by AA, she lives with her three "kids"—her cats Truffles, Jimmy, and Greta.

Paul Morrissey directs one film after another. His latest are *Beethoven's Nephew* and an Italian-American comedy, *Spike of Bensonhurst*. Early on, with impeccable taste, he began collecting Americana—mission furniture, old books with engraved illustrations, pottery, turn-of-the-century paintings. "It's all trash," he said of Andy's vast hoardings of collectibles, although he ad-

mits Andy dealt with the period of the sixties more fully than anybody else.

Billy Name, born Lenick, walked out of the black closet at the rear of the loft in 1970, leaving behind cigarette butts, astrology charts, and a note: "I'm fine, just gone." He went to San Francisco, wasn't heard of again, and we all assumed he was dead. Imagine the rejoicing when he turned up at the memorial service, distributing his card and telling us that he does community work in Poughkeepsie, New York.

I ask, "Why did you leave the Factory?"

"To go to the planet. I'm an artist." He calls himself a concrete poet/sculptor. He says of Andy, "Naturally synthetic, a Czechoslovak wizard, a true monk. He was given a second chance to live, and so was I."

Baby Jane Holzer is alive and living well on East Seventy-fourth Street in New York. She had the foresight to pull out early, in October 1965, after the filming of her last movie, *Camp*. "The scene was too scary," she says. "Too many drugs, too many crazies, too much laughing gas for everyone to sniff." She is now a successful producer of plays and movies—in 1985 she was associate producer of *The Kiss of the Spider Woman*—and is involved in real estate. She is divorced and has a grown son.

Gerard Malanga left Andy in 1970. In Rome, he had an encounter with the authorities for selling questionable Warhol paintings. Authentication is at best nebulous for Andy's silk-screen works, especially since Andy's non-touch policy sometimes disinclined him to put his signature on a canvas.

It became normal practice for anyone who happened to be around to sign his name on "Brillo Boxes," "Marilyns," various versions of the soup cans. I myself took my turn at signature duty. Gerard, in charge of all the mechanics of the Pop production, ordered the silk screens, stretched the canvases, applied the screens, mopped on the paint, and, on various occasions, wrote Andy's name.

Question: Whose painting is it?

When that question was raised during the flap in Rome, Andy told me, "The painting's mine. There's my name on it. They should send me the money." The incident blew over, and Gerard, still a poet, a photographer, and a filmmaker, is now the curator of the photo archives at New York City's Parks Department.

Taylor Mead, bohemian poet of the counterculture and brilliant star of the underground theater, says, "I live on disinheritance and $350 a month." I saw his impressive performance in Kenneth Koch's play *Red Robins* at the Lower Manhattan Ocean Club; he played six roles, from Mike the Tiger, a carnivorous-vegetarian Asian mammal, to an Oriental sage with the wisdom of the ages strapped to his shoulders.

He says, "My happiest films with Andy were *Lonesome Cowboys* and *Nude Restaurant*."

"Why didn't you make more films with Andy?"

"The more destroyed you were, the more likely he was to use you."

Taylor recently impersonated Bernhard Goetz in a play by Stephen Miller. Bernie used to repair my old radios. I tell Taylor that Goetz is the only person in town who knows how to fix those old boxes I collect. When he came to my house about seven years ago, we had a passionate argument about mission furniture. I told him it was great; he said it was junk. He struck me as highstrung.

Lou Reed is living on his farm in Pennsylvania, working on a new album.

Joe Dallesandro is busy starring in spaghetti Westerns in Italy.

I run into Timothy Leary in October 1986. With his tanned skin and clipped white hair, the leader of the drug revolution looks like a retired West Point general. When I comment on the devastation wrought by drugs, he says cryptically, "I don't tattoo genes."

Holly Woodlawn still does a terrific nightclub act. When I see her in 1978, we reminisce about the old times. She says, "I

never knew *Trash* would gross nine million or whatever. I was paid only for my five days' work. If I'd been smarter, I'd have asked for a percentage."

"None of us was smart."

"I'm bitter. I made all that money for him. *Trash* really established Warhol. Before that he was doing those out-of-sync boring movies. Who could sit through *Empire State Building*? *Trash* at least had a plot and involved welfare and drugs and made its mark on society. I hate him and adore him. He's rich and I'm not. Overnight I was a star, but I didn't take advantage of it. I was dumb."

"It's like all the people Toulouse-Lautrec painted," I tell her. "Their names are printed in some art books, but you know nothing about them. Only Lautrec is known—and Andy. Do you think he owes us anything?"

"He would say no, because I got my twenty bucks for each day's work. But maybe that's why that girl shot him."

Fred Hughes, the executor of Andy's estate, after presiding over the dispersal of his fabulous trash-to-treasure trove, is licensing Andy's name to a wide range of products and administering megamillions to be distributed by the Andy Warhol Foundation for the Visual Arts, as specified in Andy's will.

My beloved Edward Ruscha has become the West Coast's leading artist. He is now back with his patient, understanding ex-wife.

Jed Johnson is a successful interior designer. He inherited Amos and Archie, Andy's dachshunds.

John Chamberlain enjoys show after show of his sculptures. "He is counting his millions," says Taylor Mead. I think of him as a genuine, grand native American.

One strange survivor of the Warhol years deserves a brief mention. Actor Allen Midgette impersonated Andy for a fee of one thousand dollars at the University of Utah in October 1967. Students demanded their money back when it was revealed that the fellow in the dark glasses who was showing them disjointed

film clips was an impostor. Andy's comment: "Maybe they'll like him better than me."

Since Andy's death, Allen, dressed in black pants, black turtleneck, white nylon wig, dark glasses, and white Kabuki makeup, shows up in SoHo streets and at club and museum openings. He just stands there. People come up to him and say, "Hi, Andy, glad you're back."

The legend goes on, even if counterfeit.

Now for the eulogies, for in the midst of the rollicking laughter, the sixties people were hell-bent on immolating themselves.

There is no need to say any more about poor, doomed Edie.

Truman Capote died of drugs, alcohol, and bodily disintegration on August 26, 1984.

Eric Emerson, the pretty, psychedelic playboy who liked both pretty boys and pretty girls and fathered four children, was found dead near the West Side Highway early one morning in May 1975; he lay next to his bicycle, which he loved to ride while yodeling like an urban troubadour. The kinder version of what happened says he was a hit-and-run victim while cycling and yodeling; the more likely asserts that after he died in someone's pad of an overdose of heroin, his body was disposed of outdoors, next to his bicycle, which was found unscratched. He was thirty-one.

Jackie Curtis died of an overdose on May 15, 1985.

Candy Darling died at twenty-five of leukemia, on May 21, 1974. Her friends recall that almost to the end she was taking hormone shots and buying additional hormones of dubious purity on the street.

Nico, born Christa Paffgen, died Monday, July 18, 1988, in a hospital on the Spanish island of Ibiza, a few hours after falling off a bicycle. A coroner's report said she had suffered a cerebral hemorrhage. She is survived by her son, Ari.

Mario Amaya, the journalist and art critic who received a gunshot wound from Valerie Solanas at the time of the assassi-

nation attempt, died in London on June 29, 1986, of pneumonia brought on by complications of AIDS.

Gregory Battcock, an actor who starred in *Horse* and *Drunk*, was mysteriously murdered on December 31, 1980.

Jimi Hendrix blew up in smoke, and Janis Joplin died of an overdose on October 4, 1970. That day, some friends and I were to pick up Janis and continue on to a concert. Our limousine stopped in front of her building, we went to her apartment, and to our horror, we found her body on her bed. Rigor mortis had begun to set in.

Tiger Morse, an almost Superstar who designed clothes for us, was born into a conservative family, but overnight dyed her hair green, pasted on lashes that lit up, and went all-electric. She used to boast, "I'm living proof that speed does not kill." Not so. She died of an overdose of speed in 1972. I found out later that it was her father, a prominent architect, who had brought out of Germany the Max Jacobson who became the notorious Dr. Feelgood. Dr. Jacobson started the fourteen-year-old Tiger, along with hundreds of other patients, on powerful amphetamines. In 1979 his professional license was revoked.

Dancer Freddy Herko went as far as advertising in the *Village Voice* that he was available for a "suicide performance." He danced around rooftops and balanced perilously close to the edge until the audience begged him not to go over. His final pirouette took him through an open window.

Ondine said of his death, "He was the world's greatest dancer, the total star, dealing with space and time and the avant-garde audience. He wanted to fly. He died in flight, making a terrible commitment to his art. Warhol got from Herko and Herko gave Andy a sense of completion. He died as he wanted to all of his life."

Mickey Ruskin, the art-collecting impresario of Max's Kansas City, did not appear to be on drugs in the wild years, but some say he was. Later addicted to cocaine, he suffered a fatal heart attack on May 15, 1984.

Ingrid Superstar, whose real name was Ingrid von Scherven, retired to Kingston, New York, ballooned up to nearly two hundred pounds, floated in and out of prostitution and drug dealing, and was at one point judged mentally disabled. On December 7, 1986, she went out to buy a pack of cigarettes and a newspaper, leaving her fur coat in the closet and her false teeth in the sink. She was never seen again.

Robert Scull, who was once upon a time, with his wife, Ethel, the largest collector of Pop Art, died on January 1, 1986, of diabetes complicated by his abuse of cocaine, LSD, Quaaludes, hashish, and opium.

Barbara and Marco St. John were both so handsome that Viva had a crush first on one, then on the other. He was an actor with Joseph Papp's Shakespearean troupe; they both hung around with the Warhol crowd. Marco was very apologetic when their little son stepped all over Andy's painting on the floor of the Factory. Andy's comment: "He made them more valuable." Barbara, beaten up and with multiple gunshot wounds, was found dead by their four-year-old-son on June 16, 1971, in their apartment on Perry Street in Greenwich Village. Marco said they were both clean of drugs by then. The murderer was never found.

Taxi, a pre-Superstar, even before Ingrid, was Andy's favorite in the late 1950s. Drugs took her before she could prove her stardom.

Andrea Wips Feldman, the sweet little lamb, twenty-four years old, plummeted from a skyscraper window on August 8, 1972, clutching her Bible and crucifix wrapped in a rosary and leaving a note for all the people she loved: "I am going for the big time. I hit the jackpot."

Sam Wagstaff, a friend of Andy's who often went to concerts with us, died of complications of AIDS.

Jon Jay Gould, a handsome, black-haired young executive with Paramount, met Andy in 1981. They were together on and off until Andy's death. Stricken by an extended illness at thirty-three, he died on September 17, 1986, in Los Angeles. Everyone

I spoke to mentioned AIDS. His death certificate lists cause of death as cryptococcal meningitis and pneumonia plus salmonella bacteremia.

Tom Baker, my starring partner in *I a Man*, received five hundred dollars from his mother three days before his birthday in 1982. He planned to clean up his act, but in a last celebration bought a speedball, a mixture of coke and heroin, in a shooting gallery in a burned-out Lower East Side building, the kind of end-of-the-line place where you sit in a broken-down chair, rest your arm on a dirty table, and get a shot from a secondhand needle. On September 2, his birthday, he died of drug poisoning in the arms of friends.

Charles Ludlam, cofounder of the Ridiculous Theatrical Company, which produced *Conquest of the Universe*, in which I starred with Ondine, died on May 28, 1987, of pneumonia brought on by AIDS.

Tinkerbelle, another sixties Warholette, became a regular contributor to *Interview*. I ran into her in 1985 and barely recognized her. She told me the devil was after her. Her once twinkling, sky-blue eyes were narrow and dim. She seemed burned out. On January 22, 1986, she jumped to her death from a fifth-floor window.

Sandy Marsh, Edie's close friend, had too much money and too much time on her hands, so at 7 a.m. on June 3, 1987 she opened a 28th floor window of her apartment on West 79th Street, facing Central Park, and jumped feet first. No one, not her husband, her children, her maid, her cook, her nanny, could help her find happiness. A regular visitor to the Factory and a pal of Edie's, she was a drug user for 20 years. In 1969, clutching her Sufi talisman, she took an overdose of pills and was rescued, but only for a time.

Jim Morrison, rock singer and composer for The Doors, was so sexy that all the women at the Factory threw themselves at him. In Los Angeles with Andy in 1967, I saw him swallow three downers with each of the seven screwdrivers he drank. By the

end of the evening he switched to poisonous belladonna, a powerful drug that dilated his pupils and put his mind in a trance. His heart gave out on July 31, 1971, in Paris.

Valerie Solanas, crazed would-be assassin, died on April 26, 1988.

Divine, born Harris Glenn Millstead, the three-hundred-pound character actor/actress and impersonator, died on March 6, 1988. He was so determined to achieve fame that along the way he ate dog excrement in the film *Pink Flamingos*. He finally won national recognition for his two roles in John Waters's film *Hairspray*.

I could write pages of obituaries for the many I saw depart. I wish I could have a reunion of the dead by drugs, a kind of ghostly press conference. I wish they could come back to tell the kids of today, "Don't do it. It's not worth it." I wish they could speak of their regret over their lost lives.

I would like this book to tell the living:

> May the sour sowing
> of our deadly reaping
> be for our learning.

In 1984 Andy is operating a General Motors of art. He presides as chief executive officer at his headquarters, a five-story block-through building at 22 East 33rd Street, decorated by Fred Hughes in resplendent corporate style. One division of Andy Warhol Enterprises endorses commercial products—Pontiac cars, Absolut vodka, electronics, wine, magazines, Drexel Burnham Lambert financial services. Another division issues prints in such volume that every wall in America is in danger of being Warholed. There is talk of franchising a chain of restaurants—the Andymat.

Still another division publishes the flourishing *Interview* magazine, which has attained a circulation of 100,000 copies a month and a gross income in the neighborhood of $2 million a year. The portrait business is going strong, and at the rate of $25,000 for a silk-screened blow-up of a Polaroid and $15,000 for a second copy, it earns somewhere between $2.5 and $3.5 million a year. In addition, there's the income from theater and video

distribution of Andy's earlier films and $10,000 for each of his personal appearances on film or TV.

His real-estate holdings include a twenty-acre estate at Montauk, at the eastern end of Long Island, forty acres near Carbondale, Colorado, a building at 57 Great Jones Street in Greenwich Village, his former town house on Lexington Avenue, and his current town house, at 57 East 66th Street, stuffed to the walls and the roof with his compulsively collected treasures and trash to rival Hearst's vast accumulation at San Simeon: furniture, art, gold, antiques, jewelry, textiles, rugs, costly flotsam and expensive jetsam—anything that can be bid on at an auction gallery and kept out of the hands of a rival collector.

On December 19, 1986, Andy is busy spending those dollars when I run into him at the Doyle auction gallery on East Eighty-seventh Street. I am shocked at the death mask he is wearing. He is surrounded by a small army of attendants and bodyguards. He is examining African artifacts, medieval religious sculptures, and the like. His crew of young boys is loading the trunk of a waiting car with old-fashioned doctors' scales, statuettes, bronzes, and carved wood figures. Although I have not seen Andy for a year, we act as if we'd met only that morning. No fuss. No what-a-long-time or where-have-you-been? I know that Andy likes the coolness of a low-key encounter. I say, "I see you're buying by the dozens."

"Yes, everything's so cheap. And I get fifty percent off. These are Christmas gifts."

Andy snaps a picture of me, and when he's finished, he asks, "Oh, can I take your picture? You're so beautiful."

Andy has not changed. Before I can say a word either way, the picture has been taken. And he's still flattering. And his camera is still an integral part of his clothing. Every morning he slings the camera on his shoulder the way a cowboy slings on his pistols. Then he slips his cassette recorder into his pocket, the way a Madison Avenue executive places a handkerchief in his upper jacket pocket. Now he is fully dressed.

I ask Andy, "What telephone long-distance company are you using?"

There is a pause before he answers. There is always a slight hesitation before the words come out. I've so often felt that Andy is a ventriloquist, who only starts to speak after you've put a coin in his slot. But maybe now he's a little surprised by my question. He says, "I don't know. Call and ask Vincent. Why do you ask?"

"I'm promoting U.S. Sprint."

"Oh."

His skin is tight. I wonder how many face-lifts he has had by now and how much silicone he has had injected into incipient lines and wrinkles. It is rumored that he had his first lift when he was in the hospital recovering from the assassination attempt.

"Is your beauty secret still Buf-Puf?" I ask.

Andy once told me that he rubbed his face with Buf-Puf until it bled. It caused a kind of natural peeling and kept his circulation going. I tried it and it tore my skin.

"How is your health?" I ask. He shrugs and takes from his pocket a handful of multifaceted quartz crystals and invites me to pick one. I take a whitish, pinkish stone and put it in my purse.

"I wear crystals all over my body," he says. Crystals have returned to vogue as healing agents. My mind flashes back to his mother's Old World faith in the protective Urim she sewed into her small son's clothes.

"Show me your tongue," I order. He clamps his jaws tight. "Come on, show me your tongue, like in the bad old days." He manages a vague smile but does not open his mouth.

I have read in a gossip column that Liberace and Andy recently lunched together. It is widely whispered on the grapevine that Liberace is dying of AIDS. (He dies two months later.) Now I say to Andy, "I hope you didn't French-kiss Liberace at lunch."

He pretends he doesn't hear me and leads his entourage down another aisle of tightly packed furniture and bibelots. He examines various items and puts them aside to buy. I can see that this

is going to be a one-sided conversation. I say, "You know, I saw you at the Church of the Heavenly Rest last Thanksgiving. I was picking up lunches for some bedridden Russian people. You were clearing tables."

In recent years, Andy is reported to spend many hours each week distributing food at the Church of the Heavenly Rest at Fifth Avenue and Ninetieth Street. When I saw him there I wondered if one of his tasks is to ladle out soup from the caldrons that look like oversized cans. It would be appropriate. I noticed that he was scanning the room with quick awareness. When a man carrying a black bag, who could be a member of a television crew, entered, Andy's eyes followed him. At the time, I shook off my ugly suspicions. Now I reject them again. I ask Andy, "Isn't it heartbreaking to see all those homeless and loveless people?"

"I don't know about love." He lifts up a four-foot-tall African pelican or seagull carved in gray wood. "Ooh, I love that."

"You do know about love."

His face tightens as he assembles objects exactly as he paints—in multiples. Andy even does his collecting in multiples. I look at the pelican-seagull and shiver, for much of African art seems to me to have a mortuary quality.

This is our last encounter in the flesh.

On Sunday, February 22, 1987, I am asleep in my bedroom. A dream-vision seizes me. Andy and I are in a setting where the color is reminiscent of the background in a painting by Rembrandt or Van Dyck: shades of moving grays, sliding spindle-tree charcoals, Venetian liquid amber browns, Siena terra-cotta, and subdued eggshell. The scene moves slowly in the tenebrous, Macbethian, misty air, evoking the sorcerers of Salem or Dante's Inferno. Amadeus's Requiem echoes in the distance. A light smoke, as in a special effect for a motion picture backdrop, enfumes us. Myriad amorphous shapes surround us.

Andy and I pick our way among a never-ending collection of knee-high objects. The sculptures, ornaments, boxes, crystals,

weird birds multiply as we walk. They multiply in the way Andy himself uses multiplication and duplication in his art process. In their infinity, they are too numerous to count.

I say to Andy, "When you go, you take only yourself. The shroud has no pocket."

Andy seems hesitant, not knowing which objects to choose. He has an ethereal quality. The atmosphere on the tremulous ground around us swirls in constant slow motion. A whirling wind whistles and wails. We faintly feel the rotation of the earth. Above us the air is very still.

We are between matter and spirit, between life and non-life. The architecture where we stand is grandiose, on the scale of a cathedral. A vaulted ceiling of whitish arched stone fades into the twilight of the sky. A mood of mild suspense suggests that a mystery is in progress. There is no threat. It is a place of transient waiting. It is the last magic movie, a finite place. Yet, if you look out, it is infinite. Andy is becoming invisible.

I wake up and look at the bedside clock. It is 5 A.M. I am shivering under my blankets. I am awake, yet not fully awake. I feel strangely peaceful, not at all apprehensive. The shivering stops. My body returns to its normal warmth. Sleep overtakes me. When I awaken in the morning, the dream has retreated. I know it was about Andy, but I can't summon it back.

A little later, I am in my kitchen, making breakfast. The radio is tuned to a news program. I hear Andy's name. The announcer says that Andy Warhol is dead. He suffered heart failure at 5:30 A.M. at New York Hospital–Cornell Medical Center on East Sixty-eighth Street in Manhattan. He was pronounced clinically dead at 6:31 A.M. I drop into the nearest chair. I cannot believe it. The announcer is launched on a quick review of Andy's career. There is no way Andy can be dead. He is too alive. Despite his death-mask look and his unearthly pallor, he is more alive than anyone I have ever known.

I switch stations. The news of his death is all over the dial. My phone rings. A dealer asks, "Do you want to sell your Marilyn

Monroe portrait?" Poor Andy's body is not yet cold, but his paintings are hot. At first I am furious that anyone can be so crass. Then I remember that Andy did his first painting of Marilyn just hours after her death. "Timing is all," he said then.

I disconnect my phone, to meditate on Andy. My dream of the night before comes vividly back to me. Once again, I am walking with Andy in the tenebrous air among the multiplying objects, and now I know what the mystery was that enveloped me in the night—the earthly body of Andy Warhol was passing into the shades beyond the spectrum of light.

I pull a coat around me and walk out onto my terrace and recall the first time Andy stood there with me. I had sent him a postcard of the Guggenheim Museum, Frank Lloyd Wright's chambered nautilus in concrete, reviled when it went up but now, nearly thirty years later, mightily defended against additions and alterations as a treasure to be left inviolate. On the card I circled in violet my bedroom window, which overlooks the rotunda of the museum, and marked in green the huge terrace where I now stand, gazing past the museum to a sweeping New York vista. Every year I mail a picture of the museum, with my windows circled, as my Christmas card.

Andy did not believe I really commanded such a splendid view. "Come and see," I said.

We went up to the top floor in the elevator, walked up a flight of stairs, stepped outdoors onto the huge terrace. Andy looked, clicked his Polaroid ten times to capture the entire panorama of Manhattan, from the Empire State Building to the Central Park reservoir shimmering in its frame of green to the George Washington Bridge swooping gracefully toward the Jersey shore and the hills in the far distance. He spoke just one word: "Gee."

That was not enough for me. I consider my home an extension of myself. I have had to fight for it through endless municipal mazes and half the law courts in New York when my ownership was threatened. I needed a more enthusiastic response from Andy.

"Isn't it great?" I demanded.

Andy clicked again, leaned over the parapet to look down into the street, made one more click at the Empire State Building, and finally gave his blessing. "Fabulous, just fabulous! We'll have to shoot a movie here."

Now some other words of Andy's ring randomly in my ears. "I am the media's medium." "There is no evil; good is whatever makes it to the press." "Record everything." "Polaroid everything." I see the glitter of the all-silver Factory the first day I walked in, the nightly pandemonium at the Dom, an entire wall of lipsticked Marilyns smiling at me.

I still can't grasp the idea that Andy is gone. It is several days before I can piece together the story of what happened.

On Friday, February 20, 1987, Andy entered New York Hospital for gallbladder surgery. The surgery was performed the next day and was successful. But that night, almost at morning, at the very hour of his birth, Andy died in his sleep. Again I recall the line from the Bible: "And the light shineth in the darkness; and the darkness comprehended it not."

At the moment of his death, was his private duty nurse awake, asleep, absent? There was no other witness.

I am aghast. Where was his entourage of helpers, the crowd of acolytes and assistants that always surrounds him? Alone— how terrible. How unlike him! Yet how inevitable, for when a man is affianced to his tape recorder and married to his camera and has exiled love from his life as beyond his understanding, how can he expect to have a living, loving human being sit at his bedside around the clock? His mother, probably the only person who would have done this for him, is long gone. His brothers are in Pittsburgh.

Without a wife, without a son, a daughter, a lover of longtime devotion, or even a close, caring friend who is ready to button-hole the doctors and nag the nurses and ask the questions that urgently need answers, how is a patient to survive the bureaucratic disorder of today's big-city hospitals?

What's more, when Andy was shot in 1968 a bullet tore through seven organs, making him a trauma victim for life. When,

nineteen years later, Andy needed gallbladder surgery, a detailed history of his long-standing trauma should have been affixed to his record. Ten months after Andy's death, the assistant director of the Office of Health Care Services of the State Health Department cited lapses in Andy's medical care, specifically mentioning an incomplete physical examination and an inadequate medical history.

The current official version of his death places the blame on the nurse, subsequently dismissed, who failed to monitor his fluid intake and output. The records show an intravenous input of 5,250 cc of fluid. The documented output lists only 915 cc. Not until the malpractice suit brought by his estate against the hospital is tried or settled will more information be revealed.

Meantime, my imagination leaps into action. Is all this a cover story, and do we have a Mozart-Salieri type plot? Did a jealous artist want Andy out of the way, permanently deposed from the pinnacle of the American art establishment? An intriguing idea. Will we ever know?

There have been whispers of AIDS, rumors that Warhol was a regular patient at one of the city's AIDS clinics. When I think back over the freewheeling drug scene of the sixties, the used and reused needles jabbed into parades of buttocks and arms at the Factory, the Dom, at parties and discos, I am amazed that anyone has survived that era. But to my knowledge Andy did not inject drugs. He was happy popping his pills.

AIDS has claimed several of his reputed lovers from the early period, but it is impossible to know when their contact with Andy began and ended. He was not promiscuous. Ondine always complained that Andy only watched orgies, never joined them. Later, I'd like to believe, he stayed faithful to his true loves, his tape recorder and his camera. AIDS seems unlikely.

But I am ready for a surprise of any kind. Andy loved surprises, and next year or twenty years from now, a revelation, a memoir, a deathbed confession may cause all of us to exclaim, "Oh, so that's what happened! We should have known!"

Andy never lets go, for now we have a strange bit of irony.

My mind goes back to teatime in 1974. Dali shows me a minuscule landscape on the outer surface of a metal ring about half an inch wide and a half inch in diameter. He has removed this metal band from a plastic ballpoint pen and soaked it for several days in his own urine. The urine oxidizes a pattern of greenish, reddish blotches on the band, which suggest a vivid outdoor scene.

Andy attends one of the viewings of the Piss Pen. The idea is bizarre enough to attract him. He has no notion that urine has been used since time immemorial—to clean an adder's bite in the wilderness, as a potion to enslave a lover, to clear a sty from the rim of the eye.

Andy must find out now if his penis can produce art as marketable as his hand. Using his own urine (or an assistant's—who is ever to know?), he leaks it over a canvas previously covered with copper paint. What he gets resembles a large Polaroid picture in the making, a bad Polaroid that stops before the Rorschach-like orange and green blobs resolve into a finished image. He calls the collection of murky images Oxidation Paintings and exhibits them at galleries in Paris and Zurich and at Documenta Seven in Kassel, West Germany, three cities presumably receptive to such experimentation, for they have all provided public urinals for their male citizenry.

To me, the paintings represent the final decay of established values. I visualize Sotheby's main auction room packed with future Warhol idolaters, hands rising to drive ever upward the prices of these men's room masterpieces. But how will the experts, the lawyers, the quarrelsome collectors authenticate the work unless they release the sniffing dogs?

Such jokes are easy, until you realize that possibly something as commonplace as failure to pass that humble waste fluid may have cost the wily wizard his life. What an absurd and humiliating end for anyone; how particularly distressing for the silvery sorcerer, who waved his magic wand, spoke his incantatory words, and created art, music, books, movies, photographs, style, excitement, scandal, chaos, fun, decadence, and his most imaginative and enduring work of art: Andy Warhol.

MASS

St. Patrick's Cathedral, April 1, 1987: the memorial service for Andy continues. Father Anthony Dalla Villa reads from the Mass for the Dead: " 'Lord God, Almighty Father, you have made the cross for us a sign of strength and marked us as yours in the sacrament of the resurrection. Now that you have freed our brother Andy Warhol from this mortal life, make him one with your saints in heaven. We ask this through our Lord Jesus Christ, your Son, who lives and reigns with you and the Holy Spirit, one God, forever and ever.' "

We reply, "Amen."

I never thought I would see the day when I would say in hearty invocation an Amen for Andy.

A musical interlude follows, "Louange à l'Immortalité de Jésus," "Praise to the Immortality of Jesus," by Olivier Messiaen. What a perfect choice! We are here to pray for the immortality of Andy. And it happens that Messiaen is my favorite modern composer. So impressed was I by his spirituality when I met him

some years back that I have collected recordings of his entire musical works. Now I think back to a conversation we once had about Zion National Park in Utah, which the composer had just visited. I remember vividly that he commented on the wondrous colors, the pink, white, mauve, red, black cliffs, the green trees and the limpid river. He saw the park as a symbol of paradise, bearing in mind that Mount Zion is synonymous with the Celestial Jerusalem.

A woman walks up the steps to the lectern to read from the Book of Wisdom. I have to rub my eyes to believe what I see. The program identifies the reader as Brigid Berlin. Is this poised, lovely woman our Brigid Polk, with her exposed, protuberant breasts and her fat folder of drugs?

She reads: " 'But the souls of the just are in God's hand and torment shall not touch them. In the eyes of foolish men they seemed to be dead; their departure was reckoned as defeat, and their going from us as disaster. But they are at peace, for though in the sight of men they may be punished, they have a sure hope of immortality; and after a little chastisement they will receive great blessings, because God has tested them and found them worthy to be his . . . grace and mercy shall be theirs.' "

The words are deeply comforting to me, and so is the sight of Brigid, reborn, living proof of God's mercy.

Now art critic John Richardson speaks. He says, "I'd like to recall a side of Andy's character that he hid from all but closest friends: his spiritual side. . . ."

Is he serious? But what can you say at St. Patrick's? You have to glorify the dead. Is it possible that Andy changed?

I think of his last work, *The Last Supper*, painted exclusively in red, as if sealed in Andy's blood, his final legacy. What was its meaning; was it serious or a mockery? Andy told a friend of mine, Pierre Restany, France's foremost art critic, "I am serious about this painting." That was in Milan in 1986, while they were both standing in front of Andy's interpretation of Leonardo's *Last Supper*, which was exhibited a few blocks away from the original.

How uncanny, I think, that he crowned his commercial career in 1959 with the title "the Leonardo of the shoe."

I remember that Dali did a stupendous *Last Supper*, now in the National Gallery in Washington, at the head of the monumental steps leading to the second floor. Marisol did another *Last Supper* in wood, twenty feet long, now on view at the Metropolitan Museum in New York.

Why does Andy's *Last Supper* contain two Jesus figures? Why are some of the images upside down? Is it really worth looking high and low for meaning?

Yoko Ono, dressed all in black, wearing very high heels, semidark glasses, and long hair, steps to the microphone. She says, "So many people's lives were touched by Andy in a very personal way. . . ."

That certainly applies to me. He turned my life downside up. He had a magical, omnipresent quality. To me, he was a personification of the sixties, as difficult to explain as the period itself, conveying what is scary, true, tasteless, ephemeral, and everlasting. His own life was a "state of pop art." Now his death is the final burial of the dark side of the sixties. The load of the sixties is lifted up off my shoulders. I feel free.

All of a sudden I feel a rush of love for Andy, that he cared enough about his time and work, which was our time and work too, to keep those relentlessly unedited, unrehearsed, uncropped records of a time and place, and that he left us his countless films, paintings, books, photos, tapes, collections.

Nicholas Love, a good-looking young actor from Hollywood, another of the million friends of Andy, reads from Andy's writings. He is the most moving of the speakers, for it is just like old Andy himself speaking: "When I die, I don't want to leave any leftovers. . . . I like to disappear. People wouldn't say, 'He died today,' they'd say, 'He disappeared.' But I do like the idea of people turning into dust or sand. And it would be very glamorous to be reincarnated as a giant big ring on Elizabeth Taylor's finger."

The Bible I hold in my hand speaks of resurrection. Andy made up his own Bible as he went along; his Bible is not like mine. Nothing about Andy is like anyone else, because Andy was and will always be the first real plastic man. Plastic, when it first became available, was always disguised as another material. In the sixties it became unashamedly plastic; it became real. If plastic is real, it follows that plastic people can also be real. Andy made up his mind to become the first real plastic man. It is not a put-on. It is authentic. It is the truth of Warhol.

A plastic man is essentially a robot. He picks up on the robotization of the environment. He is exquisitely in tune with his times. He is pleased when someone describes his work as synthetic. Will Andy be the first robot to be admitted to heaven?

At communion, there is a rush of people to the front of the cathedral. Claus von Bulow is at the head of the line. Mourners and sightseers—it is hard to tell them apart—jostle each other to get next to Don Johnson or two feet from Bianca Jagger. The music takes me back to my childhood convent. I see the chorus of nuns chanting, "She's possessed, she's possessed, she must be exorcised." Well, their exorcism did not work. My sins multiplied and amplified with Warhol. It is only after Edie's death and my own collapse and my reading of the Scripture that I am saved, saved, yes, saved by the grace of God alone.

As if on cue, singer Latasha Spencer soars into "Amazing Grace." Tears flow down my face. Each word of the traditional gospel song moves my soul:

> Amazing grace, how sweet the sound
> That saved a wretch like me.
> I once was lost, but now am found,
> Was blind, but now I see.
> Through many dangers, toils and snares,
> I have already come.
> 'Tis grace has brought me safe thus far,
> And grace will lead me home.

Yes, I have gone through many dangers, toils, and snares. I have been brought safe, I feel, to tell this story. To tell about the psychological and sociological devastation, the errant activities, the public sex, the hedonism, the anything-goes films in which the performers were stoned on drugs. Then, to make it worse, we exposed our exploits before young students and encouraged them to get as stoned as our performers. Even though for me sexual immorality was but the despairing side of the search for emotional security, I have to acknowledge that I participated in a movement that helped lay the basis for the explosion of hard-core pornography, drug pestilence, and the AIDS plague. Most of us have paid a heavy price, some with our lives, some with our health, others with years squandered. I feel I was luckier than most, for in the seventies, when death brushed me, I repented and found my way to inner peace.

Now a feeling of release comes over me. My long-lost brother Andy rests in peace. Perhaps at this very moment he is telling St. Peter about it all. St. Peter, of course, will not believe him. He will not believe a word Andy says. Because it is unbelievable. So were our lives. So were those sixties. Not just unbelievable—unthinkable. But it did happen, all of it. I am so utterly relieved now to seal the book of my life's past and to look at tomorrow marching forward on the feet of little children.

I watch the crowd empty the cathedral. It is a crowd of all kinds of people, all types. The Warhola clan is there, recognizable by their noses, reddish, bumpy, protuberant, and their non–New York clothes: his oldest brother, Paul Warhola, with his wife, Ann, and six of their seven children: Martin, Madalen, James, Mary Lou, Eva, and Paul; his middle brother, John, with his wife, Marj, and their three children: Don, Marc, and Jeff; five first cousins: Jean King, Julia Zavacky, John Zavacky, Michael Warhola, and Emy Passarelli; and two second cousins, Julie Rekich and Catherine Warhola. I see neatly dressed secretaries, little old ladies, acned teenagers, Madison Avenue executives, hookers, bellboys, a policeman, a baby in his mother's arms, more gays

than I've ever seen under one Gothic roof. Everyone looks at everyone. As in the sixties, the people are still it. In Andy's phrase, "They came to see who came."

The names are all here.

From the early Factory days, I spot Viva, dressed as the Veuve Joyeuse, in black suit, black veil à la Jackie Kennedy for Jack's funeral, black hat with a bow the size of helicopter wings; Gerard Malanga in a T-shirt silk-screened with Andy's face; Baby Jane Holzer with flying hair and aviator sunglasses; Billy Name; Paul Morrissey, looking very distinguished, who stood all through the service.

The artists include Roy Lichtenstein, Claes Oldenburg, Marisol, Jean Michel Basquiat, Richard Serra, Leroy Neiman, Jamie Wyeth, David Hockney, Julian Schnabel, Keith Haring, dealer Leo Castelli.

Among the writers are Tom Wolfe, Terry Southern, Jesse Kornbluth, Fran Lebowitz, George Plimpton, Taki, Brendan Gill, Bob Colacello.

The wealthy socialites include Anne Bass, D.D. Ryan, Ahmet Ertegun, Lynn Wyatt, Christophe and Dominique de Menil, Consuelo Crespi, Philippe Niarchos, Sao Schlumberger.

From fashion come Mary McFadden, Calvin Klein, Diane von Furstenberg, Halston, Beverly Johnson, Stephen Sprouse, Giorgio Sant'Angelo, Carolina Herrera.

Music is represented by Bianca Jagger, Grace Jones, Yoko Ono, Lou Reed, John Cale, Ric Ocasek.

Hollywood, Broadway, and TV have sent a large contingent: Liza Minnelli, Richard Gere, Don Johnson, Irene Worth, Swifty Lazar, Sylvia Miles, Peter Allen, Patti D'Arbanville, Eric Anderson.

Photographers: Francesco Scavullo, Robert Mapplethorpe.

Designers and architects: Andree Putman, Philip Johnson.

Also: Timothy Leary, Dianne Brill, Anita Sarko, Rudolf, Nell Campbell, Ann Magnuson, Regine, Paloma Picasso, Henry Geldzahler, Steve Rubell, Susan Blond, Jerome Zipkin, John Waters,

Lou Christie, Johnny Dynel, Vivienne Westwood, Debbie Harry. More, many more.

As I cross the vestibule, the photographers' flashes await us. It's just like a museum opening. The show must go on. Singer Grace Jones poses, smiling. All heads turn for Raquel Welch.

Outside, the vox pop of the street and the bright colors are all about Warhol: the yellow taxicabs with their horns honking, the red and green traffic lights, the beautifully made up women, the blue sky, the walking-talking people, the flashbulbs popping, the laughter, the blue jeans, the henna-dyed hair, the lettering above the storefronts, the silk-screened photos on the magazines and the trademarks in the newspapers under the arms of hurrying people, the shopping cart ladies rolling their plastic bags, the radio blasting out of the black Cadillac, the wigged mannequins in the store windows, the pink flowers of the street vendors, a dirty truck on the side street carrying boxes of Mott's apple juice and Brillo, the dark sunglasses, people taking pictures of people, the sexy kids, the dollar bill exchanged at the corner for a hot dog, people's feet walking the pavement as in a dance diagram, almost the same diagrams Andy painted way back in 1961 in *Fox Trot* and in 1962 in *Tango*, two of his earliest Pop paintings, the two gays holding hands, the big red Marilyn Monroe lips of the Kiss ad for a radio station on the side of a bus.

Stuart Pivar, a collector and a longtime friend of Andy's, asks me, "Are you coming to Steve Rubell's new disco?"

"Yes, I am."

Four hundred people have been invited to a luncheon at the former Billy Rose Diamond Horseshoe nightclub on West Forty-sixth Street.

I hop into Stuart's limousine. Off to the last Warhol party.

POST MORTEM: THE KINGDOM OF KITSCH

Andy collected through all the stages and phases of his life. There were the awards as a commercial artist in the early days, the Pop Art of the Factory years, always press clippings, and, compulsively, art, artifacts, trash, treasures, the detritus of all the centuries of history.

In the 1960s, on our way to the movies, Andy and I often stopped in junk stores, where he bought plastic Art Deco bracelets, rings and brooches and Bakelite bibelots. Still, I hardly suspected the full dimension and passion of his collecting.

After Andy's death, I visit and photograph his 1911 Georgian-style town house at 57 East 66th Street, where his possessions pile up to the chandeliers, objects of breathtaking beauty hoarded in tandem with rummage-sale discards.

As I wander through the crammed corridors and gaze at the fantastic array of possessions he kept out of the hands of competing collectors, I try to reconstruct in my mind Andy's days

and nights in this house, more warehouse than home, loaded to the rafters with the spoils of the echoing past:

Under the fixed look and mute lips of nineteenth-century American portraits, which falsely root him in an American ancestry, Andy arises in midmorning from his bed, a carved mahogany Federal four-poster, canopied with a painted cornice and dark amber fringes. The bed is oriented east to west in the room, which is embellished with a Directoire dado.

Dressing, he glances briefly into a monumental American Empire mahogany cheval glass. Walking past a grand mahogany rolltop desk, a massive dresser, a rococo mantel, an imposing Empire chest, he reaches into a grandiose armoire for a black leather jacket. The rich mahogany of the furniture summons up the image of Mahagonny, Bertolt Brecht's mythical city, where the only god is money.

Unlocking the door, Andy circulates through his mausoleum of funeral urns and amphoras, as dozens of antique wig stands, Roman marble busts, and neoclassical statues seem to bow their heads at his approach. American Empire chairs are weighed down with bags of polychromed and scrollwork vases. Elaborately bound books are piled up against American Renaissance Revival furniture. American and European paintings, by Norman Rockwell, Bouguereau, Maxfield Parrish, Magritte, Dali, hang on and lean against the walls.

Opening door after door of his six-story, twenty-by-seventy-foot mansion, he visits a closet crammed to the ceiling with American Indian wares: silver, turquoise, and coral jewelry and belts, Apache and Prima baskets, Tlingit blankets, Navajo rugs, boxloads of Indian photos, large wooden spoons and ladles, Northwest Indian carvings, ceremonial masks, leather and woven baskets, terra-cotta gourds, painted bowls, Zuni silver and shell flasks, and much, much more.

In a narrow passage reminiscent of a Zulu trail, bordered by an African drum, stands a nineteenth-century carved and painted

cigar store figure in pine, whimsically juxtaposed with a display of jeweled eighteen-carat gold compacts signed and hallmarked Van Cleef and Arpels, Cartier, Tiffany. Jewelry cabinets spill over with pounds of gems: citrine quartz, ruby, diamonds, platinum, gold, blue, and yellow sapphires, plus some one hundred twenty pins, bracelets, and rings. Do I see Andy clasping a Bulgari necklace around his neck as an amulet?

Fortified by his good-luck charm, he pushes open the massive mahogany double doors on the parlor floor and enters the Federal-style sitting room, which contains a pair of neoclassical recamiers, circa 1825, by Philadelphia cabinetmaker Anthony Quervelle. No one ever sits on the fine silk of the two symmetrically placed sofas, upholstered in ancient verdure and gold damask, for the touch of coarse jeans would tear the delicate fibers to shreds.

Dead center in the drawing room, a painted and stenciled marquetry table with a slate top, attributed to John Finlay of Baltimore, holds books, cigarette cases, and two shopping bags; an Egyptian-revival armchair, gewgawed with gilded birds and gold lions' paws, harbors three more shopping bags; ornate antique gold capitals atop flat-ribbed columns adorn each corner of the room. At their feet cluster busts, candlesticks, and bronzed statuettes.

Paintings on easels, walls, floors, and marble-topped tables keep each other company, awaiting an Art Judgment Day when still life will resurrect into real life. An Alma-Tadema and a Guy Penè du Bois have cracked with impatience under the burden of time. At the closed windows, dark burgundy draperies held by giant tassels and bordered with hundreds of pom-poms forbid the intrusion of fresh air. As Andy takes a fusty breath, he notices that his Aubusson rug is buried under his trophies. Perhaps he thinks: My possessions are possessing my house.

He walks past a Chippendale camel-back sofa (not meant to be sat on) in the large landing hall leading to his Art Deco sitting room. Sharkskin furniture ensembles with Art Deco vases,

dozens of lacquered cigarette cases, a smiling cat by Lichten-stein, 1926 cabinetry by Émile-Jacques Ruhlmann, a dark bust by Renoir, a profile/full-face Picasso portrait. As Andy advances, he rests a talcum-colored hand on a gigantic clear crystal ball. He surveys mission, Oriental, and Dunand vases, a gray Jasper Johns screen piece, scribbled code paintings by Cy Twombly, an Arp, a Léger, a Klee, and two erect cobra andirons guarding the hearth beneath the veined marble mantel. A suite consisting of a chair, a console table, a desk, and a cabinet in galuchat by Pierre Legrain holds Puiforcat partly gilded silver and art glass. A large canvas of a woman's torso by Man Ray represents the only fe-male to undress in that room for Andy. Some Marcel Duchamp readymades sit here and there on lacquered chairs that wait for hypothetical guests. Inside the mirrored sharkskin cabinet nestle twenty Erté designs and portraits of film stars from Hollywood's golden era.

Glancing at his Rolex, the only ticking watch among the 313 silent timepieces in his collection, Andy hurries down the stairs, thickly populated with memorabilia, to the well-proportioned en-try hall, where he unlocks the massive mahogany double doors that lead into the once-upon-a-time grand dining room, now turned storage space for some of his 439 paintings. The dining room has not witnessed a meal for at least a decade. From floor to ceiling, crates, cardboard boxes, papers, academic paintings, and useless ornaments pile up under the immovable eyes of a bust by Houdon. Buried like a gigantic mummy is a mahogany dining table for at least twelve, surrounded by Ruhlmann chairs; these, in turn, are entombed by an Art Deco tea service and other silver galore, an hourglass, stacks of photos, including a full-size portrait of King George III in ermine-trimmed robes, and min-iature Adirondack furniture made of twigs. Yes, Andy loves chairs; he owns about 180 of them.

As if the Warhola tribe back in Pittsburgh were not enough, Eskimo and Kwakiutl masks, portraits of Hercules, nineteenth-century bronzes of Laocoöns and of Bedouins, a cast-iron statue

272

of George Washington, busts of Benjamin Franklin, the Marquis de Lafayette, and Daniel Webster, plus handsome marble heads of Hermes and unidentified austere faces, constitute his extended family.

Andy is now on his way to the kitchen, about to share his breakfast with his adopted family: Nena and Aurora, his gentle live-in Filipino maids, and their two brothers, Augusto and Flordelino, nicknamed Tony, who drive and paint and do whatever else is needed. Also among the breathing clan are Amos and Archie, Andy's dogs.

Reaching the kitchen, filled with stacks of bowls, cups, saucers, and plates of red, green, yellow, black, blue Fiesta ware, Andy glances at his 175 cookie jars, with their yellow faces, mustached faces, clown faces, pig faces, dog faces, black faces, clock faces, twins' faces, house faces, balloon faces, and their mother and child tops with skirted bottoms. He reaches into a jar for his favorite food, a piece of instant heaven.

He swallows cornflakes and skim milk while watching TV. The old-fashioned cast-iron stove with its six burners stands idle, seldom used. Through the glass door of a cupboard, the wide-open eyes of the funny-faced driver of a wind-up "Milton Berle" car watch Andy eating. Miss Piggy restrains her oinking and the other toys are noiseless, while the Wizard of Odd gulps his breakfast.

Walking back along a labyrinthine path hedged by treasures and trivia, Andy picks up a thousand dollars in hundred-dollar bills from under his mattress, then relocks all the doors. Leaving his temple of ten thousand offerings, Andy waves goodbye to an original cast of Canova's monumental head of Napoleon, his soulmate, before stepping into a yellow cab en route to Andy Warhol Enterprises, there to collect his daily receipts in order to resume his circuit of antique stores, auctions, and flea markets.

On May 3, 1988, the last fall of the auctioneer's gavel at Sotheby Parke Bernet concluded the ten-day sale of Andy's earthly

273

treasures ransacked from the planet's past. The sale proceeds of $25,313,238 will purportedly be recirculated for the benefit of artists.

Who would have guessed that the little Pittsburgh waif, drawing his delicate, disconnected lines would become the first man to fuse into one the opposite roles of artist and Maecenas, thereby earning double immortality far beyond his self-allotted fifteen minutes.